The Drawing Bible

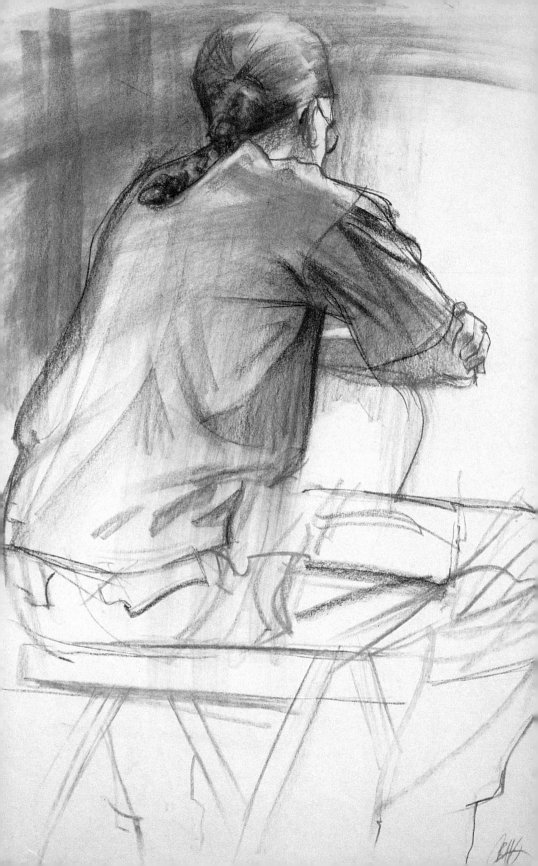

the DRAWING BIBLE

Craig Nelson

NORTH LIGHT BOOKS

CINCINNATI, OHIO

www.artistsnetwork.com

North Light Books, an imprint of F+W Publications, Inc., 4700 East Galbraith Road, Cincinnati, Ohio, 45236. (800) 289-0963. First Edition.

Other fine North Light Books are available from your local bookstore, art supply store or direct from the publisher.

11 10 09 08 07 6 5 4 3 2

DISTRIBUTED IN CANADA BY FRASER DIRECT
100 Armstrong Avenue
Georgetown, ON, L7G 5S4 Canada
Tel: (905) 877-4411

DISTRIBUTED IN THE U.K. AND EUROPE
BY DAVID & CHARLES
Brunel House, Newton Abbot, Devon, TQ12 4PU, England
Tel: (+44) 1626 323200, Fax: (+44) 1626 323319
Email: postmaster@davidandcharles.co.uk

DISTRIBUTED IN AUSTRALIA BY CAPRICORN LINK
P.O. Box 704, S. Windsor NSW, 2756 Australia
Tel: (02) 4577-3555

Library of Congress Cataloging-in-Publication Data

Nelson, Craig
 The drawing bible / Craig Nelson.
 p. cm.
 Includes index.
 ISBN-13: 978-1-58180-620-5 (wire o : alk. paper)
 ISBN-10: 1-58180-620-5 (wire o : alk. paper)
 1. Drawing--Technique. I. Title.
 NC730.N45 2006
 741.2--dc22 2005024335

Edited by Kelly Messerly
Designed by Wendy Dunning
Page layout by Joni DeLuca
Production coordinated by Mark Griffin

METRIC CONVERSION CHART

TO CONVERT	TO	MULTIPLY BY
Inches	Centimeters	2.54
Centimeters	Inches	0.4
Feet	Centimeters	30.5
Centimeters	Feet	0.03
Yards	Meters	0.9
Meters	Yards	1.1

About the Author

Craig Nelson graduated with distinction from the Art Center College of Design in Los Angles, California, in 1970. He began teaching in 1974 and currently teaches painting and drawing at the Academy of Art College in San Francisco, where he is Department Director of Fine Art.

His work has appeared on many record album covers for Capitol Records, Sony and MGM. He has also painted many portraits for various stars including Natalie Cole, Neil Diamond, Rick Nelson, Sammy Davis Jr. and Loretta Lynn.

Craig has won over two-hundred awards of excellence in various national shows including being selected for the Arts for the Parks competition for the last eight years. His work can be found in several galleries throughout the United States and continues to appear in exhibitions both nationally and internationally. His paintings also appeared in the book, *Art From the Parks* (North Light Books).

Craig is a member of the Oil Painters of America, the American Society of Portrait Artists and a signature member of the California Art Club. He resides in northern California with his wife and three children.

Acknowledgments

To all of the fantastic teachers that I was fortunate to study under including; Don Puttman, Joe Henninger, Midge Quinell and Reynold Brown

To all of the students whom I have taught over the past 32 years and have become some of today's leading artists, you have given me a lot.

To the Academy of Art University, especially to Elisa Stephens and Richard Stephens for allowing me to create a superb Fine Art department.

To all of my fellow artists who continue to inspire me . . . keep it up!

Dedication

To my amazing family; My wife Anna, a wonderful painter, wife and mother

My creative children; Sasha, Brendan and Ian

My artistic mother Maxine, father James and sister Heidi

All of who constantly inspire me, I love you all!

TABLE of CONTENTS

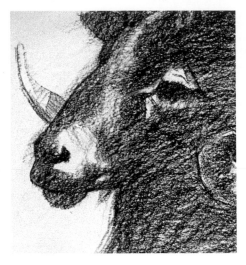

1

MATERIALS and MEDIUMS

2

LINE and TONE

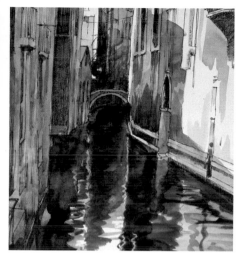

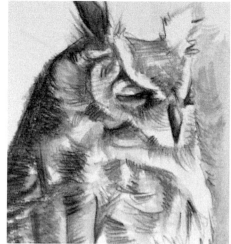

3

PERSPECTIVE and PROPORTION

4

COMPOSITION and SKETCHING

5

SUBJECTS for DRAWING

6

DRAWING FIGURES and FACES

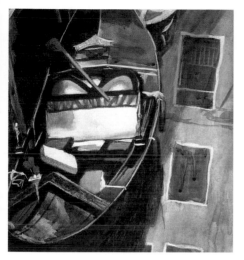

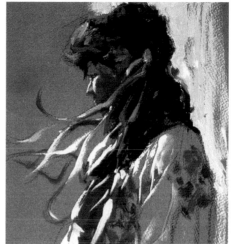

7

MIXING MEDIUMS

8

Drawing as PRELIMINARY STUDIES and as FINISHED ART

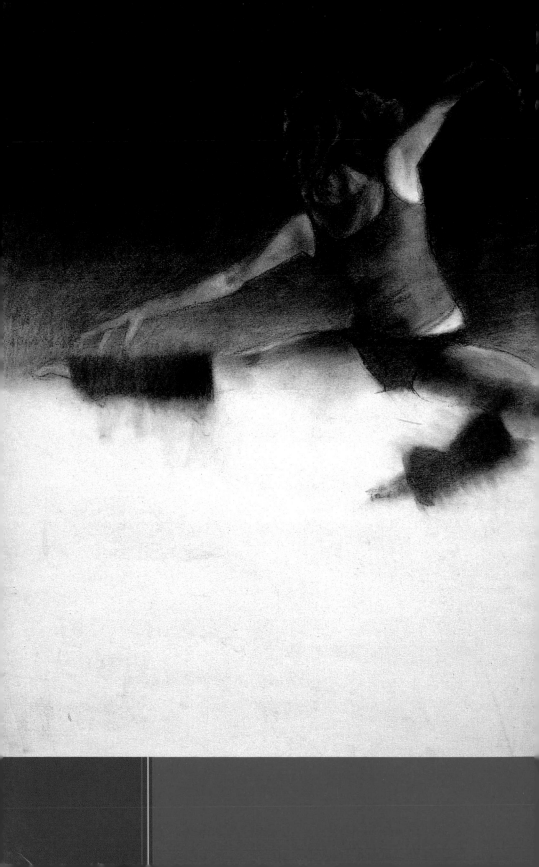

INTRODUCTION

Drawing is the one artistic endeavor that everyone has experienced at sometime. It was most likely the first written form of communication, and continues to be a favorite leisure activity.

It is the seemingly magical act of drawing that captivates the heart and imagination of so many. The thrill of making a group of marks create an image offers a special sense of accomplishment. As a child matures, each new year brings a greater awareness of how to make those marks accurately reflect the subject he or she chooses to depict.

The act of drawing is timeless. Although mediums, techniques and concepts have changed, the use of marks and tones has always been the foundation on which drawings are made. Beginning with a blank page and ending with a pleasing image can be a rewarding experience. As in any endeavor, improvement comes with practice and repetition. Eye-hand coordination and sensitivity to mediums may be developed through experience.

Today, those who engage in the art form known as drawing work on a variety of levels. There are those who doodle, those who sketch for fun, those who draw for a living, and those who draw for the sheer aesthetic beauty of drawing. Whatever the motive, drawing is something that everyone can enjoy and grow with. It takes only desire and practice, practice and more practice. The satisfaction of creating an outstanding drawing is hard to beat, so pick up your pencils, pens, markers, charcoals or pastels and enjoy!

DANCER'S LEAP
Charcoal and black pastel on artists' vellum
20" × 18" (51cm × 46cm)

DRAWING FOR EXERCISE

As in any skill-based endeavor, exercise and practice is the surest way to advance in drawing. Practice drawing from models, objects or the environment in various mediums, and your observation skills and eye-hand coordination will greatly improve. To learn how to make meaningful marks and tones, you must practice.

An Exercise in Attitude
The model posed for about twenty minutes, and I did the sketch in two or three earth tones of Conté pencils, accented with white Conté on a light neutral toned Canson paper.

CASUAL ATTITUDE
Conté pencils on Canson paper
22" × 17"
(56cm × 43cm)

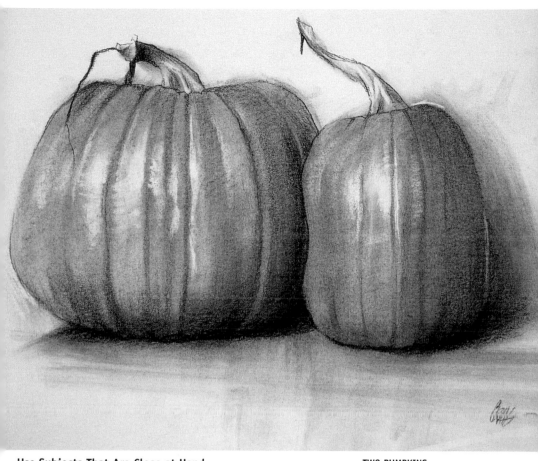

Use Subjects That Are Close at Hand

Sometimes you may find the best subject matter
by looking around your home. Here I used a
couple of pumpkins left over from Halloween to
practice value and form. Try this using a 4B
charcoal pencil, soft vine charcoal and a knead-
ed eraser on bristol board.

TWO PUMPKINS
Charcoal on bristol board
9" × 12" (23cm × 30cm)

13

DRAWING FOR INFORMATION and STUDY

Drawing is often used as a method for gathering information or to study subjects and ideas for use in future art-work. A quick sketch can also help you make design, composition, value and color decisions.

A Compositional Sketch

Fine-line pens are useful for sketching specific subjects in complex environments. Add tonal variations by building up hatching.

ANTELOPE
Pen and ink on bond paper
7" × 4" (18cm × 10cm)

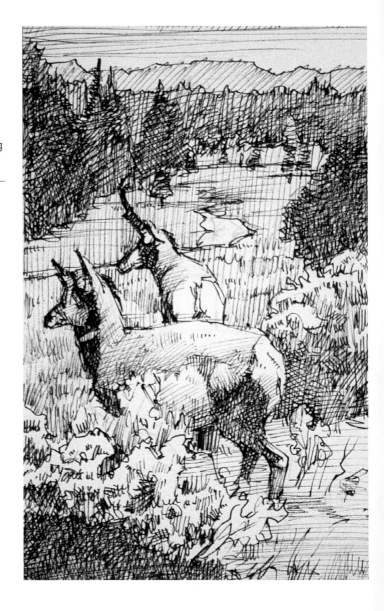

Do a Line Study to Gather Information

A location line study is a quick and spontaneous way of recording shape and rhythm. Hatching provides a degree of tonality and form.

A LILY PAIR
Fine-line marker on bond paper
8" × 6" (20cm × 15cm)

DRAWING as EXPLORATION

Many artists refer to exploration as "messing around." This is a bit of over-simplification. Perhaps "messing around with a purpose" is a better definition.

Both drawing new subjects and trying out new mediums are valid and exciting forms of exploration.

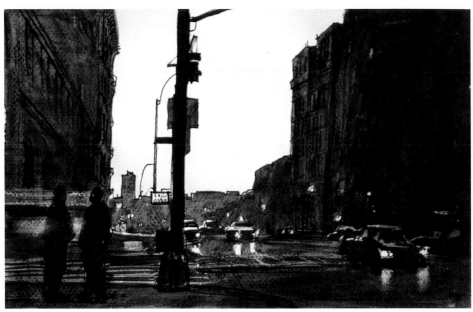

Try New Mediums and Subjects
A New York City street scene at evening is a new subject for drawing. A watercolor pad with permanent fine-line sketch pen and black watercolor works well for this. Touches of white Nupastel for a few lights complete the effect.

A NEW YORK EVENING
Pen and watercolor wash on bristol paper
7" × 11" (18cm × 28cm)

FINISHING a DRAWING

A drawing is finished when the image achieves the artist's desired quality. It may be created with simple lines, fully developed tones or a combination.

Create a Sense of Completion
Warm earth-toned Conté and CarbOthello pencils on acid-free bond paper creates a pleasing variety of tones. Add a few sharp linear accents to finish the composition.

KEEPING DRY
Conté and CarbOthello pencils on bond paper
22" × 17" (56cm × 43cm)

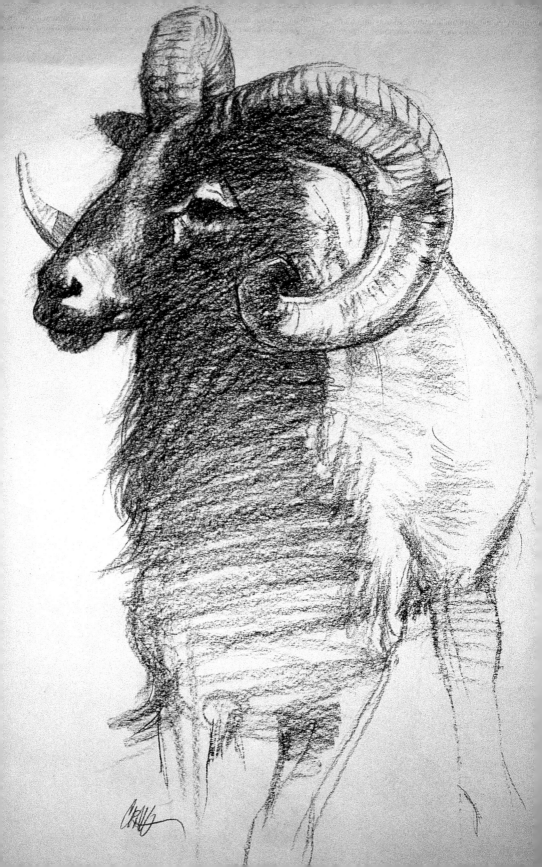

MEDIUMS and MATERIALS

Just about anything that can make marks or tones may be used for drawing. The yellow-jacketed no. 2 graphite pencil with an eraser that we are all familiar with is usually our first drawing tool.

However, even graphite comes in various degrees of hardness, offering a variety of tones. There are many other types of mediums that all have unique characteristics and therefore offer unique drawing opportunities. Try as many as you can.

THE BACHELOR
4B and 6B charcoal on gray sketching paper
24" × 18" (61cm × 46cm)

DRAWING MEDIUMS and TOOLS

Drawing mediums are referred to as either dry or wet. Both types can be combined in countless ways to produce everything from quick, hard contour lines to rich, graceful gradations.

Pastels, soft

Dry Mediums

Colored pencils

Charcoal pencils and sticks

Oil pastels

Pastels, hard

Graphite pencils and sticks

Conté pencils and sticks

Wet Mediums

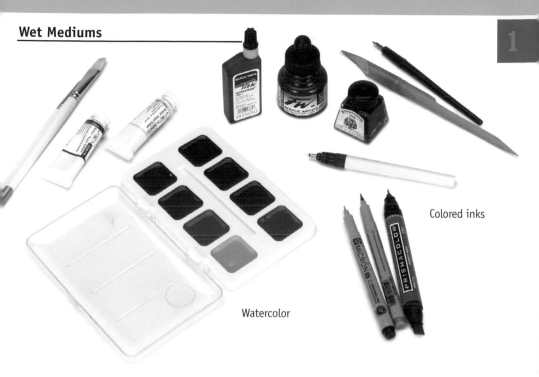

Colored inks

Watercolor

Drawing Tools

The proper drawing tools combined with your chosen mediums and surfaces will help you achieve your artistic vision. Here are some tools you may find useful.

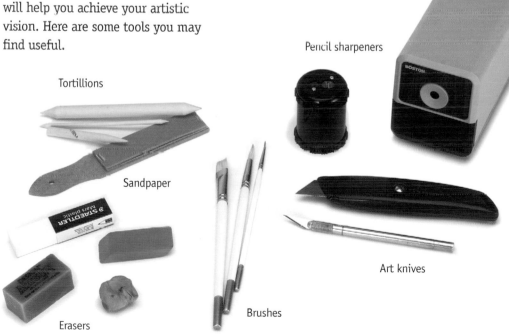

Tortillions

Pencil sharpeners

Sandpaper

Art knives

Erasers

Brushes

21

GRAPHITE

Graphite is most commonly referred to as pencil. However, graphite is a specific type of pencil that produces silvery blacks, and it comes in sticks as well as pencils.

Forms of Graphite

Pencils are best for detailed work while graphite sticks are good for creating large tonal areas. Mechanical pencils, for which a variety of leads are available, are a favorite of many artists.

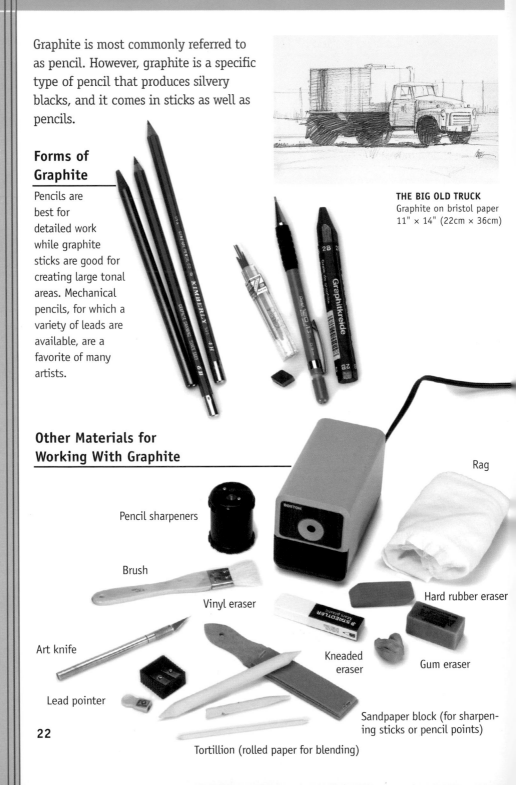

THE BIG OLD TRUCK
Graphite on bristol paper
11" × 14" (22cm × 36cm)

Other Materials for Working With Graphite

Rag

Pencil sharpeners

Brush

Vinyl eraser

Hard rubber eraser

Art knife

Kneaded eraser

Gum eraser

Lead pointer

Sandpaper block (for sharpening sticks or pencil points)

22

Tortillion (rolled paper for blending)

Characteristics

Artist's graphite is a combination of graphite and clay. The higher the proportion of graphite to clay, the softer the medium.

Graphite comes in degrees of hardness from 8H to 6B (the *H* refers to hard and the *B* designates black). Hard graphite (H) is good for fine details. Soft graphite (B) can produce a wider range of tones than hard graphite and is good for large tonal areas. Soft graphite requires sharpening more often than hard.

Hard ←————————————————————————————→ **Soft**

| 6H pencil | H pencil | 2B pencil | 6B graphite stick |

With point

With chisel edge

Held flat against paper

Techniques

Lifting Out
The complement of the graphite pencil is the eraser. A kneaded eraser is pliable and is great for picking out soft whites. The hard eraser is better for adding crisp whites.

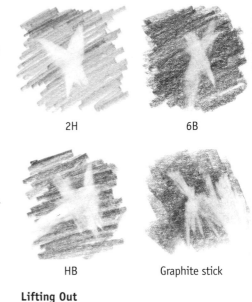

2H

6B

HB

Graphite stick

Lifting Out

Hatching and Crosshatching
Hatching is a closely spaced series of lines, usually parallel. Hatching is used for shading, shaping and building texture.

Crosshatching is hatching done in layers so that the lines intersect each other. By adding layers of crosshatching, you can increase the density and darken the value in small increments. This makes crosshatching an ideal technique for creating shadows.

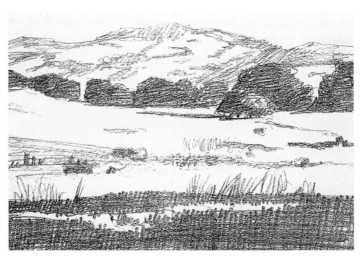

A Quick Graphite Sketch With Crosshatching
Solid tonal shapes and rapid lines make up this sketch. A few soft tones here and there make this a more accurate depiction.

HILLSIDE LANDSCAPE
Graphite on ledger paper
5" × 7" (13cm × 18cm)

24

CHARCOAL

Charcoal's incredibly rich blacks make it a seductive medium. Since charcoal marks are easily made and can be quite broad, charcoal lends itself to large drawings.

Forms of Charcoal

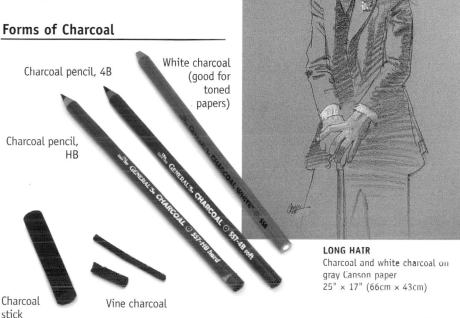

Charcoal pencil, 4B

White charcoal (good for toned papers)

Charcoal pencil, HB

Charcoal stick

Vine charcoal

LONG HAIR
Charcoal and white charcoal on gray Canson paper
25" × 17" (66cm × 43cm)

Other Materials for Working With Charcoal

Kneaded eraser

Chamois

Tortillions

Brush

Rag

Paper towels

25

Characteristics

Charcoal sticks and pencils are made of compressed charcoal. There is also a softer variety called vine charcoal, useful for sketching.

Compressed charcoal, like graphite, comes in varying degrees of hardness. The 2HB through 6B are generally the most desirable.

Charcoal sticks are good for laying down wide strokes, while pencils are better for delicate work. Charcoal pencils are encased in either wood or paper and are less messy than sticks.

WHITE CHARCOAL HAS MANY USES

White charcoal may seem like a contradiction in terms, but white charcoal pencils do exist. White charcoal can be blended with black charcoal or used by itself on toned paper. White charcoal can also be used to cover charcoal stains on white paper.

Vine Charcoal

Compressed Charcoal

White Charcoal on Black Paper

Charcoal Pencil

Techniques

Charcoal is easily blended with tortillions, facial tissue, chamois or even your fingers. As with graphite, you can subtract lines or tone from charcoal by lifting with an eraser.

Because charcoal is soft, the *tooth*, (texture) of your paper greatly affects the look of charcoal marks. Use spray fixative to keep finished charcoal work from smudging.

Lines

Blended

Lifted

Vine Charcoal

Lines

Blended

Lifted

Compressed Charcoal

TAKE SOME OF THE MESS OUT OF CHARCOAL

Wrap charcoal sticks in paper towels or aluminum foil to keep your fingers clean.

Gallery

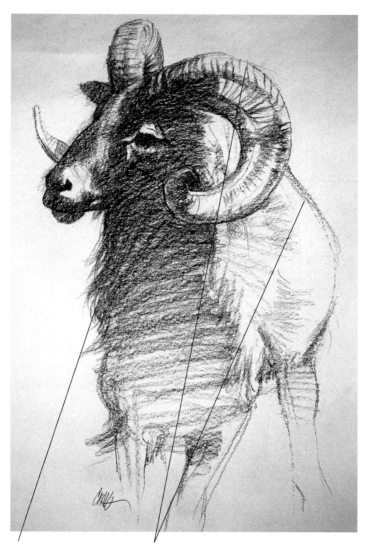

Use Charcoal for Texture

In this sketch, I used soft charcoal to create different textures for this ram. Although the charcoal was soft, I did this entire sketch without blending. Instead, lines create the shading and give the animal form. Tone and line are more concentrated in the head area for focus.

THE BACHELOR
4B and 6B charcoal on gray sketching paper
24" × 18"
(61cm × 46cm)

Fine, sweeping lines create the texture of hair

Strongly directional lines indicate the contours of the animal

CONTÉ

Conté is the trademark name for a chalklike drawing medium. The most familiar Conté colors are rich, warm earth tones, from reddish sanguines to deeper umbers and blacks. For years Conté has been closely associated with figure drawing.

A FISHING ICON
Conté on ledger paper
17" × 18" (43cm × 46cm)

Conté Sticks and Pencils

USE THE SMOOTH SIDE OF YOUR PAPER

For more control when working with Conté, use the smooth side of your paper.

Use Toned Paper With Conté

Conté is an excellent medium for experimenting with different colors of paper. You can use many of the same materials as you use with graphite and charcoal.

Characteristics

Like graphite and charcoal, Conté
comes in sticks and pencils and in vary-
ing degrees of hardness and softness.
Conté also comes in different colors:
black, white, brown umber (bistre),
gray, sanguine orange, sanguine brown
and sanguine red.

Fine Conté Lines
The shape of a Conté
pencil allows you to
create lines of varying
width. If you want to
create thin lines, use
the edge of the pencil.

Thick Conté Lines
To vary the size of the
lines of Conté sticks,
change the angle at
which the stick hits
the paper. Although
you can make wide
lines with pencils,
they will not be as
dark as those made
with Conté sticks.

Techniques

Conté has a dry, chalklike feel similar to charcoal. The more pressure you use with Conté, the darker the mark. You might begin a Conté drawing with a lighter color and softer lines and progress to darker colors and more powerful marks. White Conté is good for adding lights on toned papers.

CONTÉ CAN APPEAR GLOSSY

The harder varieties of Conté can display a rather glossy look—particularly the black.

Blending Conté
You can let your Conté marks show the texture of the paper, or you can blend them with a tortillion for a smooth look.

White over red White and gray over red Red over black

Combining Conté Colors
Just a few Conté colors can be blended to produce a variety of effects.

Gallery

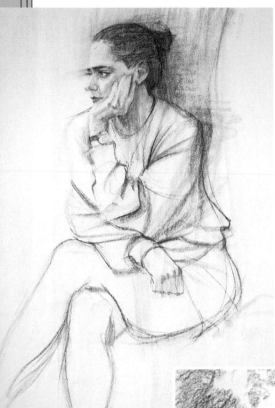

The Figure in Conté

The progression from soft sketch lines to firm, dark lines and tones is left in here, demonstrating the searching nature of the drawing process.

THE LOOK OF DETERMINATION
Conté on bond paper
23" × 18" (58cm × 46cm)

Light and Dark Conté Tones

Abbreviated and simplified light tones are enhanced with darker umber tones and crisp architectural lines for definition.

SHADED BARN
Conté on gray sketching paper
17" × 17" (43cm × 43cm)

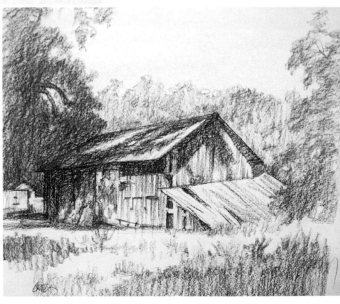

COLORED PENCIL

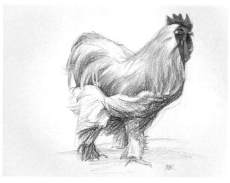

Colored pencils consist of binder, filler, wax and pigment. The more wax a pencil contains, the more smoothly it glides across the paper. Water-soluble colored pencils allow for watercolorlike effects. You can even find color sticks, which are colored pencils without the wood casing.

BARNYARD STRUT
Prismacolor pencil on ledger paper
16" × 16" (41cm × 41cm)

Prismacolor Verithin (hard)

Colored Pencil Choices

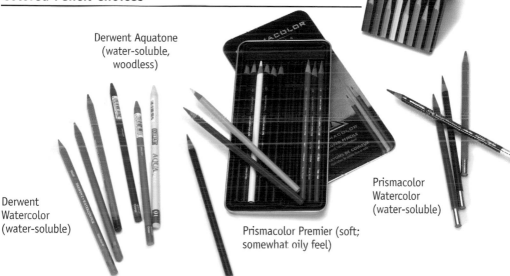

Derwent Aquatone
(water-soluble,
woodless)

Prismacolor
Watercolor
(water-soluble)

Derwent
Watercolor
(water-soluble)

Prismacolor Premier (soft;
somewhat oily feel)

Materials for Working With Colored Pencils

Drafting tape

Sandpaper block

Pencil
sharpeners

Erasers

33

Characteristics

Soft colored pencils provide opaque coverage of the paper surface, and they excel at producing smooth, vivid color. Hard colored pencils have thinner leads that can be sharpened to a fine point, allowing for crisp lines but not for heavy coverage. You can use both kinds in one composition.

With water-soluble colored pencils, you can create fuzzy marks or flowing, luminous washes of color simply by adding water with a brush.

CHOOSING A SIZE FOR YOUR COLOR PENCIL WORK

You might prefer to work smaller when using colored pencil than you would with other mediums. Completing a large, detailed colored pencil piece can be time-consuming. Of course, a loose gesture sketch in colored pencil would take less time.

Sharpened tip Side Blunt chisel edge

Colored Pencil Strokes
Colored pencils can make a wide range of strokes depending on how sharp your pencil is and at what angle you hold it to the paper.

Water-Soluble Colored Pencils
You can soften strokes of water-soluble colored pencil with a brush and clear water.

34

Techniques

Basic Strokes

Colored pencil strokes can be light or dark, crisp or feathered, delicate or defined.

Choppy

Run the pencil at an angle across paper or a sanding block to achieve a blunt, slanted, "chisel" edge. Use this edge to make firm, short strokes.

Feathered

For feathered strokes, let your pressure on the pencil trail off at the end of the stroke. The result is a gently faded edge.

Tonal Variation

For a gradated tone, increase or decrease your pressure on the pencil as you work across an area.

Defined

A defined stroke has a clear start and stop with no feathering.

YOUR COLORED PENCIL PALETTE

Generally two or three each of yellows, oranges, reds, blues, greens and earth tones will suffice, with the addition of one or two flesh tones and possibly black and white.

Blending With Colored Pencils

A variety of blending techniques can be used to produce shading or to combine colors.

Burnishing
Apply layers of color with firm pressure to achieve an opaque, shiny look.

Layering
With light to medium pressure, lay one color atop another.

Crosshatching
Apply one color with parallel strokes, then add other colors similarly but at different angles.

Crosshatched Colored Pencil
The white of the paper is surrounded by blues in a crosshatched effect combined with a group of free gestural curves. The orange acts as visual punctuation.

WHITE REFLECTION
Colored pencil on ledger paper
11" × 15" (28cm × 38cm)

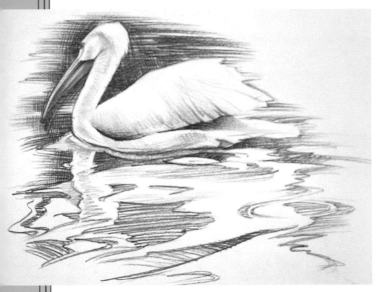

Water-Soluble Colored Pencils

Water-soluble colored pencils may be used strictly as pencils for sketching, or you can apply water with a soft brush for a fluid look. I think the dry application of lines combined with a touch of water here and there gives optimum balance to this unique medium.

SURFACES FOR WATER-SOLUBLE COLORED PENCILS

A porous surface such as ledger, bristol or watercolor paper works best for this medium.

Using Water-Soluble Pencils

Apply water-soluble colored pencil . . .

. . . then brush on water.

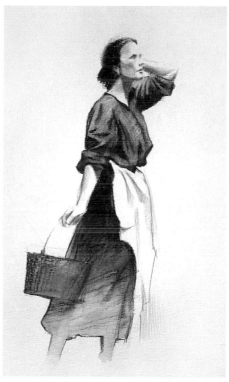

Layered Colored Pencil
Darks have been layered on top of a lighter water tone for strength.

CARRY THAT PAIL
Water-soluble colored pencil on watercolor paper
14" × 11" (36cm × 28cm)

37

Gallery

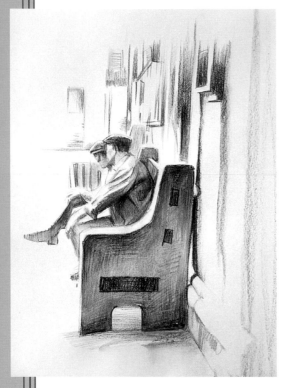

Experiment With Water-Soluble Pencils' Possibilities

Leaving a great deal of white space, combine water tone with dry line work to create a sketchlike quality.

A COUPLE OF BUDDIES
Water-soluble colored pencil on ledger paper
12" × 9" (30cm × 23cm)

TRAVEL LIGHT WITH WATER-SOLUBLE PENCILS

Water-soluble colored pencils make a great travel medium, especially for people who enjoy watercolor painting. There is no need for a palette—just a small water container, a pad, a brush and six to eight pencils.

Layer Colors to Add Richness

Layer dry pencils with wet then dry again for a strong, saturated color.

A RED ROSE
Water-soluble colored pencil on ledger paper
24" × 18" (61cm × 46cm)

PASTEL

Pastels are composed of the same pigments used in oil paints without the oil binder. It is a great medium for quick sketches or a fully developed painting. A rich array of color is evident in many pastels; however, a simplified palette may be equally intriguing.

Forms of Pastel

Hard pastels

Soft pastels

Pastel pencils

PETALUMA FARMHOUSE
Hard pastel and Conté on toned Canson paper
14" × 18" (36cm × 46cm)

PASTEL'S CLOSE COUSINS

For drawing, pastel sticks are often combined with pastel pencils, Conté pencils or even charcoal pencils, since they are all chalklike tools.

Other Materials for Working With Pastel

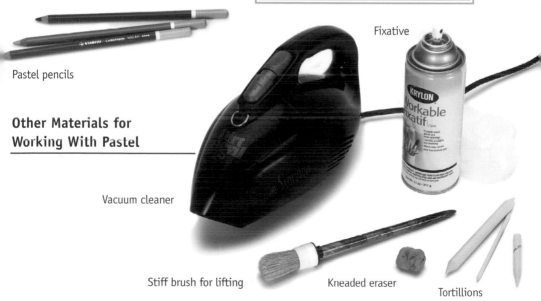

Fixative

Vacuum cleaner

Stiff brush for lifting

Kneaded eraser

Tortillions

39

Characteristics

Pastels are made from a combination of chalk, pigment and a binder (usually gum tragacanth) that has been formed into sticks or pencils. The binder holds the pigments together, but pastel needs a paper with a lot of tooth to remain on the suface.

Hard Pastels

Hard pastels are usually rectangular. Because they contain more binder than soft pastels, they tend to break less often and emit less dust. Sharpened

hard pastels are great for linework. Turned on their sides, hard pastels can be used to create broad areas of color, a useful technique for applying the initial layers of color for a picture.

Soft Pastels

Soft pastels tend to be rounder than hard ones and usually are enclosed in a paper sleeve to help prevent breakage. Because they have less binder, soft pastels create more dust and are more easily broken.

Pastel on Cold-Pressed Watercolor Paper

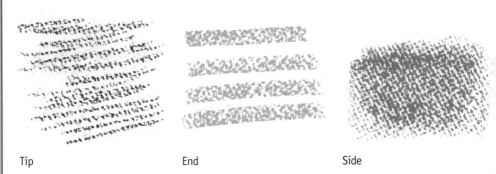

Tip End Side

Pastel on Bristol Vellum

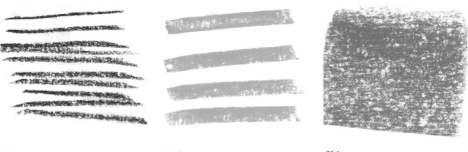

Tip End Side

Techniques

Ways to Blend Colors

Pastels can be blended with fingers, a tortillion or (for large areas) a rag.

Mingling pastel colors without blending them lets the colors combine visually for a textured effect. A few different ways of doing this:

- *Layering.* Apply one color atop another without blending.
- *Crosshatching.* Apply lines of color at different angles.
- *Scumbling.* Apply one color over another in loose, wide strokes.

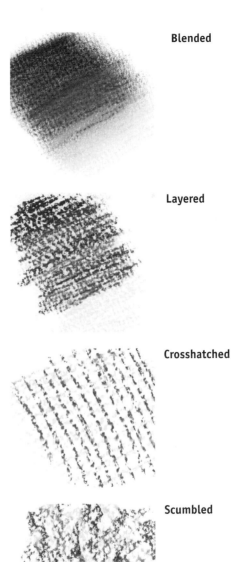

Blended

Layered

Crosshatched

Scumbled

Sharpening a Pastel Stick

To sharpen the edge of a pastel stick, scrape it with an art knife. Use this technique to sharpen Conté sticks, too.

Gallery

Hard Pastels Are Good for Details

This quick, unfinished sketch shows hard pastel on top of a faint charcoal sketch.

GIRL WITH A SCARF
Hard pastel and charcoal
11" × 8" (28cm × 20cm)

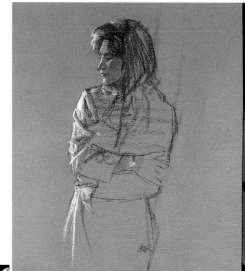

Soft Pastels Create a Painterly Look

This small, quick sketch shows the opacity of soft pastel on a darker piece of Canson paper.

TRUCK IN THE WEEDS
Soft pastel with Conté on toned Canson paper
8" × 10" (20cm × 25cm)

TRY PASTELS ON A TONED SURFACE

Pastels work well on toned surfaces since they are bold and opaque. They have a great quality of building tone upon tone, light over dark as well as dark over light.

Many artists use pen in their sketchbooks because marking pens produce sharper lines than pencils. A pen drawing can consist of simple, expressive lines, hatched tones that create volume and form, or both.

Since pen marks are permanent, an artist must draw with conviction. The spontaneous quality of pen drawing contributes to its charm and beauty.

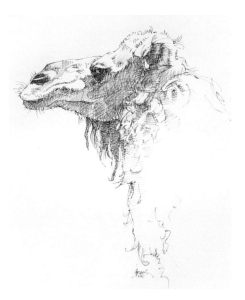

A NOBLE PROFILE
Fine-line pen on bond paper
12" × 10" (30cm × 25cm)

Drawing Pens

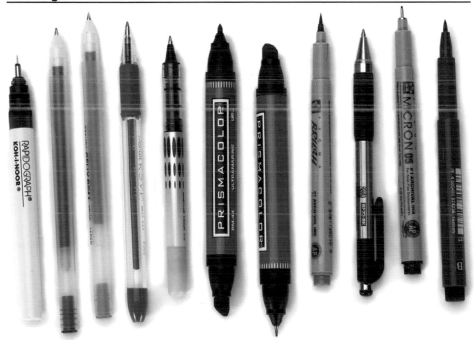

Pens, from left to right: Koh-I-Noor Rapidograph technical pen, Sakura Gelly Roll pens (2), Pentel fine ballpoint pen, Sanford uni-ball Vision roller ball pen, Prismacolor markers (2), Sakura Pigma Micron 0.45mm pen and Faber-Castell PITT artist's pen.

43

Characteristics

Ballpoint Pens

Although most commonly used for writing, ballpoint pens are great for quick sketches or for transferring a drawing. Most ballpoint pens are not permanent.

Fine-Line Drawing Pens

There is a terrific variety of permanent fine-line drawing pens. A .03 size is probably the best for drawings 11" × 14" (28cm × 36cm) or smaller. However, it is possible to create exciting drawings with bolder pens.

Technical Pens

Technical pens come in three types:
- *Refillable.* This has a plastic cartridge you fill with your choice of ink. You

Drawing Pens

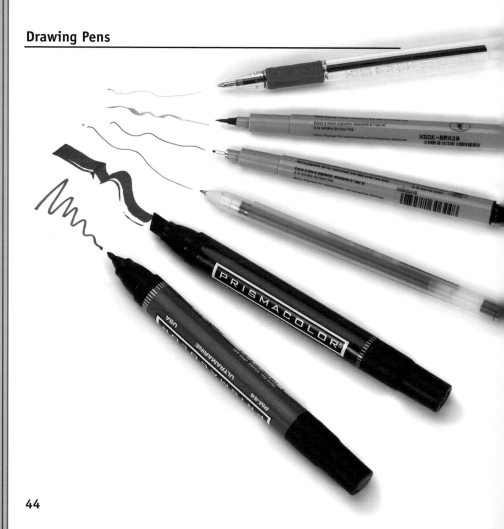

can also choose from a range of point sizes.

- *Disposable cartridge.* This has a plastic cartridge already filled with ink that you replace when empty.
- *Disposable pen.* Throw out the entire pen when it's empty.

Felt-Tip Pens

Felt-tip pens come in various sizes and colors. Experiment to find the pen that works best for you.

Brush Pens

Brush pens have a flexible, fibrous point. The pen can make lines of varied widths from fine to broad, like a round paintbrush.

Cleaning Technical Pens

Keeping your technical pens clean is extremely important. Follow the instructions that accompany the pen for specific cleaning techniques.

Techniques

Using Pen

There are two basic types of marks you can make with pen: dots or lines. You can vary both types of marks in size, volume and arrangement. The marks will seem lighter if they are spaced further apart and will seem darker if they are close together.

Ballpoint Pen Marks

Gelly Roll Pen Marks

Fine-Line Pen Marks

Artists' Pen Marks

Different Marks Made With Pens

Different types of drawing pens have unique characteristics and will make the same types of marks in slightly different ways. Experiment to find the drawing pen that best suits your pupose.

Ink is great for quick sketches. Inks come in full-strength liquid form. You can create softer variations of each color by simply diluting them with water.

You can apply ink with a brush, a pen or a stick. Inks are totally additive in nature, meaning that once applied, they cannot be lifted from the drawing surface. This is different from working with watercolor, which can be manipulated somewhat after it is laid down.

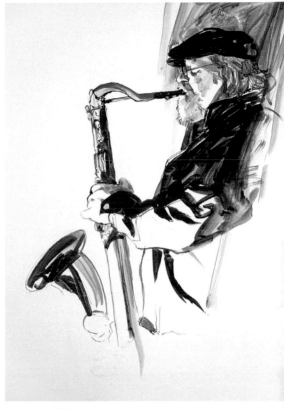

Ink Line and Wash Combined
Slippery, nonporous board lets ink flow easily, showing off brushstrokes.

PATRICK'S SAX
Ink on cast-coated paper
20" × 16" (51cm × 41cm)

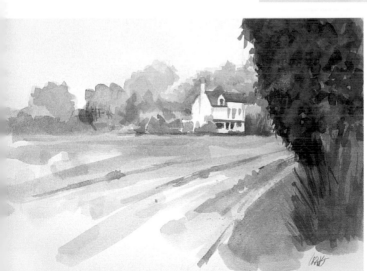

Plan for Lights
When working with ink, build dark shapes gradually. Plan ahead for lights and white areas.

OUTSIDE BALLARD
Colored ink on bristol board
10" × 13"
(25cm × 33cm)

Characteristics

Dip Pens

Dip pens do not have a built-in ink reservoir and must be dipped into a container of ink to pick up a new supply. Their steel nibs are removeable and come in many shapes, giving you a range of possible marks.

Bamboo Pens

These dip pens are made from a slender stick of bamboo. The bamboo is sharp-ened to a point and split, creating a reservoir for the ink.

Oriental Brushes

These are brushes that lend themselves well to drawing with ink. You can get soft, medium and hard tips.

Calligraphy Brushes and Pens

There are a variety of brushes and pens that are used for calligraphy. The brush-

Inks and Dip Pens

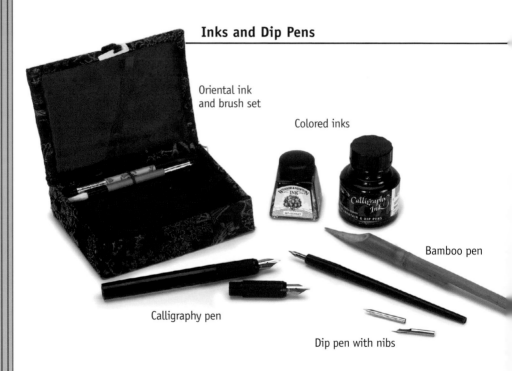

Oriental ink
and brush set

Colored inks

Bamboo pen

Calligraphy pen

Dip pen with nibs

es come in many shapes and sizes, and the pens have a variety of nibs to create different ornamental effects.

Black Inks

These are made up of fine carbon pigments. When buying black ink, look for a manufacturer's date on the container. Inks that have sat on the shelf for longer than two years may have separated and therefore will not be suitable for use.

Colored Dye-Based Inks

Many colored inks are made of impermanent dyes and should therefore be used only for work that does not demand permanence.

Colored Pigmented Inks

These inks work well in technical pens as long as you choose colors that are labeled as transparent.

Inks

A STARTER INK SET

I recommend purchasing two earth tones (one dark, one warm), plus one each of yellow, red, blue, green and black. To add interest, you can also add one or two more colors of shocking intensity.

Techniques

You can use many of the same techniques with ink as you can with drawing pens (page 46). What you use to apply the ink greatly affects the way the ink looks on your drawing surface.

Ink Applied With a Brush

Ink Applied With a Pen

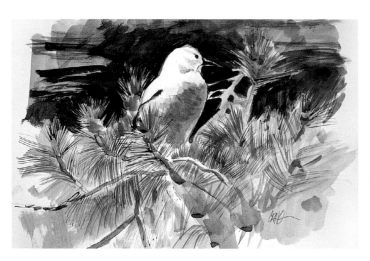

Enhance Basic Shapes With Line
Refine the pine needles by using hogbristle brushes to apply darker greens onto the light green field.

NESTLED IN THE PINES
Colored inks on bristol board
11" × 14"
(28cm × 36cm)

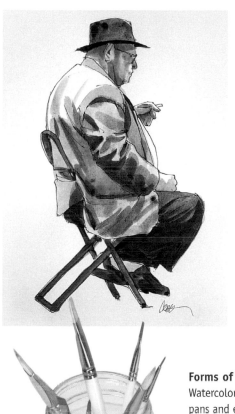

Watercolor is relatively easy for the artist to transport and set up on location. The addition of line brings a new spontaneity to the beauty of the colorful tones. Watercolor may be used as an accent to line, or line may be used to accent watercolor. Many artists prefer to use hatching to deepen some darks, but this is a personal preference.

Watercolor as Accent to Line
This black line contour drawing is brought to life by the addition of light, medium and dark tones from a limited warm earth-tone palette.

STUDY OF A MAN IN A HAT
Fine-line pen and watercolor
12" × 9" (30cm × 23cm)

Forms of Watercolor
Watercolor comes in tubes, pans and even bottles.

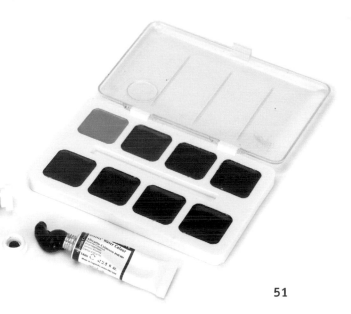

Gallery

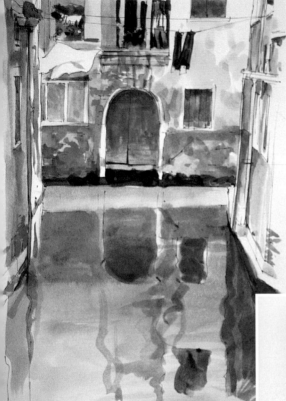

Watercolor and Pen
The basic perspective of the composition is sketched in initially with black line. Loose watercolor stains add color and character.

LAUNDRY LINES
Fine-line pen and watercolor on bristol board
14" × 11" (36cm × 28cm)

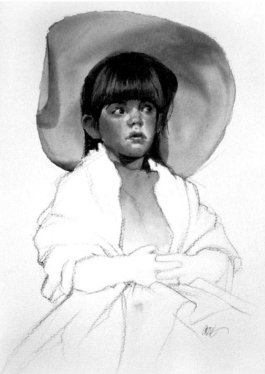

Watercolor and Graphite
The proportions are all worked out in graphite line before watercolor washes are carefully applied in a wet-on-wet manner. The dark hair anchors the softer facial values.

MOM'S BIG HAT
Graphite and watercolor on rough watercolor paper
16" × 12" (41cm × 30cm)

DRAWING SURFACES

The surface you choose for your artwork will contribute greatly to the character of the finished piece. A coarse surface may enhance certain mediums, bringing out the texture and adding variety to the tones. A smooth surface may be more appropriate if you don't want the marks you make to have textured appprearance.

Drawing Surfaces

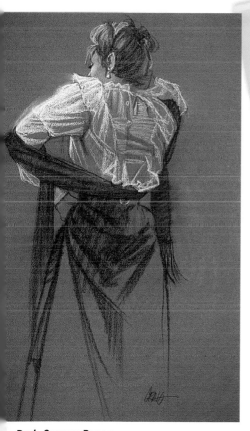

Dark Canson Paper
On dark paper, the white pastel dominates and the dark charcoal supports.

White Bond Paper
Charcoal on simple white bond paper, the most commonly used white paper.

53

Paper

Choose paper that is acid-free to ensure a long life for your artwork. Also be aware that heavier papers withstand erasing, scratching and rubbing better than lighter papers and do not warp as easily.

Charcoal Paper

Charcoal paper comes in varying degrees of tooth. Although designed for charcoal drawings, you can use it with other mediums such as pastels.

Vellum

Vellum is a nonporous surface with a slight tooth. It is a good surface for pen-and-ink work, graphite sketches and for oil pastels.

Pastel Paper

Like charcoal paper, pastel paper comes in different degress of tooth and an also be used with other mediums.

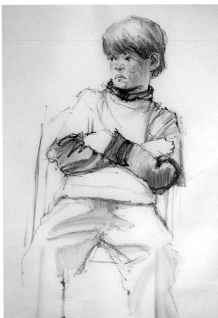

BRENDAN'S COOL SHIRT
Oil pastel on vellum
25" × 19" (63cm × 48cm)

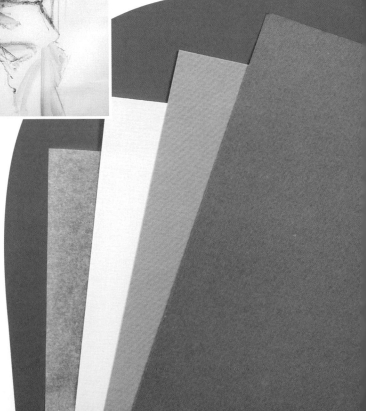

From left to right: vellum, charcoal paper, pastel paper (2)

Watercolor Paper

The surface of a paper greatly influences the look of the medium you apply to it. Watercolor paper, best suited for wet mediums, comes in three textures:

- *Hot-pressed*. This has a very smooth surface.
- *Cold-pressed*. This is moderately textured.
- *Rough*. This is highly textured.

FIXING HER SKIRT
Soft pastel and black charcoal pencil on Canson paper
20" × 12" (51cm × 30cm)

From left to right:
rough, hot-pressed,
cold-pressed

55

Board

Boards are a great option for drawing, especially when working with wet mediums. They are thicker and therefore less likely to warp when washes are applied.

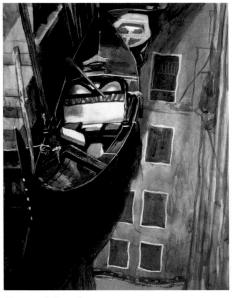

Watercolor Board

Watercolor board is watercolor paper glued to a stiff backing of cardboard. Like the paper, watercolor board comes in hot-pressed, cold-pressed and rough textures.

Bristol Board

Bristol board is created by compressing two or more pieces of paper together. The more paper used, the heavier the weight of the board.

Mat Board

Mat board is a type of cardboard that comes in a wide variety of colors and textures. It can be used for drawing or as the border around a framed picture.

Gessoed Board
The nonabsorbent quality of gesso is a bit rough, great for textural charcoal and for wash-like stains which can be layered to build varying grays.

LONE GONDOLA
Graphite, acrylic, colored pencil and gesso on illustration board
20" × 16" (41cm × 51cm)

From left to right:
watercolor board,
mat board,
bristol board,

Other Types of Surfaces

Exploring other types of surfaces is a lot of fun. Surfaces such as canvas, Yupo and foamcore board can provide exciting and inspirational results.

Canvas

Canvas may be purchased in roll form, prestretched on stretcher strips or mounted on a stiff backing of cardboard or hardboard. It can also be found raw or primed. You can draw on it, but canvas is best suited for oil and acrylic paintings.

Sketch Paper and Newsprint

Inexpensive sketch paper and newsprint are useful for doing quick idea sketches but they should not be used for finished art as neither one will last. Newsprint is especially problematic because its high acid content will cause your art to quickly fade.

Foamcore

Foamcore is a strong, stiff, lightweight board of plastic fibers with paper laminated on both sides. It comes in many colors and thicknesses. Foamcore is often used as a backing for papers and other surfaces, but can be drawn on, too.

Yupo

Yupo may best be described as plastic paper. It's most often used for big, bold watercolors. Yupo is acid-free and archival, but you should spray your work with fixative to prevent the image from smearing.

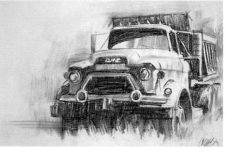

Canvasette
Canvasette is a paper that has been coated and texturized to imitate canvas. You can purchase it in pads and is suitable for sketching in either tone or color.

THE WEATHERED TRUCK
Conté pencil on fine canvasette pad
10" × 14" (25cm × 36cm)

From left to right: sketch paper, canvas, Yupo, foamcore

DRAWING SURFACE GALLERY

Experiment with different surfaces and mediums to determine which ones will best suit the subject and your style. A rough surface may be best for capturing the texture of a rocky landscape, while a delicately detailed portrait might be more suited to smooth, coated paper. Choose a surface that will work with you, rather than against you.

Gessoed Board
Gesso is nonabsorbent and a bit rough, making it great for textural charcoal and for washlike stains which can be layered to build varying grays.

FAMILY
Charcoal, Conté and acrylic on gessoed board
12" × 9" (30cm × 23cm)

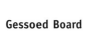

Smooth Paper
Charcoal lines look more refined on a smooth paper. A surface with little texture allows you to smear tones more easily to create softer edges and more gradual value changes. The tone of the paper also softens the highlights.

SMALL ITALIAN VILLAGE
Charcoal on smooth, toned Strathmore drawing paper
11" × 16"
(28cm × 41cm)

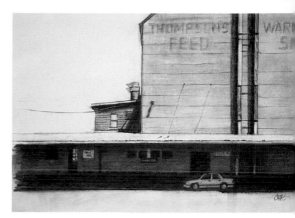

White Paper

An arrangement of gray and black geometric shapes make up this architectural structure. A bit of line and small graphics accent the design, while the shaded white auto provides a sense of scale.

THOMPSONS FEED
Charcoal on bristol board
8" × 11" (20cm × 28cm)

Toned Paper

The neutral gray Canson acts as a great surface for darks and lights, both of which allow the gray to act as the midtone.

THE WEATHERED SAILOR
Charcoal and Nupastel on gray Canson paper
24" × 18" (61cm × 46cm)

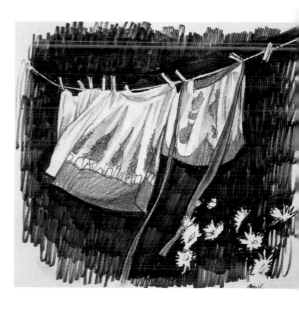

Vellum

Dark marks on vellum make a strong statement. Since vellum has a very slight tooth, marker stays on the surface and charcoal smears easily.

CLOTHES ON THE LINE
Black marker and charcoal on vellum
11" × 12" (28cm × 30cm)

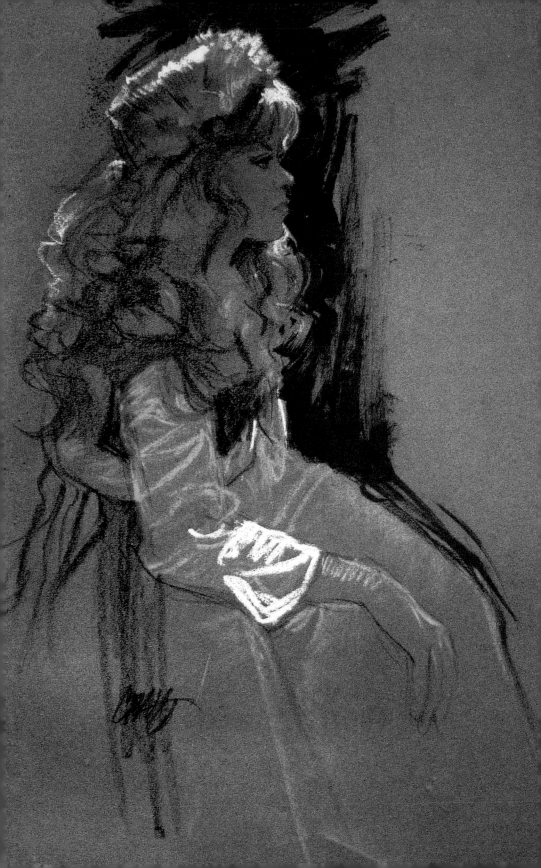

LINE and TONE

When most people think of drawing they envision linework only, without considering the tones we usually associate with painting and photography. However, all of these forms of representational art rely on proportions, perspective and composition. A variety of drawing possibilities opens up when line and tone are combined.

THE FUR CAP
Charcoal pastel and oil on toned Canson paper
24" × 18" (61cm × 46cm)

WORKING WITH LINE and TONE

Generally it is more aesthetically pleasing, for either line or tone to dominate a drawing while the other provides the accent. A drawing may consist primarily of line with tone as an accent, or a drawing may be made up of tone accented by line. Use the accent in the drawing's focal point (page 130) or in an area to which you wish to call more attention.

You may use a variety of mediums in line and tone drawings, or only one. Utilizing both line and tone in your drawings allows you to explore and dis-

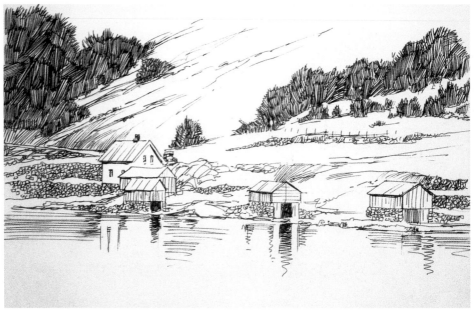

Line Can Serve as a Contrast to Tone
This ink sketch uses line and tone to establish the contrast between the geometric architecture forms and the organic landscape forms.

ALONG A FJORD
Fine-line pen on vellum
11" × 14" (28cm × 36cm)

cover new directions for your work. Starting with line and then adding tone, or developing a group of tones and then unifying it with line can help you express your ideas more fully. Your ability to work with different mediums, approaches and technical applications will improve with practice and repetition. As you experiment you will discover exciting new methods; practice will make you comfortable with them.

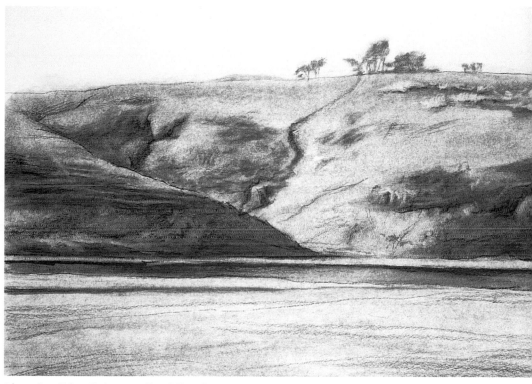

Lines Can Bring Unity to a Tonal Drawing
This drawing is predominantly tonal. Linear accents clean up the toned edges, adding definition and refinement.

MARIN HILLS
Charcoal on vellum
18" × 24" (46cm × 61cm)

63

HARD-LINE DRAWINGS

Line drawings are primarily *contour drawings* (page 70). Here, *contour* refers to edges, either exterior edges or interior edges (such as those around belts, collars, eyes and other features). It is also possible for a line to begin as an exterior contour and move into an interior line. This may be seen in folds of clothing or in anatomical features. Hard-line drawings may be precise and formal, or fluid and casual. Pen lines may be thick or thin. Brush, stick or quill lines may vary from thick to thin as well.

Using line exclusively to create a drawing may seem limiting, but if employed creatively, you can achieve a variety of interesting and charming effects. With practice, your line-drawing ability will develop and become a very satisfying method for creating details.

EXTERIOR CONTOURS AND INTERIOR LINES

It is possible for a line to begin as an exterior contour and move into an interior line. This may be seen in folds of clothing or in anatomical features.

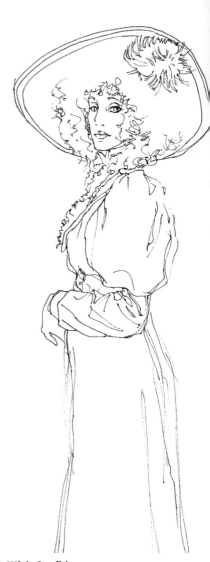

Draw With Confidence
This hard-line drawing shows fluidity, conviction and confidence. The artist betrays no fear of making mistakes.

THE GIRL IN THE HAT
Fine-line marker on bristol board
14" × 9" (36cm × 23cm)

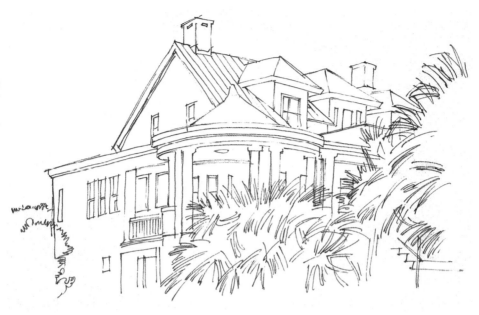

Creating Detail With Line

This pen sketch relies upon line to delineate the features and characteristics of the foliage-covered house.

SOUTH CAROLINA HOUSE
Fine-line technical pen on vellum
9" × 12" (23cm × 30cm)

Hold Your Pen Properly for a Better Drawing

It is important to draw in a free and comfortable fashion. Do not grip your pen tightly, using only your wrist. Instead, keep your arm involved in your drawing. Don't draw as if you are writing; this will result in a stiff drawing devoid of feeling.

SOFT-LINE DRAWINGS

Soft-line drawings, such as those done with graphite or charcoal pencil, may consist of neat, crisp lines and soft lines that seem to just fade away. The beauty of soft-line drawings is in the variations of line work you can achieve.

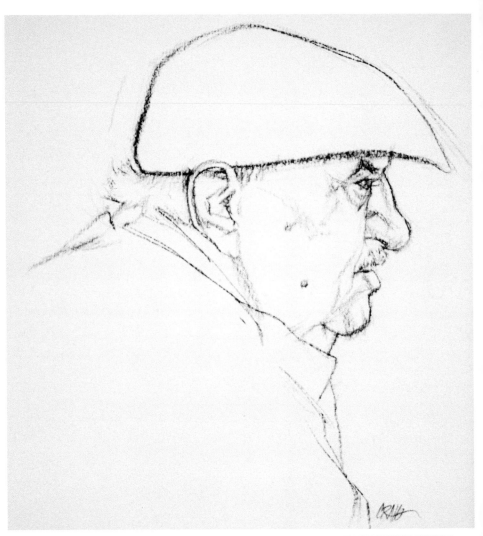

Drawing With Soft Lines
This soft-line drawing employs the variety of line qualities available with charcoal.

AN INTERESTING PROFILE
Charcoal pencil on ledger paper
10" × 10" (25cm × 25cm)

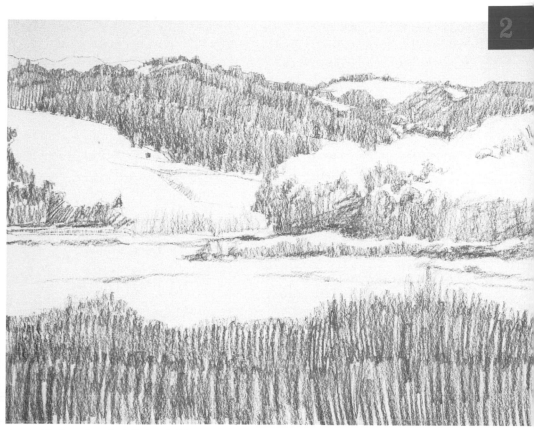

Create Various Details With Soft Lines

Here I used CarbOthello pencils to create an array of detail using soft lines.

LAYERS OF LANDSCAPE SKETCH
CarbOthello pencils on vellum
18" × 24" (46cm × 61cm)

COMBINING HARD AND SOFT LINES

You can make your line drawings more interesting by combing hard and soft lines. Soft lead pencils such as graphite and charcoal are especially good for creating both hard and soft lines. This type of drawing lends itself to more spontaneous compositions, without the use of tone.

The feeling of a hard-and-soft line drawing is usually somewhat carefree. It is important to realize that all line characteristics come from you and your response to your subject.

Detail of Hard and Soft Lines

COMBINING HARD AND SOFT LINES

To create variations from hard to soft lines in a drawing:

- Hold the drawing tool loosely. This will enable you to use either the tip or the side.

- Vary the pressure. More pressure will create darker lines and less pressure will create lighter lines.

- Vary the speed with which you make lines to control the precision and character of the line.

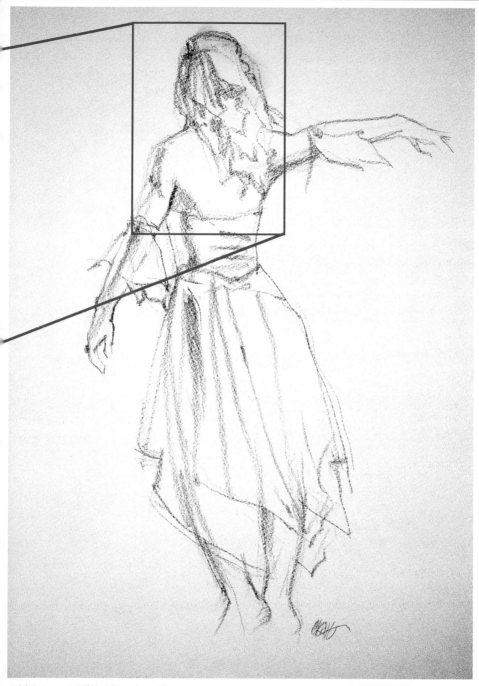

Add Interest With Line Variation

A dancer in motion is a great subject for this combination of crisp and soft lines. The variation effectively way to creates the feeling of motion.

DANCE SKETCH
6B charcoal on charcoal paper
16" × 10" (41cm × 25cm)

CONTOUR LINES

Contour lines define edges. The contour of something is its outside edge or shape. However, specific features within larger shapes also have contour, including folds, eyes, ears and hair lines. All these may be described by simple line.

Drawings consisting solely of contour lines must rely upon the correct application of the principles of proportion, perspective and gesture to be successful. Accuracy with these elements will be extremely helpful to the viewer because, without tone, it might otherwise be difficult to "read" the drawing. Pale sketch lines will help you achieve correct proportions and perspective. Hold your drawing tool with a sensitive, delicate grip. You should feel the drawing tool make the mark, but you should not press so hard that you etch the marks into your surface.

Sketch of Contour Lines
In this sketch I drew mostly contour lines but added a minimal amount of hatching to indicate tones in the focal point.

SKETCH FOR OUTDOOR CAFE
Fine-line pen on vellum
12" × 9" (30cm × 23cm)

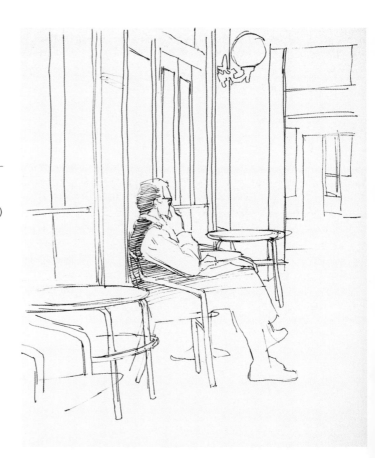

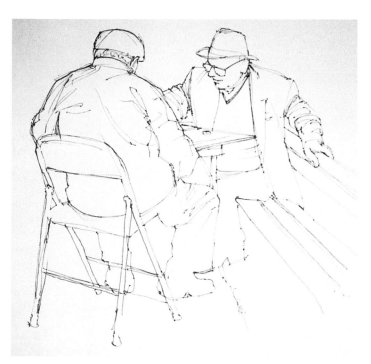

Contour Line Drawing

This drawing relies completely on contour lines. Shapes and proportions are crucial to the readability of the drawing. An indication of a few folds prevents the drawing from seeming incomplete and gives the drawing a bit of authenticity.

A GAME IN THE PARK
Fine-line pen on ledger paper
16" × 12"
(30cm × 41cm)

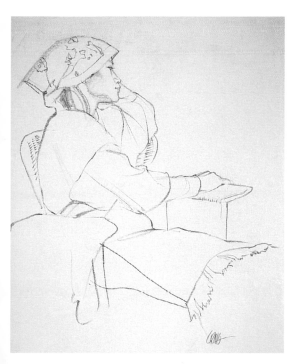

Contour Is an Important Part of a Successful Drawing

This soft contour drawing consists of crisp and soft lines defining a variety of contours. Using only the lines most essential creates a pleasing line quality.

THE ASIAN GIRL
Conté and charcoal on bond paper
24" × 18" (61cm × 46cm)

DESCRIPTIVE LINES

Generally speaking, descriptive lines are used to convey details. It is possible to enhance contour with descriptive lines. Careful linework may be used to describe smaller details or textural characteristics that would be difficult to convey with tone.

Descriptive linework may take the form of a group of close lines used to show off a specific subtle texture, or a few careful lines describing folds in a shirt or other fabric.

Closely Examine Your Subject
Examine your subject carefully as you decide what to describe and how to describe it.

BEAT-UP BRUSH
Graphite pencil on ledger paper
10" × 8" (25cm × 20cm)

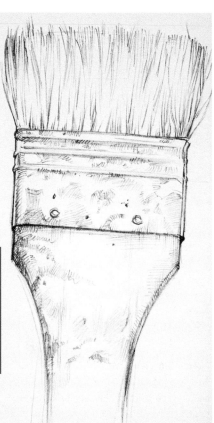

Detail of Close Lines

What to Use

Mediums used for descriptive linework should have a good sharp point. Fine-line pens or neatly sharpened graphite or charcoal pencils will work best. A sand pad is helpful to keep pencils pointed for a more precise line.

Carefully choosing what to describe and how to describe it with your chosen medium will also help to bring about a successful descriptive drawing.

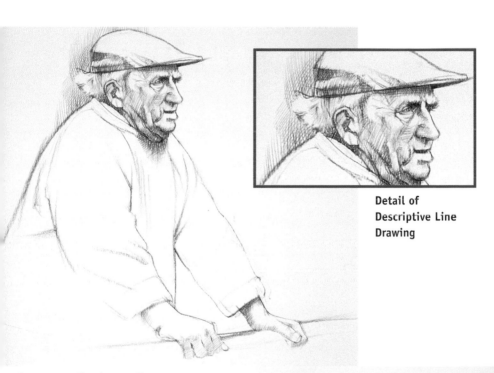

**Detail of
Descriptive Line
Drawing**

Choose an Effective Medium
This drawing was done with charcoal pencils. Keeping the point of the pencil sharp was necessary for the detail.

COTSWOLD MAN
Charcoal pencil on ledger paper
14" × 11" (36cm × 28cm)

**Keep the Point Sharp for
Descriptive Linework**

LINE VARIATIONS

Various line techniques such as scribbling, hatching, pressing hard or barely pressing, all may achieve interesting effects. Using exterior and interior contours will keep your drawing from looking like a simple outline.

Perhaps the most important factor in a successful line drawing is knowing what to leave out. "Editing" is absolutely necessary to a successful line drawing. Too many lines or too much detail can overwhelm the viewer and overshadow your focal point. Try using soft interior lines as an accent to hard contour lines. Varying the lines will add interest to your drawing.

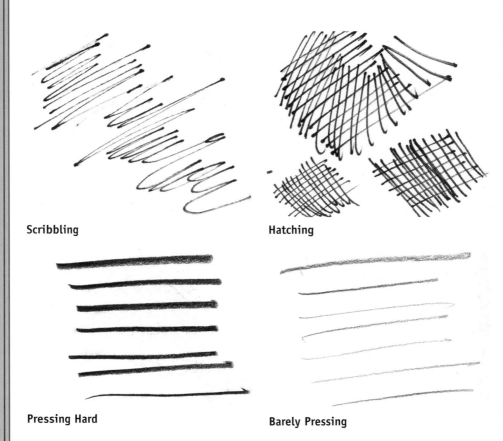

Scribbling

Hatching

Pressing Hard

Barely Pressing

Use Varied Techniques to Enhance Line
The hard line is enhanced with some strategic hatching, creating a slightly tonal feeling.

A SIMPLE BOAT
Fine-line pen on vellum
8" × 12" (20cm × 30cm)

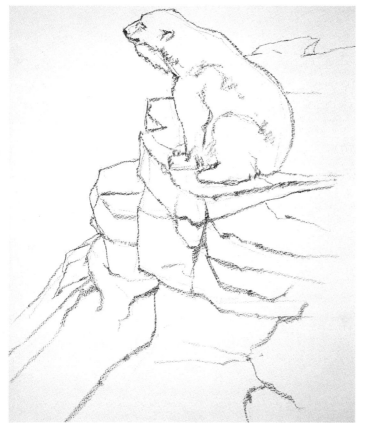

Line Drawing Offers Many Creative Possibilities
This is a very casual line sketch of the bear. It exhibits a lot of fluidity and freedom.

POLAR BEAR
Charcoal pencil on charcoal paper
18" × 14"
(46cm × 36cm)

TONE

Tone is the term artists use to refer to color and value (page 78) in the areas between contour lines. Tone covers a broader area than a line and offers more possibilities for variation in value. Tonal drawings define shapes with areas of contrasting value rather than with definite, hard contour lines—the same way our eyes distinguish shapes. Adding tonal values to a sketch can make objects appear more three-dimensioinal, enhancing form and increasing the viewer's ability to "read" a drawing. Tone may be applied with dry medium such as charcoal or pastel, or it may be added with a wet medium such as an ink wash. The drawing surface itself may also add tone to the artwork.

Use a Variety of Tones

Here I used hatching to create the variety of tones in this drawing. To establish the dark areas, I simply layer the hatching.

AN OFFSHORE BREEZE
Fine-line technical pen on bristol board
12" × 9" (30cm × 23cm)

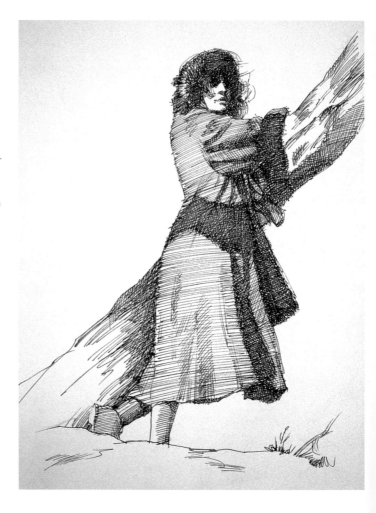

A Tonal Sketch

In this quick tonal sketch the hatching is coarse and abbreviated to quick-
ly establish the placement of different tonal values. This establishes the
shape of the lilies.

LILIES
Fine-line technical pen on bristol board
10" × 8" (25cm × 20cm)

VALUE

Value is the degree of lightness or darkness of a specific tone. Black is at one end of the value scale and white is at the other, with all shades of gray in between. Each color has a corresponding value scale with similiar gradiations.

Contrasts and variations in value may be used in drawings for many purposes. Value variations can describe and model form, and contrasting values can define shape. Value contrasts may be used to accent an area or draw attention to a specific part of the drawing.

Whether used in conjunction with a line drawing or all by themselves as a tonal drawing, value variations give

Value Adds Richness
This loose charcoal line drawing has been enriched through the use of value variation. The gray-tone Canson paper acts as a middle value to set off both the dark charcoal and the light Conté.

SPANISH DANCER
Charcoal and Conté on
Canson paper
18" × 24" (46cm × 61cm)

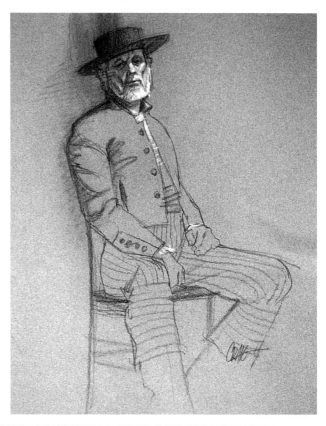

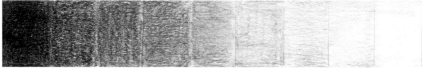

Value Scale

78

weight to a composition, create form and establish a three-dimensional quality.

Use a Range of Values

When creating a range of value for your drawings, gradually build the tones from the lightest to the darkest by applying a darker tone on top of a lighter tone. Using your subject as a reference, continue building layers as required until you reach the extreme darks. This will give you more control over the value range you create.

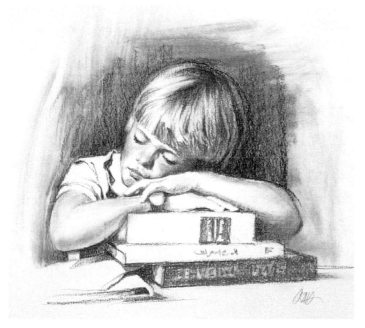

Build Darker Values On Top of Lighter Tones
I chose to use a sanguine pencil for the first tonal layer. Then, I applied charcoal on top to create the darker values.

THE NAPPING STUDENT
CarbOthello pencil
and charcoal pencil
on vellum
12" × 14"
(30cm × 36cm)

Building Up Tones
Start with lighter tones and layer to make the value darker.

USING VALUE TO CREATE FORM

You create form in a drawing by using value to depict light and shadow. Develop value variations carefully and slowly, and only after carefully observing the tones on the subject itself. Be sure to consider the character of your subject. For example, round or soft, turning forms will have a soft, gradual value change, while sharper edges will have a crisp, abrupt value change.

It is also vital to consider the location of your light source when using value variations to model forms and create shadows. Be sure that your highlights and shadows are located consistent with the direction of the light. Also consider the differences between types of shadows. *Form shadows* are those dark areas on the side of an object where the light does not hit; *cast shadows* are those dark areas where the light has been blocked by another object.

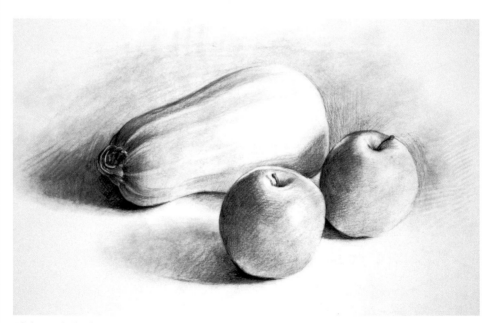

Light and Shadow Are Necessary to Create Form
The three relatively simple forms here (a squash and two apples) are all light in value. This enables shadow tones to show well. A single light source helps define the forms.

THREE PART COMPOSITION
Charcoal on bristol board
12" × 18" (30cm × 46cm)

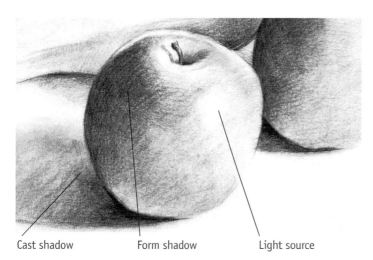

Detail of Apple

The form shadows in the apple goes from light to dark as the light source gets further away. A similar principle applies to the cast shadows, only they get lighter the further they get from the object.

Cast shadow Form shadow Light source

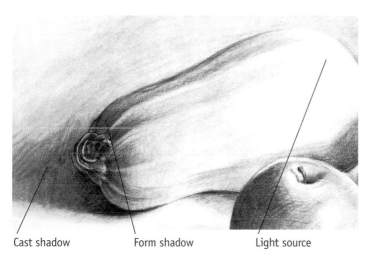

Detail of Squash

For the squash, I use form shadows to create the effect of the ridges. Notice how the top of the ridges are lighter (where the light hits) while the bottom part of the ridge is darker. I also gradually darken the values to give more shape to the ridges.

Cast shadow Form shadow Light source

USE A SINGLE LIGHT SOURCE

To make value changes on your subject easier to see, shine one light directly on your subject and block out other unnecessary light.

POSITIVE AND NEGATIVE SHAPES

When you're drawing, it's natural to want to concentrate on the *positive space* that is, the shape of the actual object or objects you're trying to draw. It's less natural, yet just as important, to draw the *negative space*, or the shapes surrounding an object. Every drawing has positive and negative spaces in it and both must be well rendered for your drawing to be successful.

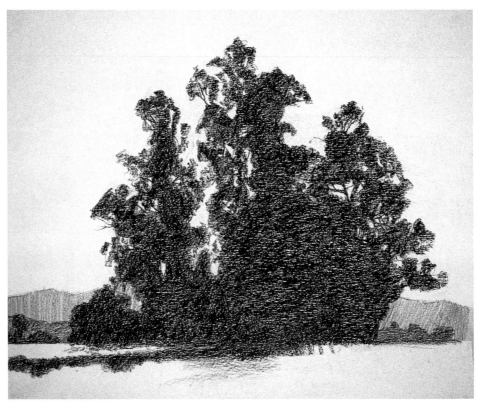

Draw the Positive and the Negative Shapes

In this sketch, the trees are the positive spaces and the lighter areas around them are the negative spaces. As you draw, look at the shapes created by the positive and negative spaces. Both should form the basis of your sketch.

EUCALYPTUS SKETCH
Soft charcoal pencil on rough drawing paper
11" × 12" (28cm × 30cm)

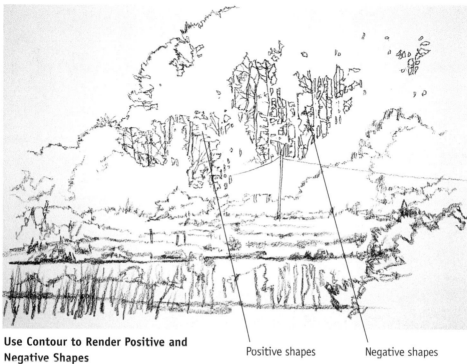

Positive shapes Negative shapes

Use Contour to Render Positive and Negative Shapes

In *Eucalyptus Sketch*, I used tone to establish postive and negative shapes. Here I used contour lines to capture the relationship of positive and negative shapes.

UNDERSTANDING LIGHT AND SHADOW

Our eyes depend on light and shadow to define form, so it is important to understand the basic properties of light and shadow to create form in drawing.

Most objects you portray with tone and value will exhibit the following:

- *Form light*. The area facing and struck by the light. This producing the lightest part, or *highlight*, of the object.
- *Form shadow*. The area where light does not hit.
- *Hard edge*. A characteristic of forms with crisp, well-defined edges.

- *Soft edge*. A characteristic of rounded forms where edges are not clearly defined.
- *Cast shadow*. The shadow created on a surface when the light on the suface is blocked by another object. It is usually hard-edged.
- *Reflected light*. Lighter areas within a form shadow, created when a bit of light is reflected back onto it.
- *Core shadow*. The darkest part of a form shadow, not affected by reflected light.

Different Aspects of Light and Shadow
These three simple white forms show the various aspects of light and shadow modeling. White objects work best for this because there is no local color variation to interfere.

WHITE FORMS
Charcoal on heavy bond paper
10" × 16"
(25cm × 41cm)

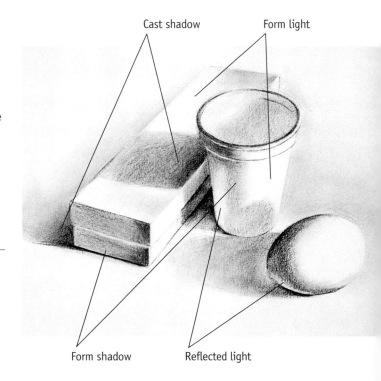

Cast shadow

Form light

Form shadow

Reflected light

84

Using Values to Create Light and Shadow

Here you'll learn how to map out the patterns of light and shadow as well as develop the principles of light and shadow. Since your paper is toned, let it act as the middle value for this drawing, applying lights and darks on it.

Materials

SURFACE
18" × 24" (46cm × 61cm) light gray Canson paper

MEDIUMS
4B and 6B charcoal pencil

Soft vine charcoal pencil

White charcoal pencil

Soft white pastel

OTHER MATERIALS
Facial tissue

1 Sketch in the Subject
Study your subject. Then, using a 4B charcoal pencil, lightly sketch on the smooth side of the paper. Do not worry about light and shadow yet.

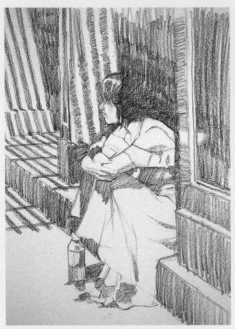

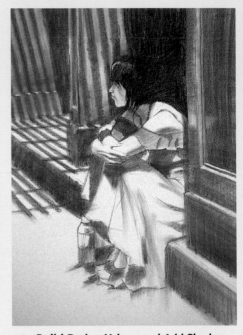

2 **Map Out the Value Variations**
See the basic patterns of lights and darks by squinting your eyes as you look at your subject. Using the side of a 6B charcoal pencil, lay in the areas where you see the darks. Pay special attention to darker value patterns such as cast shadows (page 84).

3 **Build Darker Values and Add Shadows**
Switch to a piece of soft vine charcoal and use it to strengthen the dark values. Use a piece of facial tissue to lightly rub the vine charcoal, blending the tones, solidifying the shadows and unifying the darks. Don't worry if you smear some of the charcoal into the light areas. Shape your kneaded eraser into a point and use it to clean up any areas where you don't want darks. Spray a light mist of workable fixative over the drawing. Allow it to dry.

2

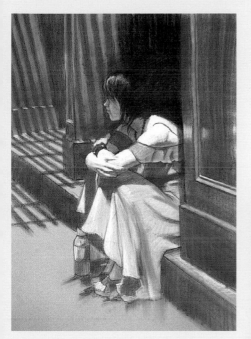

4 Strengthen the Value Contrast
Add soft whites with a white charcoal pencil. This will strengthen the value contrast in the flesh tones, the skirt, a bit of the hair and the reflections in the wall on the right.

5 Amplify the Value Contrasts and Finish
Re-examine your subject, looking for the darkest darks within the shadows. Use the 6B charcoal pencil to clarify and refine values and edges of the shadows. Follow this same procedure for the lights. Use a white Nupastel for the lightest lights. With the 6B charcoal pencil, add the pattern detail in the dress and, with a soft white pastel, amplify the value contrasts where necessary.

A SEAT IN SOHO
Charcoal and pastel on gray Canson
18" × 24" (46cm × 61cm)

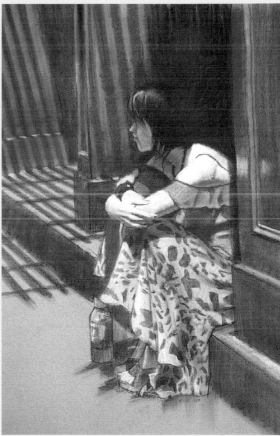

LOST AND FOUND EDGES

In order to add a dramatic effect to a drawing, use the concept of *lost and found edges*. A lost edge occurs where the edge of the form seems to disappear into the background. You lose light edges in a light space or dark edges in a dark area. Basically, a lost edge fades into an area with a similar value, while a found edge relies upon contrasting values to define it.

One strong light source and a dark background will provide ample opportunities for dramatic effects. Keep your use of contour line to a minimum. Use it only in discrete places as a very subtle accent. Most of the form should be defined by the edges created by the transitions between light to shadow. Add some limited details and softer descriptive values within the light side of the form.

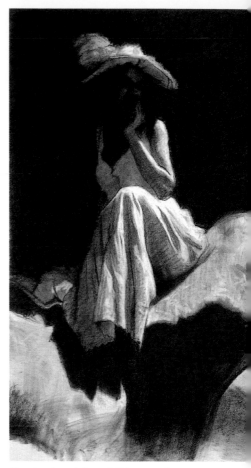

Use Lost and Found Edges to Create a Dramatic Effect
The contrast of strong black and white creates drama as this figure almost emerges from the deep shadows of the background. I used midtones and lights to clarify the details.

WHITE ON THE ROCKS
Charcoal on artists' vellum
24" × 18" (61cm × 46cm)

CHIAROSCURO

The lost-and-found idea is not new. Caravaggio, a Renaissance painter, used this concept to give a sense of drama to his work. *Chiaroscuro*, meaning light and shadow, is the term associated with such dramatic, highly contrasting tonal effects. In this approach, the darks basically melt into the background, allowing the subject to emerge out of a dark void.

Using Lost and Found Edges

Lost and found edges can make your subject look like it's in motion, which is perfect if your subject is a dancer in mid-leap. The focus will be the upper body, so that will have the most detail, while the legs will remain blurry to suggest action.

Materials

SURFACE
20" × 18" (51cm × 46cm) artists' vellum

MEDIUMS
6B charcoal pencil
Black soft pastel

OTHER MATERIALS
Kneaded eraser
Paper towel or facial tissue
Workable spray fixative

1 Lightly Sketch the Subject
Draw a light gesture sketch with a 6B charcoal pencil. Be sure to maintain proportional accuracy.

DRAW LIKE A PAINTER

When you draw on white paper, let the white of the paper be your lightest light. Shape your kneaded eraser into a point and use it to lift out the highlights, just as a painter uses a brush to lift paint.

89

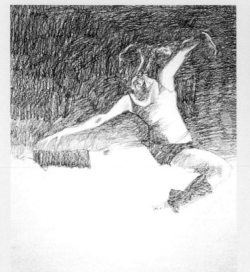

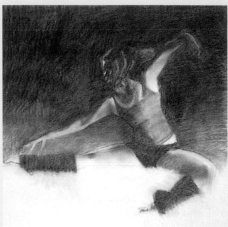

2 Lightly Add the Initial Layer of Shadows

Use the 6B charcoal pencil to lay in the overall shadow tones on your subject, but keep them lighter than they appear. (You will build the darks later.) Lay in the background in the same manner.

3 Soften the Edges and Clean Up the Light Areas

Use a soft paper towel or facial tissue to smear these initial tones. Do not be too concerned about smearing the tones into the white areas or over edges. You may use a kneaded eraser to clean up some light areas. Leave soft edges in the legs to suggest movement.

VARY THE PRESSURE AS YOU LIFT HIGHLIGHTS

Use lots of pressure to lift out a nearly white highlight. Use a little pressure when a soft gray is what you need.

2

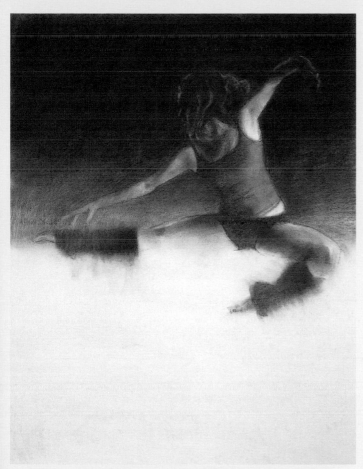

4 Add Another Layer of Darks and Refine the Lighter Tones

With a soft black pastel, add another layer of darks and repeat smearing to deepen the darks, losing edges in the background. Shape a kneaded eraser to a point and use it to carefully to lift out the lighter tones and bright, clean lights in the upper body. Add a light layer of workable spray fixative and let this dry for 2–3 minutes.

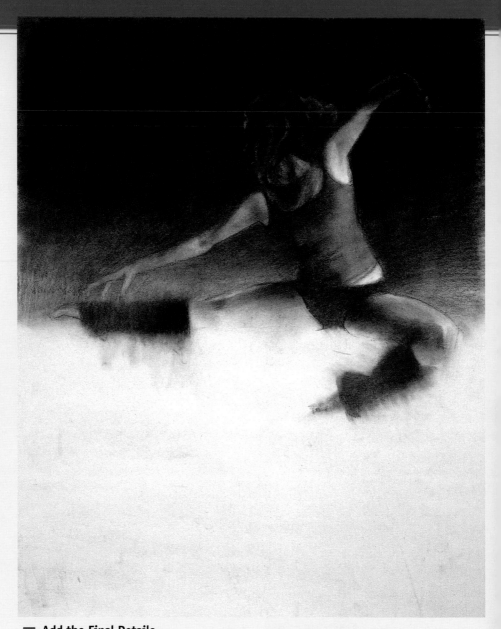

5 Add the Final Details

Use a very sharp (page 73) 6B charcoal pencil to carefully add another layer of darks. Keep the shadow edges lost. With a kneaded eraser, delicately pick out the lights. Add any subtle line work that may be needed to refine some areas. Keep the legs and feet more blurred to suggest action.

DANCER'S LEAP
Charcoal and black pastel on artists' vellum
20" × 18" (51cm × 46cm)

ADDING TONAL ACCENTS

Including tonal accents can add excitement to a drawing. You might choose to add a spot of color or a simple value. Many of the drawings exhibited in this book thus far employ tonal accents. These may indicate local tone, create lighting or reveal form. Tonal accents can also help emphasize a focal point.

Choosing exactly where to place a tone or how much tone to use is a matter of personal preference. With experience, your ability to decide when you use tonal accents will increase. Initially, think of less as more. Add tone only if you feel it is necessary.

Less Can Be More
The very simple, understated line drawing is accented by adding tone in the dead and minimal shadow on the left, then smearing it with a brush and turpentine.

WISE
Oil pastel on box board
18" × 12" (46cm × 30cm)

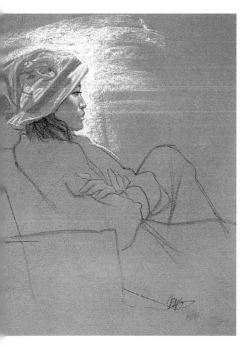

Use Tone to Establish a Drawing's Focus
I added tonal accents to the young girl's scarf along with a white accent behind her face to make her profile the focus of this piece.

A PATTERNED SCARF
Charcoal and Conté on toned Canson paper
20" × 18" (51cm × 46cm)

AESTHETIC MARKS

Aesthetic marking means varying the nature of your marks to better capture the subject. Aesthetic marking is often overlooked or taken for granted by many artists because they are usually more concerned with accuracy. However, it is marks that make up the image, so one must consider of how those marks are made and how they affect the drawing style.

Aesthetic marks may be made with a variety of tools and can take many forms. Aesthetic marks may be careful and refined, casual and spontaneous, powerful and bold, soft and sensitive, fluid and curvy or sharp and straight. One mark may gradually change from dark to light or thick to thin. Some variations of aesthetic marks, such as quick curving or looping lines, may be used to add tone or develop form. Experiment with different types of aesthetic marks to find the drawing style that expresses your ideas.

Aesthetic Marks Can Be Used for Toning and Suggesting Form
This quick, abbreviated drawing of a cylinder uses crisp control lines on the contours and broad soft marks to suggest the form shadow.

One Medium Can Create a Variety of Aesthetic Marks
A variety of marks from careful and crisp to rapid and soft are shown here. The medium is a 6B charcoal pencil.

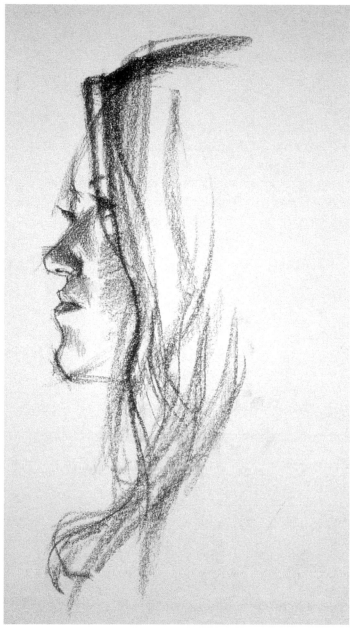

Aesthetic Marks Can Be Used for Many Purposes
A variety of aesthetic marks from free, soft lines and crisp, controlled lines
to tones form this profile sketch.

SASHA'S PROFILE
Conté pencils on vellum
5" × 9" (13cm × 23cm)

LOCAL TONE

Local tone refers to the basic value or color of an element, independent of value variations used to model the subject with light and shadow. Every subject has a local tone: a black coat, a white shirt, a gray tie, dark hair or medium-light skin.

Although the line work may stand on its own, the addition of a few, well-placed local tones can give snap and vitality to the drawing.

Be selective when adding local tones or you will overwhelm your focal point (page 130). Local tones may be flat and graphic, or they may have a loose texture. This is a stylistic choice that often depends upon the drawing medium, so don't be afraid to use a different medium to get the effect you want.

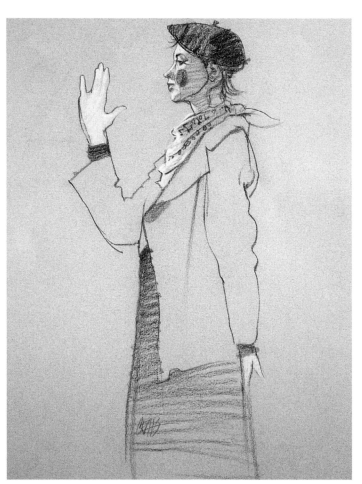

Add Local Tones to Your Drawing
The lights and darks in this drawing have more to do with local tones than with modeling with light and shadow: a dark hat, a white glove, a medium coat and a darker skirt.

PART-TIME MIME
Black and white charcoal on gray Canson paper
18" × 24"
(46cm × 61cm)

COMBINING LINE and TONE

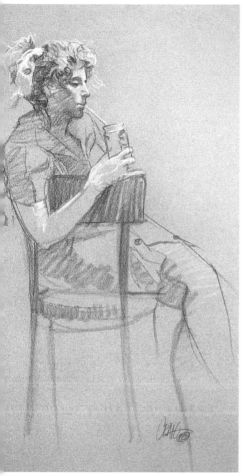

Using line and tone together gives a special quality to a drawing. A fully toned drawing such as the one on page 80 exhibits a unique sense of unity. Pieces that combine line and tone, however, invite the viewer to take part in the drawing process.

The relationship of line to tone in a drawing may be one to one, or either may take a subordinate role. Your aesthetic sense—or perhaps the amount of time you're willing to spend on the project—will be the determining factor for this relationship.

Most mediums or medium combinations can work well together. Hard line and ink wash work effectively together, as do charcoal and pastel or graphite and watercolor. Some of the enjoyment of line-and tone-drawings lies in discovering the ratio of line to tone that you like and the medium or mediums that feel right to you.

Determining Line and Tone Relationships
The time frame helped dictate the line-to-tone ratio in this drawing. The model posed for only twenty minutes so limited tones accent the loose line drawing.

BREAK FOR THE WAITRESS
Black and white charcoal on gray Canson paper
18" × 24" (46cm × 61cm)

Using Line and Tone Together

Roughly two-thirds of this drawing will remain as line work. You will add tone to the remaining third. Drawings like this allow viewers to become involved in your drawing because they will see some of the light sketch, the parts that you refined and, finally, the finishing tones.

Materials

SURFACE
22" × 17" (56cm × 43cm) piece of heavy bond paper

MEDIUMS
4B and 6B charcoal pencils

1 Sketch the Subject
Using a 4B charcoal pencil, do a light proportional sketch as a foundation to build your drawing upon.

2 Go Over the Initial Sketch With a Line Sketch
With the 4B charcoal pencil go over your initial sketch to correct and refine it. Much of the finished drawing will remain line so be sure to give special consideration to type and quality of your line work.

2

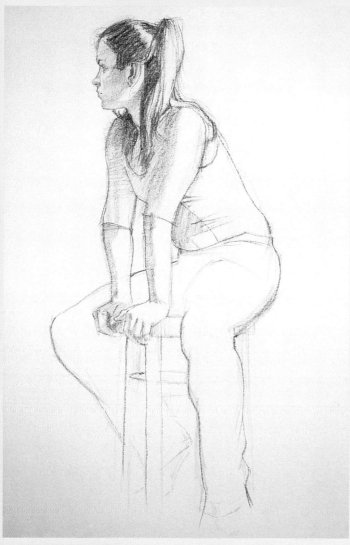

3 Add Tone and Focus

Using the side of a 6B charcoal pencil, begin adding tones in a soft, careful yet loose and free fashion. Begin to add details to the face, since it is the focal point.

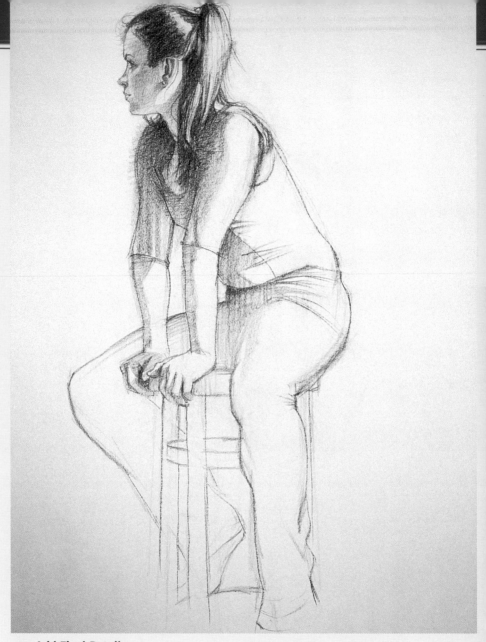

4 Add Final Details

Use a 6B charcoal pencil with a very sharp point to add a few dark tonal accents to the softer tones, creating more value contrast. Study your drawing to see if anything needs clarified. (I added some detail to the hands and face.) Use careful line work to emphasize your focal point.

LAUREN
Charcoal pencil on heavy bond paper
22" × 17" (56cm × 43cm)

STYLE

Your drawing style results from a combination of your mind and the medium. Of course, the medium you choose will dictate certain aspects of your style. For example, your work will undoubtedly include more hard, crisp lines and stark value contrasts if you use a black ink pen than if you use pastels, but it is what goes on in your mind that really determines how your drawing will look. What is your intent? What you plan to achieve with a medium? Do you want to express freedom, or exercise control? Do you hope to capture a moment or to develop discipline? What are your personal tastes?

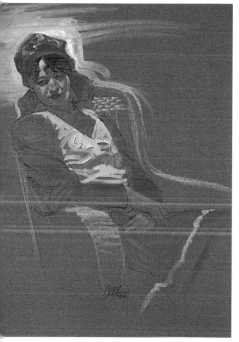

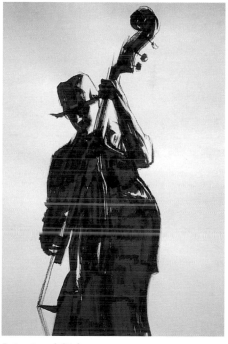

Medium and Style
This mixed-media sketch uses color and the tone of the paper as value variations.

MARIE
Charcoal, oil and oil pastel on toned Canson paper
22" × 17" (56cm × 43cm)

Intent and Style
This loose, graphic brush drawing employs a silhouette effect with a touch of light from behind right. The intent here was to focus on the essential shape only. Learning to edit out detail can be a challenging exercise.

THE BASS FIDDLE
India ink brush and oil pastel on white artists' vellum
22" × 17" (56cm × 43cm)

101

STYLE AND INTENT

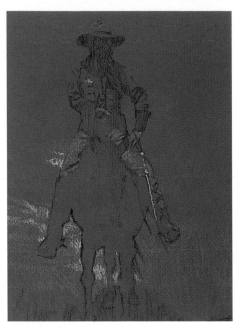

Do you prefer symmetry or asymmetry? Simplicity or complexity? Are you mostly interested in people, places or things? What are your thought processes? Do you see and think in linear patterns, or in more tonal or graphic ways? The answers to these questions will determine your personal style.

One aspect of style to avoid is gimmickry. Do not force a style by using methods or incuding faddish characteristics that feel unnatural or uncomfortable. Your drawing should not be about the style; it should be about you and what you wish to convey. Experiment, but with integrity. Your style is part of who you are.

A Minimalist Approach
How much can be said with very little? This image contains a lot of empty space, but a minimum of outline and tone can say a lot if used carefully. Planning ahead and not overdoing are the keys to this minimalist approach.

ON HORSEBACK
Pastel on toned Canson paper
14" × 11" (36cm × 28cm)

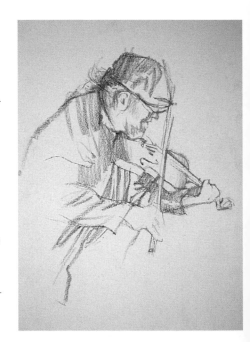

Use Style to Convey Intent
The basic intent behind this quick sketch was to underplay detail, using sketchy, earth-toned lines of varied weights to help create energy.

FIDDLER
Conté pencils on toned Canson paper
14" × 11" (36cm × 28cm)

DRAWING EXPRESSIVELY

Each artist has his or her own unique way of making marks, as individual as handwriting. Your personal marking style, combined with your immediate reaction to your subject, will produce a unique expression of that subject.

When creating expressive drawings, your marks should be free, unfettered and relatively fluid. You should not necessarily abandon traditional princi-ples such a proportion and perspective; just relax a bit. Obsverve carefully, then indicate what you've seen with loose gestures and simplified marks. In this case, the quality of the marks is every bit as important as the subject. They should exude energy while describing the subject, capturing more of its essence than a detailed depiction.

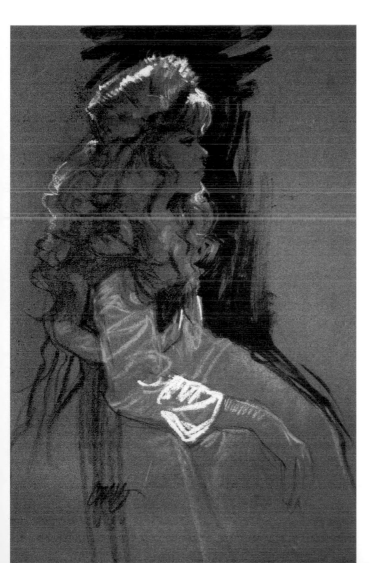

The Way You Draw the Subject is as Important as the Subject Itself
The variety of marks used here is under-stated yet energetic. I applied the pastel with a quick, gestural quality and the abbreviated oil back-ground helps the figure stand out.

THE FUR CAP
Charcoal pastel and oil on toned Canson paper
24" × 18"
(61cm × 46cm)

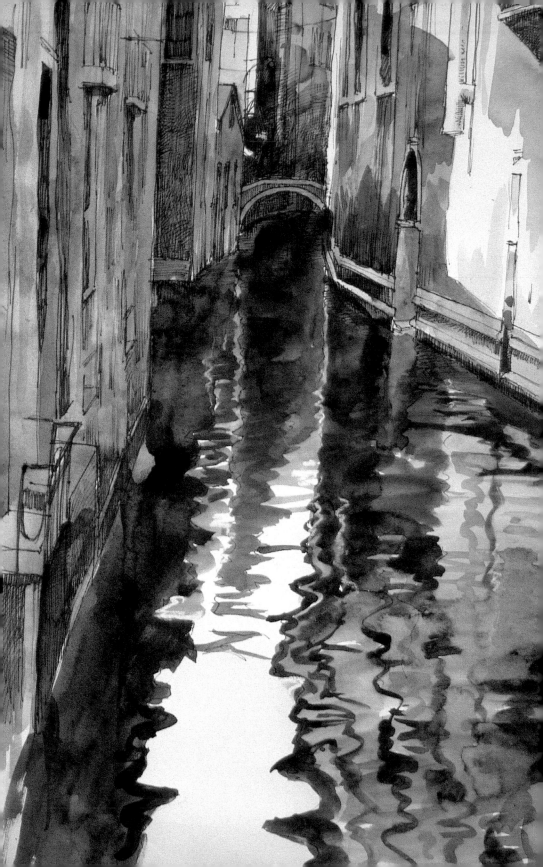

PERSPECTIVE and PROPORTION

Perspective and proportion are important principles of drawing because they add authenticity to your work. Trying to draw perspective and proportion accurately can be a daunting task if you don't fully understand these concepts. This chapter is intended to help you strengthen your knowledge of perspective and proportion and to provide you with techniques to incorporate them successfully.

VENETIAN ALLEY
Pen and watercolor on hot-pressed watercolor paper
15" × 10" (38cm × 25cm)

WHAT IS PERSPECTIVE?

Perspective is one of the most important principles of drawing. It gives authenticity, depth and dimension to a composition. The concept of perspective is simple: Objects of the same size appear larger when they are closer to the viewer and progressively smaller as they recede further in space. Perspective is most easily seen in rectangular forms such as cubes, houses and buildings. Repetitive forms that advance or recede, such as rows of windows, poles, automobiles, cups or cans, all show perspective, their sizes diminishing as they go back in space. As elements recede into the distance, they converge toward what is referred to as the *vanishing point* on the *horizon line*. The horizon line is usually placed at eye level, which will vary depending on the height and location of the viewer.

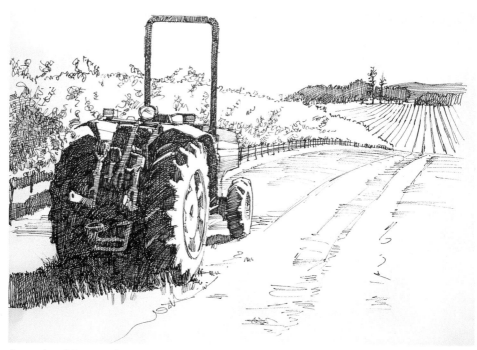

Example of Perspective
This pen sketch is a good example of perspective. It features the mechanical form of the foreground tractor and the distant trees and converging lines of the distant vineyard.

THE TRACTOR
Fine-line technical pen ledger paper
9½" × 12½" (24cm × 32cm)

Perspective in drawing is classified into three basic types: one-point perspective, two-point perspective and three-point perspective (pages 112–117). Artists must check and double-check the accuracy of their rendering. Since all elements in a composition must relate to each other accurately in perspective, the more elements a drawing contains, the more

challenging it will be to achieve convincing perspective.

Much about perspective is geometric in concept and mechanical in plotting, but used aesthetically as well as accurately, it gives a wonderful and necessary authenticity to any scene.

Viewed straight on

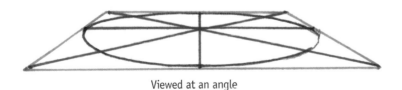

Viewed at an angle

An Ellipse in Perspective
A circle becomes an ellipse when viewed in perspective. Notice how the ellipse appears to recede into the distance when viewed at an angle.

POINT OF VIEW

Basically, point of view is the position or angle from which an object is seen. Point of view is important to consider as you use perspective because it will help you effectively create the illusion of depth. The artist must establish the point of view of a composition before attempting to show depth through the use of perspective.

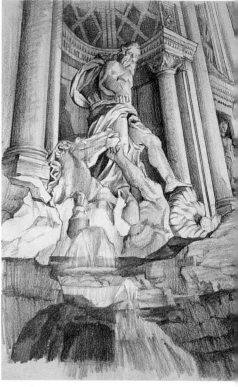

Worm's-Eye View
This sketchbook drawing depicts a low point of view sometimes called a worm's-eye view.

A VIEW OF TREVI FOUNTAIN
Graphite on sketchbook paper
12" × 8" (30cm × 20cm)

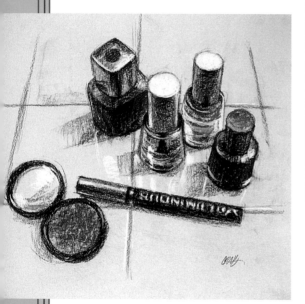

Bird's-Eye View
This pastel sketch has a high point of view, with the viewer looking down on the scene. This type of perspective is sometimes called a bird's-eye view.

MAKEUP AND GOODIES
Pastel and Conté on drawing paper
14" × 14" (36cm × 36cm)

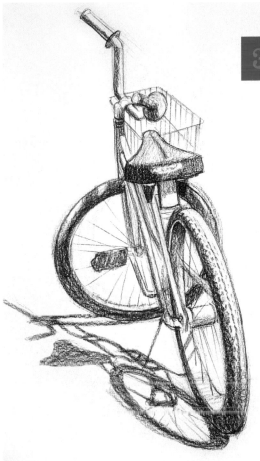

Point of View Requires Planning

This diagram shows the various angles that compose this unique point of view. Note the wheels are initially indicated with straight lines, not a continuous curve.

Maintain Accuracy as You Build Upon Your Initial Sketch

After completing the initial sketch, I filled in the details and smoothed out the lines. Because of the bike's unusual point of view (usually bikes are drawn in profile), I had to constantly check the angles and proportions as I drew.

TWO-WHEELER
Charcoal on toned Canson paper
16" × 12" (41cm × 30cm)

USING DEPTH TO SHOW PERSPECTIVE

When using perspective, remember that the sizes of objects in the distance must become smaller. Vertical lines remain vertical, but horizontal lines become angled as they recede and converge toward the horizon line, whether or not you perceive the change. The illusion of depth is enhanced with overlapping forms.

Create a Sense of Depth

This wash drawing demonstrates how the combination of over-lapping forms, con-verging lines and scale change can cre-ate a sense of depth. The large, bold fore-ground elements are set off by the more-distant elements as well as the back-ground figure.

THE NARROW STREET
Pen-and-ink on bristol board
14" × 11" (36cm × 28cm)

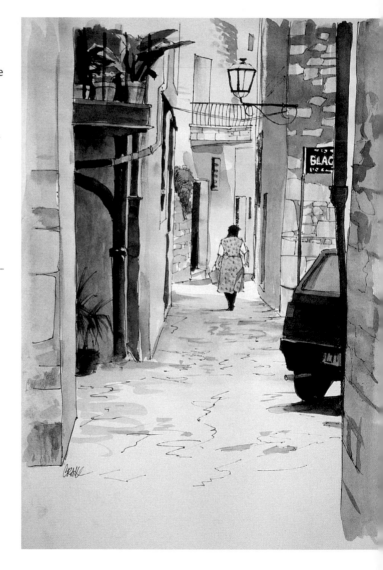

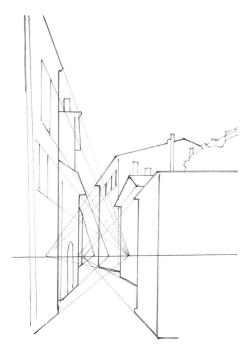

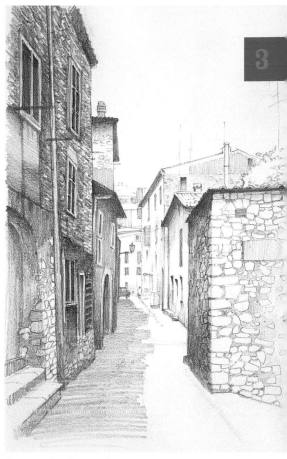

Perspective Diagram

This is the perspective diagram I did before completing Sermonetta Street. It shows the thinking and planning necessary for a realistic rendering of depth.

Perspective Applied

This narrow street scene employs one-point perspective (page 112). The addition of surface characteristics takes away the mechanical appearance of this linear drawing and adds interest.

SERMONETTA STREET
Graphite on ledger paper
14" × 11" (36cm × 28cm)

111

ONE-POINT PERSPECTIVE

One-point perspective is the simplest and most basic form of perspective. It may be employed when the viewer is looking at objects within a scene straight on. The technique uses only one vanishing point, with all receding horizontal lines converging at one place in the distance. All nonreceding horizontal lines are parallel to the picture plane and therefore are truly horizontal. One-point perspective is perhaps best illustrated by looking down a long hallway. It is obvious that ceiling lines, or *base lines*, all converge towards one common point. By adding dramatic lighting to a drawing with one-point perspective you can create a great impact.

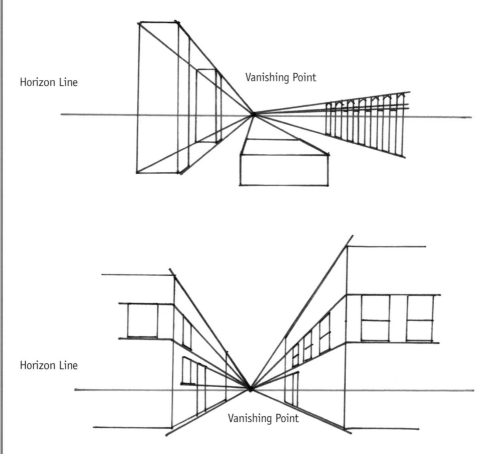

One-Point Perspective Diagrams
These one-point-perspective diagrams illustrate the basic principle of the single vanishing point.

One-Point Perspective Applied

The receding architecture progressively diminishes in scale. The addition of strong value contrasts adds a dramatic flair.

VENETIAN ALLEY
Pen and watercolor on hot-pressed watercolor paper
15" × 10" (38cm × 25cm)

Use One-Point Perspective for a True Sense of Depth

The grapevines in this one-point drawing act as a fence might, leading the eye into the distance. Overlapping the figure over background elements also contributes to the sense of depth.

WALKING TO UNLOAD
Charcoal on ledger paper
10" × 5" (25cm × 13cm)

TWO-POINT PERSPECTIVE

Because we generally view objects within scenes at an angle rather than head on, we usually tend to see things in two-point perspective. As the name suggests, this type of perspective includes two vanishing points. All horizontal lines will seem to converge toward one point or the other, depending on the angle from which they are seen.

There may be multiple two-point perspectives again depending on the viewing angle.

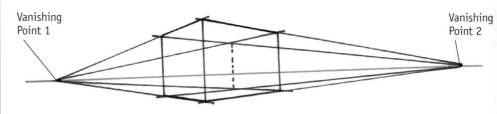

Vanishing Point 1

Vanishing Point 2

One Form, Different Two-Point Perspectives
This diagram shows a cubic form as seen from two points of view, with two-point perspective applied.

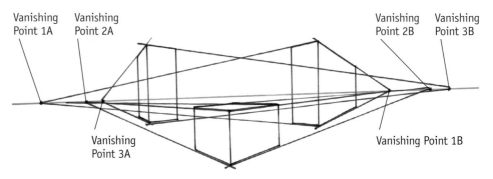

Vanishing Point 1A

Vanishing Point 2A

Vanishing Point 2B

Vanishing Point 3B

Vanishing Point 3A

Vanishing Point 1B

Many Forms, Two-Point Perspective
This diagram shows multiple forms viewed at different angles with two-point perspective applied.

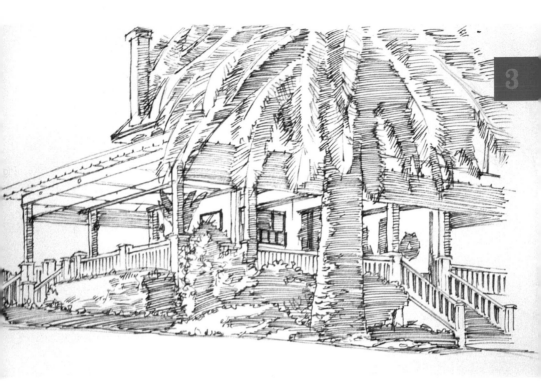

3

An Example of Two-Point Perspective

This ink sketch is a good example of two-point perspective. The lines of the geometric architectural form converge sooner on the left than on the right. The viewer's eye level is below the porch, so the vanishing point would be below it as well.

A NICE PORCH
Fine-line technical pen on bristol board
6" × 10" (15cm × 25cm)

THREE-POINT PERSPECTIVE

Three-point perspective is employed when the viewer is looking either up or down at a subject. Whereas one- and two-point perspective involve horizontal lines, three-point perspective involves vertical lines that converge at a third vanishing point. If the viewer is looking up, the vertical lines will con- verge above eye level; if looking down, they will converge below eye level.

Think of gazing up at a very tall building. The verticals of the long rectangular forms will converge upwards. If, on the other hand, you are gazing down from the top of that tall building, those same verticals will converge downward.

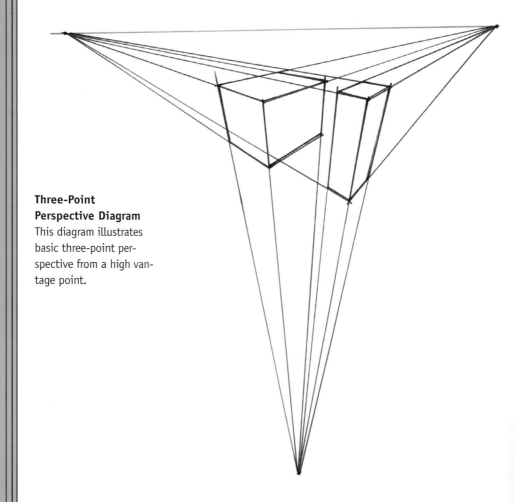

Three-Point Perspective Diagram
This diagram illustrates basic three-point perspective from a high vantage point.

Three-Point Perspective Applied

I used three-point perspective to make it seem like the viewer is looking up at these buildings.

WHEN TO USE THREE-POINT PERSPECTIVE

Three-point perspective is required when the scene is being viewed from either a high vantage point or a low one. Be sure to consider the viewer's eye level in relation to the forms you want to depict.

WHAT IS PROPORTION?

Creating an accurate drawing depends upon a true understanding and interpretation of proportion. Simply stated, *proportion* is nothing more than a size relationship. Perhaps the easiest way to begin learning about proportion is to think of a 12-inch ruler. An object that is half as long as the ruler is six inches; one three-quarters or 75 percent of that length would be eight inches. Calculating measurements is an easy, mechanical way of dealing with proportions. However, an artist must learn to observe and deal with proportions in a more subtle and sensitive manner when exact measurements are not so easily determined.

Use Visual Markers to Render Proportion Accurately

Here I used such visual markers as the folds in my subject's clothes and the position of her body in the chair to achieve accurate proportions in the drawing.

ONE COOL OUTFIT
Charcoal, Conté and white chalk on toned Canson paper
18" × 24"
(46cm × 61cm)

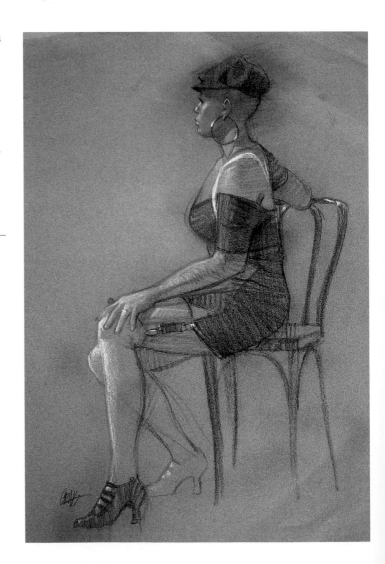

Find points or "landmarks" that you can use to relate the size of one shape to another. For example, at what point does the handle intersect the side of the mug? Is it three-fourths of the way up, or closer to five-eighths? Practice and repetition will improve your ability to render proportions correctly. Training your eye to estimate and compare measurements will also increase your sensitivity to subtleties.

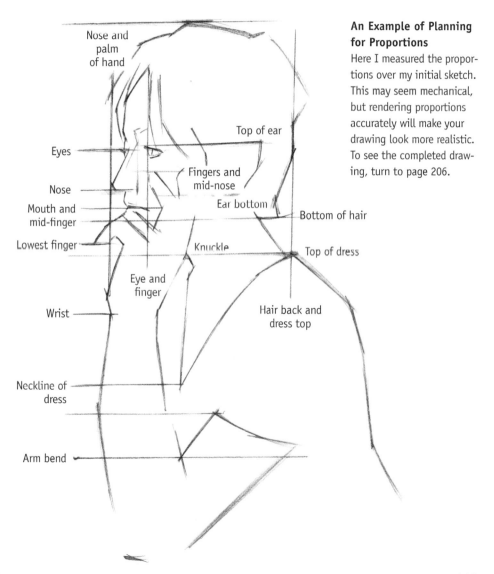

Nose and palm of hand

Top of ear

Eyes

Fingers and mid-nose

Nose

Ear bottom

Mouth and mid-finger

Bottom of hair

Lowest finger

Knuckle

Top of dress

Eye and finger

Wrist

Hair back and dress top

Neckline of dress

Arm bend

An Example of Planning for Proportions

Here I measured the proportions over my initial sketch. This may seem mechanical, but rendering proportions accurately will make your drawing look more realistic. To see the completed drawing, turn to page 206.

USING TICK MARKS

Since measuring involves distances, you may find it helpful to use *tick marks* to indicate distances. Tick marks are tiny marks you draw on your paper to indicate a visual landmark that you use to map out other visual landmarks as you draw. This is preferable to just eyeballing the distance and assuming you are correct. Tick marks help you create a basic diagram or structure for your drawing.

Diagram With Tick Marks
This diagram of tick marks shows how they establish the key points for your drawing.

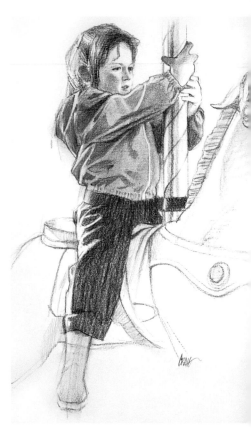

Fill in the Tick Marks to Complete the Drawing
Once you've mapped out the proportions with tick marks, the details are much easier to add. Be sure to include your subject's environment in your tick mark diagram. The subject's environment provides additional reference points for measuring to achieve correct proportions.

THE YOUNG HORSE WOMAN
Charcoal on bond paper
10" × 14" (25cm × 36cm)

USING SIZE RELATIONSHIPS

Careful observation of size relationships is another way to achieve correct proportions. Compare the heights and widths of various objects and note the differences with tic marks before proceeding to the drawing or painting stage.

PRACTICE ESTABLISHING SIZE RELATIONSHIPS WITH STILL LIFES

Still lifes are great for practicing this technique. It is easy to find objects of various sizes to set up in the studio.

3

Size Relationships Are Important
Although this is a loose oil sketch, the size relationships—both height and width—must be accurate for the composition to be suc cessful. The sizes and shapes of this collection of glassware and fruit are relatively simple, but they create an interesting arrangement.

GLASSES AND LIMES
Oil sketch on gessoed Masonite panel
20" × 24" (51cm × 61cm)

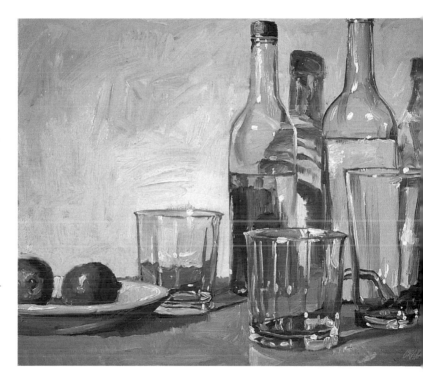

USING A GRID

A great tool for figuring out proportions is a grid. A grid will help you find the the center of a composition and sub divide it into quadrants or even smaller sections. Such subdivisions establish points to help you correctly locate elements of your subject within the com-position. Many painters use a literal grid before painting over it. For a draw-ing, however, a virtual grid may be indicated with light marks on the sides, top and bottom of your page.

Many artists may do small "thumb-nail" sketches for design, composition

Use a Grid to Determine Proportions
The exterior grid marks divide the picture plane into quarters. The interior cross hairs give key points to help determine proportional relation-ships. Note the implied center; it falls on the belt line, just to the right of the hanging sash. You may want to divide your composition into eighths, or just approximate eighths as you measure and draw.

FASHION-ABLE
Charcoal on bond paper
18" × 24" (46cm × 61cm)

or content. Once the sketch is completed, it must be scaled up to keep its proportional integrity. Using a grid is the most accurate way to accomplish this.

On a piece of acetate, draw a grid with the same exterior dimensions as your thumbnail sketch, then divide it into quarters, eighths or even smaller units. Now indicate similar subdivisions on your drawing surface. Transfer the sketch to the larger surface square by square, matching key reference points of the subject to corresponding points on the grid.

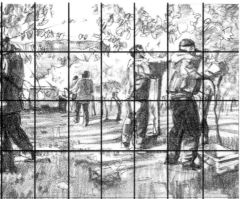

Compositional Sketch With Grid
This sketch of workers focuses on the placement of the figures and how they relate to the vineyard. With the grid on top, you can see how the relate to the cross points, horizontals and verticals.

WORKERS
Fine-point pen and charcoal on vellum
5½" × 7½" (14cm × 19cm)

WHEN USING GRIDS

A dark, literal grid is fine as long as you're going to paint over it. Otherwise, a light "virtual" grid works best.

USING VISUAL LANDMARKS

Proportion is all about measuring and comparing. When measuring, look for key reference points or *visual landmarks* on your subject. These may include sharp angle changes such as corners, or distinct tonal changes between shapes such as pieces of clothing. The intersection of two lines makes a great visual landmark.

Another measuring device that will help you place elements correctly is alignment. Notice when one element in a composition lines up with another. Usually vertical or horizontal alignments work best.

Use Visual Landmarks
This three-quarters back view includes a variety of visual land-marks that make checking proportions easier. The many folds are extremely useful.

BACK AGAIN
Conté on bond paper
17" × 22" (43cm × 56cm)

Window height

Bench

Figure height

Trash

Figure 1

Figure 2

Bench

Diagram of Proportions

The more elements in a composition, the more visual landmarks there are. I simplified the task of determining the proportional relationships in this piece by mapping out the proportional break up of space.

FRIENDS
Ultra-fine-point pen on bristol board
8" × 12" (20cm × 30cm)

COMPOSITION and SKETCHING

Many may wonder, what exactly is a sketch? A sketch is a drawing, usually done in a casual or more abbreviated way. A sketch may be done anywhere, anytime. It may consist of simple line, crosshatched tones, pencil, charcoal, ink wash or casual paint strokes. Sketching may be best defined by intent. A sketch is usually an informal drawing not necessarily intended to be carried to a finished state. Some sketches, however, may be considered as finished artworks in their own right.

Sketching often serves as practice for artists, a way to observe and study subjects of interest. It develops eye-hand coordination, drawing skills and a keen sense of observation. It allows artists to experiment with drawing styles, mediums, techniques and compositions.

OLD AND WISE
Colored water-soluble pencil on bristol board
16" × 12" (41cm × 30cm)

COMPOSITIONAL SKETCHES

Planning for composition is one of the most important purposes of the sketch. Through sketching, you may explore such compositional issues as where to place subjects or where to crop a scene. In this type of sketch, the aim is not accuracy but placement of the subject within the picture plane. This enables the artist to focus on the composition and worry about the details later.

Experimenting with formatting options is another purpose of sketching. Vertical or horizontal, square or elongated rectangular formats are possibilities that compositional sketches can help you explore.

Mediums for compositional sketches may be whatever the artist wishes. A little color may feel right or a simple pen sketch may suffice. Choose a medium that feels comfortable and natural for you to use.

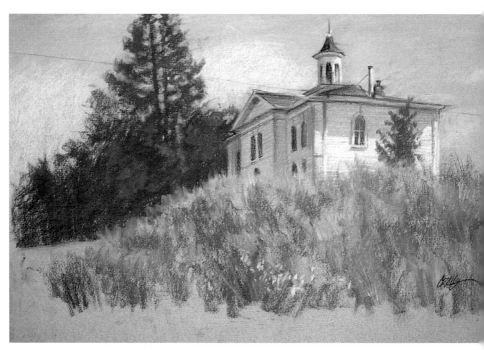

Sketching for Composition

This is the schoolhouse from *The Birds*, an eerie Alfred Hitchcock film. I wanted to create a similar mood in my drawing, so I needed a composition that was somewhat unsettling. Placing the house way off to one side in this long, rectangular horizontal format was the best solution.

HOUSE FROM *THE BIRDS*
Charcoal and hard pastel on Canson paper
9" × 16" (23cm × 41cm)

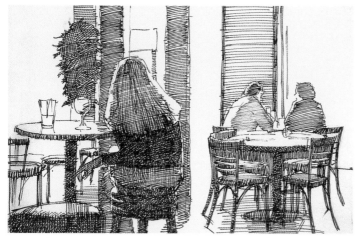

Sketch to Map Out Your Subject

Here I focused on the architectural forms of the interior, the geometric forms of the furniture and the organic forms of the figures. The change of scale between the foreground figure and the background figures establish depth and interest.

IN THE RESTAURANT
Fine-point pen on opaque vellum
5" × 9" (13cm × 23cm)

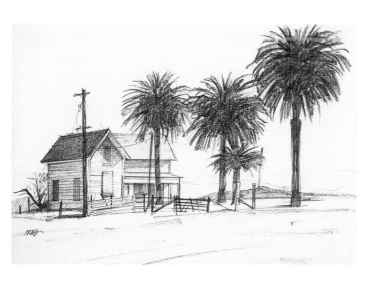

Sketch Architecture and Environment on Location

The "blocky" architecture of this old house is complemented by the sleek, thin palms. The fence activity and linear elements contribute to the overall composition.

HOUSE ON OCCIDENTAL ROAD
Graphite on ledger paper
7½" × 11"
(19cm × 28cm)

FOCAL POINT

The *focal point* is the area in a drawing
or painting that commands the most
attention. As the artist, you can control
the viewer's eye, leading it where you
like, by a variety of means. One way to
establish a focal point is to emphasize
one area with more detail, while under-
stating the detail in others. Emphasis
may also be achieved with more value
contrast or more intense color. Compo-
sitional elements such as converging
lines can also draw the eye toward a
focal point.

An effective focal point will not
only attract attention, but will inform
and entertain the viewer as well.
Remember to also provide areas where
the eye can rest.

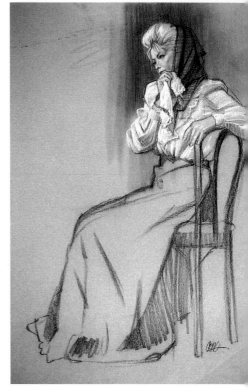

VARY THE SPACE IN YOUR SKETCH FOR INTEREST

Vary the spaces that surround the
objects in your composition for inter-
est. You can experiment with the size,
shape and spacing around your
objects in your compositional sketch.
It's also a great way to discover new
and exciting focal points.

Add Detail to the Focal Point
To establish the focal point in this figurative
sketch I simplified the torso and the skirt, then
added more tone and refinement in and around
the face. I also added a dark accent behind the
head to draw further attention to the focal
point.

THE HANDKERCHIEF
Charcoal and Conté on toned Canson paper
24" × 18" (61cm × 46cm)

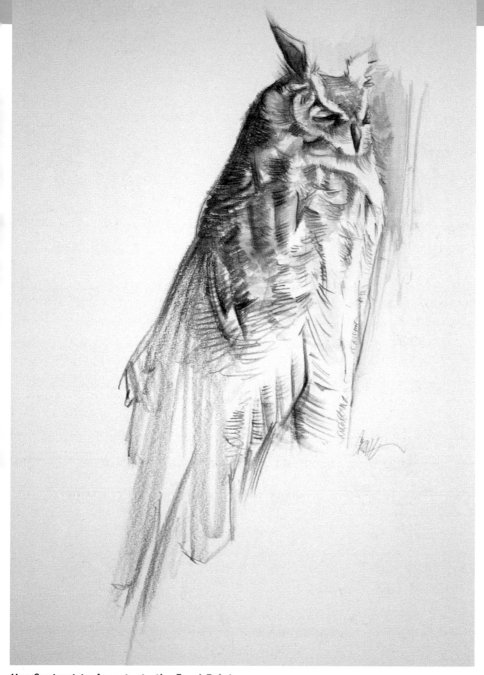

Use Contrast to Accentuate the Focal Point
The focal point of this sketch, done in black and two to three earth tones,
was accentuated with a little water applied around the owl's head.

OLD AND WISE
Colored water-soluble pencil on bristol board
16" × 12" (41cm × 30cm)

ESTABLISHING THE FOCAL POINT

To establish a focal point, the degree of interest in one area should be greater than in the rest of the composition; otherwise, the picture will seem monotonous. You can create interest in different ways:

- *Stronger value contrast.* The eye is naturally drawn to areas with the greatest contrast.
- *Composition.* Use lines to lead the eye through the picture and toward the focal point.

- *Definition and detail.* By controlling the amount of descriptive detail used in various areas, you can control the amount of time the eye spends in each place. Details can be well-defined in areas of light, or lost in dark shadowy areas. You can also create large areas of simplified lines or tones, punctuated by smaller areas of more intense, active detail. Selectively edit out nonessential details in areas you want to downplay.

Use Value Contrast for the Focal Point
Here, I accentuated the moose through strong value contrast. I also used softer, more casual lines and tones to create the surrounding terrain, which contains a lot less refined detail.

ALMOST CAMOUFLAGED
Charcoal and Nupastel on toned Canson paper
12" × 18" (30cm × 46cm)

Use Composition and Tonal Variation to Lead the Eye to the Focal Point

For this shadowy cityscape, I included very little detail in the large shadowy areas. This draws the eye toward the background, where I used more tonal variation. The activity near the ground is accented by more defined line details.

FROM THE SHADOWS
Charcoal on ledger paper
14" × 11" (36cm × 28cm)

Edit Out Details to Establish the Focal Point

In this charcoal drawing I edited out a lot of information, leaving the bottom hollow and undefined. More detail with line and a little tone draws attention to the head. The black hair, the modeling in the face and the additional line work there emphasizes the focal point.

GYPSY
Charcoal on bond paper
22" × 17" (56cm × 43cm)

FORMATS

Most formats for drawings are rectangular or square, but this does not have to be the case. Unusual formats can lead you to a new way of thinking about composition and your overall use of space.

A wide horizontal format may suggest a sweeping vista or landscape, while a narrow vertical format generally indicates something very tall, but these are not the only possibilities. By forgetting the stereotypes and opening your mind to other possibilities, an enormous variety of ideas may result.

Think Outside the Box
A wide horizontal format is typically used for sweeping, panoramic vistas. Instead, I used it for an image of sandals lying in the sand. By portraying several different kinds of sandals, I was able to fit this image comfortably into the unusually wide format. The various colors and patterns also adds interest to this work.

SANDALS
Oil on gessoed Masonite
12" × 36" (30cm × 91cm)

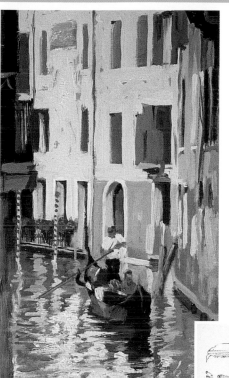

A New Format Can Lead to an Exciting New Way of Making Pictures

Landscapes are usually associated with square or horizontal formats. Occasionally a vertical is used. The study shown here is an exploration of another format: an extreme vertical. A lot of abstracted negative space at the bottom adds interest to the composition. This unique format treatment shows what might be possible by doing the unexpected. Although this is a small study, it may eventually lead to a larger piece.

A LONG CANAL
Oil on gessoed Masonite
20" × 6" (51cm × 15cm)

Break Your Normal Rules Regarding Composition, Design and Subject

This sketch of a chaotic cocktail party comprises a number of individual vignettes depicting a variety of intimate moments. The numbers were thrown in as a graphic design element, because there were thirty attendees at the party.

COCKTAIL PARTY
Fine-line technical pen and gouache on cold-pressed board
9" × 24" (23cm × 61cm)

135

IDEA SKETCHES

By beginning the creative process with quick idea sketches, you can explore a number of compositional possibilities and produce a plan for your final artwork. Idea sketches are usually rough and abbreviated, acting only as diagrams from which to proceed.

While idea sketches may deal primarily with composition, they also can assist the artist in developing of a new idea. An interesting concept, a specific point of view, the memory of an intriguing scene, or anything else that has inspired you may be worked out in idea sketches.

Use Idea Sketches to Experiment With Lighting
A strong light and dark contrast has been rendered in bold crosshatching to bring out the elk. The landscape is indicated in textured patterns.

An existing drawing or photo may be a great source of inspiration. However, it may need an additional element such as a figure. A quick sketch can turn this thought into a visual statement, which you will be able to evaluate for effectiveness. You may then find a model or an additional element from which a more refined or finished composition can be created.

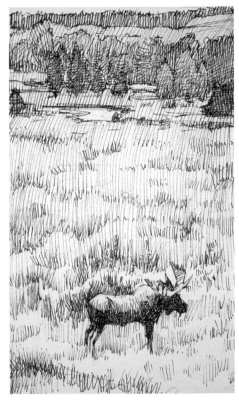

Use Idea Sketches to Map Out a Scene
The irregular foliage shapes at the top were intended to contrast with the bold bull moose at the bottom.

LONE BULL MOOSE
Fine-line technical pen on bond paper
7" × 4" (18cm × 10cm)

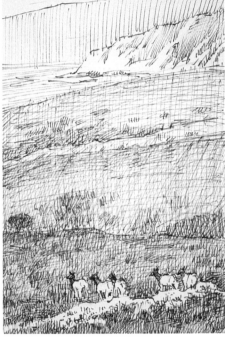

Use Idea Sketches to Explore Composition
This quick idea sketch was intended to explore the relationship of the dark shapes to the light shapes.

TULE ELK IN SPRING
Fine-line technical pen on bond paper
6½" × 4½"(16cm × 11cm)

ABBREVIATED SKETCHES

An *abbreviated sketch* is the prelude to a finished drawing or painting. It contains only the information necessary to help the artist decide how to proceed.

An abbreviated sketch is not for show; it may appear abstract or almost incomprehensible to a viewer. Such sketches are valuable, however, because they allow the artist to experiment with variations on a composition, adding or subtracting an element or trying a different format.

Methods and mediums for abbreviated sketches can vary, but those that promote speed and fluidity are best. Speed encourages you to concentrate on essentials and avoid getting hung up on details. Pens, soft pencils and char-

Abbreviated Sketches Are Not Meant to Be Finished Pieces
On this piece of pre-toned stretched linen, I used a small liner brush to sketch my subject. Before going further, it's important to double check for proportion and perspective accuracy.

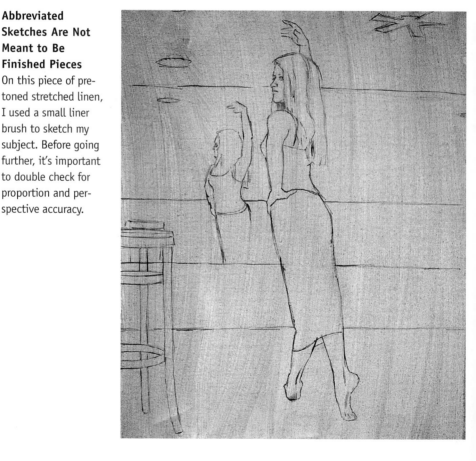

coal are conducive to quick work. Tissue pads or thin vellum allow you to do one sketch over another, making quick variations. These surfaces also are easy to draw on and take tone well. Your sketch may be made up of scribbled lines, or it may include varied tones to help you plan your values.

4

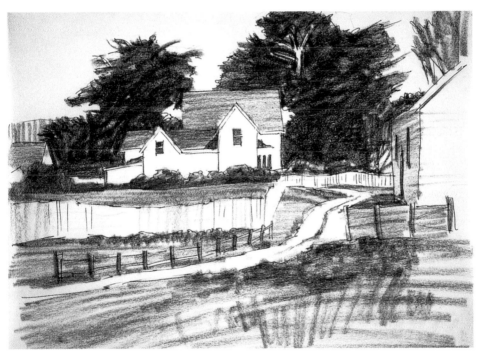

Abbreviated Location Sketch

This quick location sketch deals with shape variation, value and overall composition. A *plein air* (page 140) study followed this sketch, but I could have followed it with a studio color study or a finished drawing or painting.

POINT REYES HOUSE SKETCH
Charcoal on vellum
11" × 14" (28cm × 36cm)

LOCATION SKETCHING

Sketching on location is a wonderful exercise and can be done quite comfortably since the supplies are so mobile. A sketchbook, a drawing pad or paper with a small drawing board is basically all that is required for a surface. Pen, pencil, charcoal, watercolor or pastel are all great location sketching mediums.

Any subject may be sketched on location: still lifes at a diner, architectural structures or a detail on a building, trees, boats, figures or vehicles on the street. Anything from a quick pen sketch to a small watercolor sketch is possible to do in almost any situation. It just takes a little preparation and some initiative.

SKETCHING *EN PLEIN AIR*

En plein air is a phrase used to describe working outside on location. It is wonderful for seeing your subject clearly and directly, allowing you to immediately interpret your subject as a drawing or sketch.

Sketch of Architecture
Here I combined line with tonal shapes to sketch out the architecture. I used abbreviated line work to add reflections and hills.

LAUNCH SKETCH
Fine-line pen on vellum
11" x 14" (28cm x 36cm)

Sketch of a Seascape
This crosshatched sketch was done as an idea sketch for a painting. The pattern of the rushing water and rock forms are the primary concern.

PACIFIC SPLASH
Fine-line pen on newsprint
8" x 12" (20cm x 30cm)

USING REFERENCE SOURCES

Another form of idea sketch is one that I fondly refer to as "will it work?" This involves bringing together two or more reference sources in one sketch to see if your idea will work before you commit to a larger project. Your resources should be compatible in perspective and lighting in addition to basic composition. Be sure to work out any inconsistencies in your sketch so the perspective and lighting in the final artwork will be accurate.

Sketch From Photographs
A great, powerful photo with dramatic lighting became the main location reference and the inspiration for finding an appropriate additional subject for a painting. I chose the moose from a variety of photos I had taken. I made this ball-point sketch one evening to see if the combination would work.

MOOSE IN THE MORNING
Pen on ledger paper
8" × 8" (20cm × 20cm)

The Finished Piece
After the sketch was completed, I felt the composition would work. There was something intriguing about the black and white sketch that inspired me to paint this in a nearly mono-chromatic color scheme.

A GLOW
Oil on linen
24" × 24" (61cm × 61cm)

TAKE REFERENCE PHOTOS

Even if you work from life, take a reference photo anyway. You might need that reference later.

Watercolor Sketch

When you sketch on location, it's easier to focus on values. The old truck sitting with junk around makes an interesting subject. Using white paper will make the truck stand out more, once all the darks have been added. Mix Burnt Umber with each of the colors on your palette. This tones down the colors and will harmonize the painting.

Materials

SURFACE
8" × 12" (20cm × 30cm) piece of hot-pressed watercolor paper

WATERCOLORS
Burnt Umber

Cadmium Red

French Ultramarine

Sap Green

Yellow Ochre

MEDIUMS
.05 fine-line technical pen

BRUSHES
1-inch (25mm) flat

No. 5 and no. 7 sable round

OTHER MATERIALS
Palette

Paper towel

1 Sketch the Composition
With a .05 fine-line pen do a simple line sketch on the hot-pressed watercolor paper.

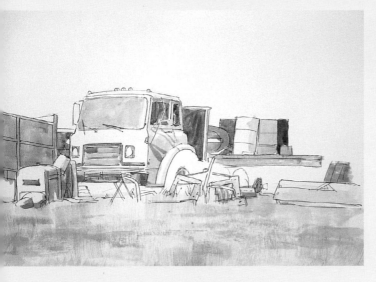

2 Add Watercolor Washes

With a no. 5 sable round, lightly add a few watercolor washes. to add color and value to your sketch. Using a 1-inch (25mm) flat, load your brush again, daub it with a paper towel and drag your brush across the paint (this is called a dry-brush effect).

3 Add Lighting Effects

Use the no. 5 sable round and a mixture of Burnt Umber and French Ultramarine thinned with water to add lights that you see. Then, sparingly add a mixture of Cadmium Red and Burnt Umber to the truck for color variation and character. Add another layer of color to brighten and strengthen the values of the objects.

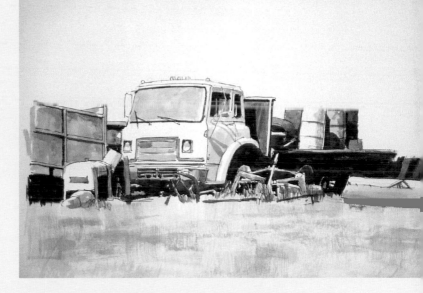

143

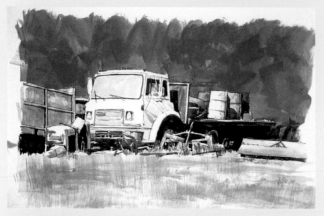

4 Lay In the Background

Lay in the base background foliage with a mixture of Sap Green, Yellow Ochre and a touch of Burnt Umber using a 1-inch (25mm) flat. Do a dry-brush pass to the foreground brush with the Yellow Ochre and the 1-inch (25mm) flat.

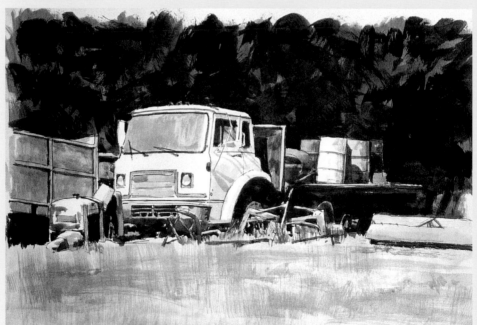

5 Add Details and Make Final Adjustments

Emphasize the white truck by adding erratic dark brushwork with a no. 7 round to the background foliage using the dry-brush effect. Add a few linear and color adjustments, and this quick watercolor sketch is complete.

THE BEAT UP WHITE TRUCK
Fine-line pen and watercolor on hot-pressed watercolor paper
8" × 12" (20cm × 30cm)

144

KEEPING A SKETCHBOOK

Most artists keep a sketchbook of one type or another. The sketchbook serves two basic purposes: 1) It is available at all times for sketching ideas or taking visual notes and 2) It may also serve as a journal for you to keep your ideas in a nice, neat notebook form.

Artists fill sketchbooks with little sketches, full-page drawings, gouache and watercolor studies as well as any notes to accompany the visual state-ments. A sketchbook may be as small as 4" × 5" (10cm × 13cm) or as large as 9" × 12" (23cm × 30cm). They may be leather-or spiral-bound with different types of papers from toned to bristol to vellum. These variations offer a number of possibilities for each artist. I suggest you keep a sketchbook with you at all times because you never know when a great subject or idea will present itself.

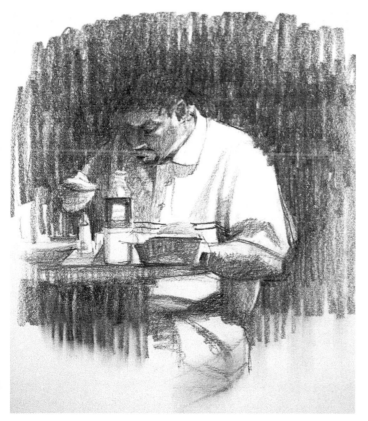

Use a Sketchbook to Record Visual Notes

A person eating in a cafe makes a great subject because the motion of the figure is repetitive. This enables you to see the same pose over and over.

LUNCH
Graphite on ledger paper
8" × 8" (20cm × 20cm)

Sketch a Figure at Rest

A figure at rest offers a model in a frozen pose. The trick is to sketch quickly before the person awakens.

ASLEEP
Fine-line technical pen on opaque vellum
3½" × 7" (9cm × 18cm)

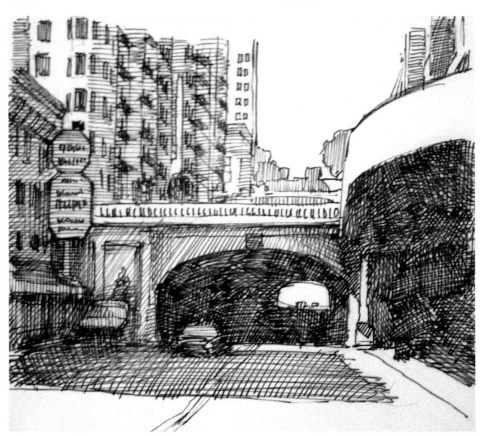

Sketch Cityscapes

This tunnel in San Francisco offered wonderful possibilities for a strong composition with dark and light contrasts in a unique cityscape.

STOCKTON TUNNEL
Fine-line technical pen on opaque vellum
5" × 6" (13cm × 15cm)

Sketch Stationary Figures

Artists often sketch other artists while they are painting. It is a way of capturing a special moment in time. This is Brian Blood, a great landscape painter, caught as we painted together at a local vineyard.

BRIAN PAINTING
Pen and watercolor on ledger paper
11" × 8½" (28cm × 22cm)

147

SUBJECTS for DRAWING

What should I draw? This is a question many artists struggle with. The best answer is: Draw everything, draw anything. The more subjects you draw, the more well-rounded your artistic abilities become and the less intimidated you will be when faced with new subjects. As you draw different subjects your observation skills and your eye-hand coordination will improve.

Landscapes, architecture, objects, animals and people are all interesting possibilities for artistic subjects. Each potential subject has its own unique characteristics, offering you new challenges that will broaden your abilities and artistic insight. The only way to discover what it is you are truly interested in drawing is to experience as much as you can.

MIXER
Oil on Masonite panel
18" × 14" (46cm × 36cm)

DRAWING LANDSCAPES

Landscapes encompass the variety of subjects in a rural setting. Natural subjects in landscapes include fields, mountains, rocks, cliffs, snow, water, trees, fallen logs, foliage and clouds. Landscapes may also include features such as roads, paths, cabins, fences, bridges and signs. Artists may choose to focus closely on a narrow subject such as a tree trunk, or they may decide to back up and take a more panoramic scope.

Sketch Distant Landsapes for Depth
This drawing is representative of the flowing, organic type of landscape, with no crisp edges or solid geometric elements. The illusion of depth was developed through layering. I started with the lighter colors in the background, building toward the darkest tones in the foreground.

SPANISH BAY
Charcoal and CarbOthello pencils
on textured drawing paper
8" × 14" (20cm × 36cm)

TEXTURE IN LANDSCAPES

Texture is an important part of landscapes; the softness of a cloud, the hard edges of rocks and the coarseness of tree bark are qualities worth rendering. When drawing landscapes often it is best to merely suggest texture rather than draw individual elements. For example, when drawing the foliage of a tree, do not draw each leaf; instead, suggest the quality of the foliage.

Use the Power of Suggestion
I created a dominant silhouette of the trees by using the side of a charcoal pencil to produce soft tones rather than drawing the actual trees.

EUCALYPTUS SKETCH
Charcoal pencil on rough drawing paper
11" × 12" (28cm × 30cm)

Mix Textures and Edges for Interest
Here I mixed the undefined edges of the trees with their abstract reflections. I used the fallen log to punctuate the scene with more definite edges.

THE OLD WHITE LOG
Pastel on Canson paper
12" × 15" (30cm × 38cm)

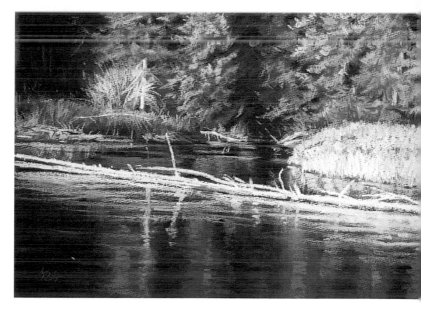

LIGHTING IN LANDSCAPES

Lighting conditions are another vital consideration when drawing landscapes. When you are working *en plein air* (page 140), the quality, duration and angle of light will have a dramatic impact on the scene. A gray day will have diffused lighting, making the pattern and shape of elements dominate. On a sunny day, strong contrasts in light and shadow will prevail. The time of day will affect the quality of light and the length of the shadows as well.

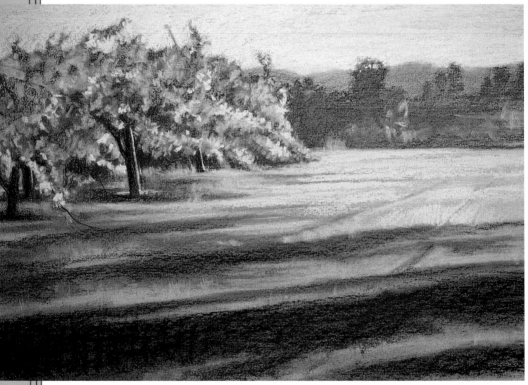

Include Light and Shadow in Landscapes

On sunny days your subject will have very obvious shadows. These shadows are a very important part of the composition, since they indicate a strong light source is affecting your subject. On overcast days, the shadows will be less obvious as a result of the subdued lighting.

SHADOWS AT THE VINEYARD
Charcoal pencil, CarbOthello pencil and hard pastel on gray Canson paper
11" × 16" (28cm × 41cm)

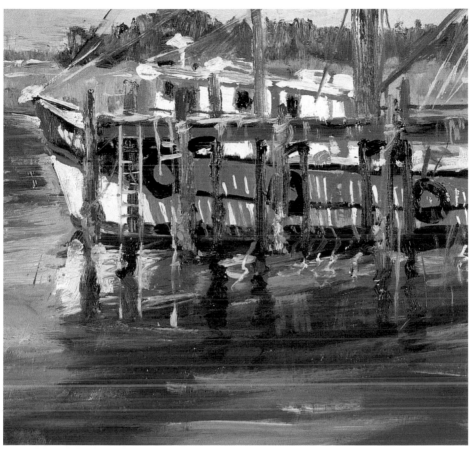

Use Color to Create the Effect of Sunlight

This quick oil sketch was done *en plein air*. To make the appearance of sunlight consistant throughout the drawing, establish the middle tones and the shadows first. Then add the sunlight, in this case a yellow-orange, consistently to the drawing. The lighter value of the sunlight creates the appearance of a stong light source.

AT SHEM CREEK
Oil on Masonite panel
12" × 16" (30cm × 41cm)

Drawing a Landscape

Pastels are dry pigments that you mix directly on the paper. Doing this effectively takes practice. An important technique to employ is that of color variation. This means adding hints of warm colors to predominately cool areas and adding hints of cool colors to mostly warm areas. Also, get hard and soft pastels in a variety of colors (you'll need more hard than soft for this demo).

Materials

SURFACE
10" × 13" (25cm × 33cm) toned Canson paper

MEDIUMS
Earth-toned CarbOthello pencil

4B charcoal pencil

Set of hard and soft pastels

OTHER
Facial tissue

Workable spray fixative

1 Sketch in the Elements

On toned Canson paper, roughly sketch in the large proportional shapes of the elements in the landscape composition with an earth-toned Carb Othello pencil.

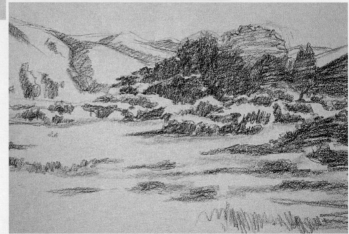

2 Add the Darker Tones
With a 4B charcoal pencil, add the darker shapes and shadows. Use facial tissue to lightly smear the charcoal. Spray on a light layer of workable fixative. Let this dry for a few minutes.

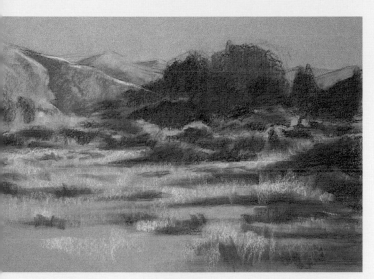

3 Lay in Initial Colors

Using the hard pastels, approximate the tones and colors in the landscape. Do not lay in the pastels too firmly since you will be building on top of this first layer.

5

4 Strengthen the Color Variations

Add color variation as you notice it within the landscape. Look for subtle warm and cool variations within the darker tones. Refine the shapes and edges in the background with the colors you have already added.

CHOOSING PASTELS

It helps if you use a color palette that feels natural to you. Make sure your pastel set contains both muted and bold colors.

5 Apply Soft Pastels

Using soft pastels, begin building stronger and firmer tones everywhere. Establish the brighter elements of the picture by adding a range of yellows to the foliage to the middle ground and color variation to the foreground grasses.

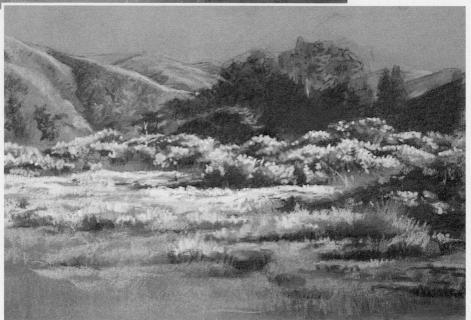

6 Continue Refining Detail

Further define the background trees and hills by adding subtle tonal lights. Make another pass over the yellow foliage, again varying the yellows for a rich, textured quality. Add brighter lights to the foreground grasses to create color and textural variations. Spray with fixative and let dry.

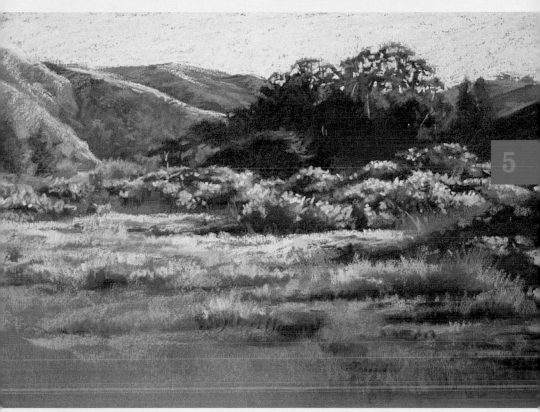

7 Complete Your Drawing

Use soft pastels to further emphasize the color and brightness of key elements. With a white and a pale blue-gray pastel, brighten the sky to clarify the hills and tree shapes.

Do not add fixative at this point because it will darken the colors. Instead, protect your work with a mat, glass and frame (pages 294–297).

SPRING IN MARIN
Charcoal, CarbOthello pencil, and pastel on toned Canson paper
10" × 13" (25cm × 33cm)

DRAWING ARCHITECTURE

Drawings of architectural structures differ from landscape drawings because they are more geometric in structure as opposed to organic. They consist of more straight lines and crisp edges.

Most lines in architectural forms are horizontal and vertical. Some details may contain curves or angles, but on the whole architecture is best characterized by straight lines.

Sketching Architecture
When doing a quick sketch of buildings focus on perspective and proportional accuracy.

OLD SEAFOOD RESTAURANT
Fine-line technical pen on ledger paper
11" × 14"
(28cm × 36cm)

Emphasize the Lines and Angles of Buildings
Here I used hatching and line work to emphasize the angle variations of the buildings. The point of view of the buildings also shows off their angles.

BUILDINGS IN MENDOCINO
Fine-line technical pen on bristol paper
10" × 16"
(25cm × 41cm)

PERSPECTIVE IN ARCHITECTURE

Because buildings are basically large geometric forms, perspective is a necessary component of the drawings. This is especially true when you draw multiple buildings. Perspective describes space and distance, gives dimension to the forms, and helps define the foreground, middle ground and background.

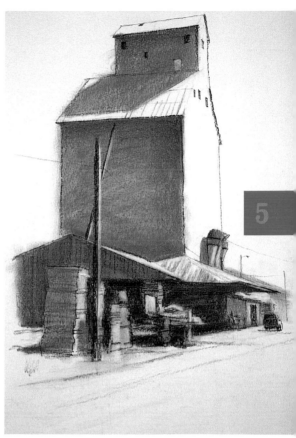

Apply Perspective to All Aspects of the Buildings

Use tonal variations to show the forms of the buildings. I used three-point perspective to create a worm's-eye view. Make sure you apply three-point perspective to the windows, too.

A PIECE OF NEW YORK
Graphite pencil on vellum
14" × 11" (36cm × 28cm)

Use Perspective to Add Interest to Multiple Buildings

Here I included a variety of small, dark structures to emphasize the height of the tall structure, making the worm's-eye view more intense.

REALLY TALL
CarbOthello pencils, pastel and charcoal pencil on ledger paper
18" × 14" (46cm × 36cm)

LIGHTING IN ARCHITECTURE

As in landscape, lighting plays an important role in architecture drawings, especially in composition. Pay special attention to the light and dark patterns created by light and shadow. When strong lighting hits the straight lines and hard edges of architecture, the picture space will be further broken up graphically. That is, the light and dark shapes will be important elements in your composition.

Use Hatching to Depict Light and Shadow

I used hatching to depict the effect of light and shadow on the bold, bulky form of this barn. Some areas are hatched more heavily to create the effect of deep, dark tones.

UNIQUE BARN
Fine-line technical pen on hot-press board
12" × 16"
(30cm × 41cm)

Frame Architecture With Natural Elements

Here the smooth, linear quality of the buildings contrasts well with the ragged edges of the surrounding trees and bushes.

WATERSIDE SILOS
Watercolor on hot-press watercolor paper block.
12" × 16"
(30cm × 41cm)

Drawing Architecture

Working on a gessoed surface enables you to pick up and re-manipulate tones and add color. Gesso is a form of paint that can add tooth to a surface (for mediums like charcoal and graphite) and it will prevent water-soluble paints (like water-color) from penetrating the surface. Use a large wash brush to apply it to your surface.

Materials

SURFACE
14" × 18" (36cm × 46cm) cold-press illustration board

WATERCOLORS
Burnt Umber

Sap Green

Ultramarine Blue

Yellow Ochre

BRUSHES
No. 1 bristle round

No. 6 or 7 sable round

No. 4 or 6 bristle flat

Small liner brush

OTHER
Craft knife

Facial tissue

Gesso

Paper towels

1 Sketch the Composition
Using a small liner brush with a dilut-ed mixture of Burnt Umber and Ultramarine Blue, make a pale sketch of your composi-tion. Use straight contour lines and pay careful attention to proportion, perspective and angles.

161

2 Apply Tones
Apply the large masses of tones with a no. 6 or no. 7 sable round. Keep things large and simple. Let the white of the paper be the white of the barn. As you add the watercolors to the gessoed surface it leaves watermarks and stains. Don't be alarmed; this is part of the effect you're trying to achieve.

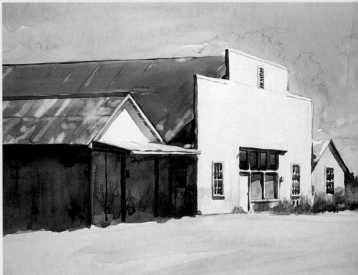

3 Add Details
Clean up and simplify the tones on the building shadows with a small brush or facial tissue. Begin to lay in the weeds and details to the architecture. Add more darks to the shadows where needed and add a slight stain to the building front. Lift out the faded lettering on the roof with a moist no. 4 or 6 bristle flat. Wipe out a cloud to two with a moist paper towel.

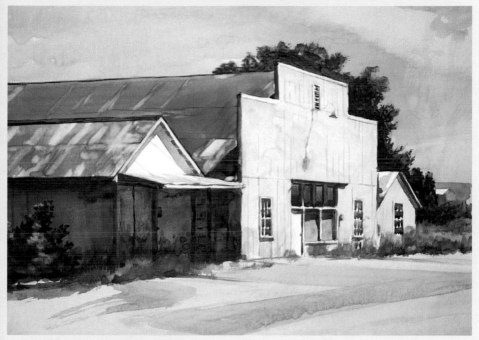

4 Add Shadows and More Detail

Working from the background to the foreground, using a no. 6
or 7 sable round and a mixture of Burnt Umber, Ultramarine Blue
and Sap Green, add a few more weeds. Add dark trees behind the
building. Add more detail to the shadows and to the architecture.
Lift out more lights on the roof if necessary.

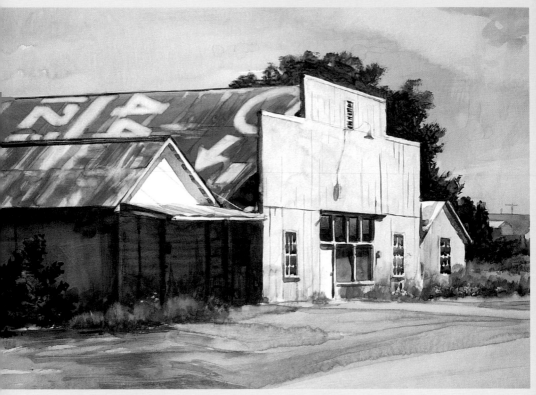

5 Finish the Picture

Lift out some light graphics on the roof with a no. 1 bristle round. Lightly add linework with a watery mixture of Burnt Umber and Ultramarine Blue to the barn to give it a wooden appearance. Add warm tones to the foreground with a heavily diluted mixture of Burnt Umber and Yellow Ochre with the sable round. With a craft knife, scratch out the lights on the window frames, around the window frames, pane separations and the light flowers.

RED ROOF
Gesso and watercolor on cold-press illustration board
14" × 18" (36cm × 46cm)

DRAWING STILL LIFES

A still life drawing is basically a picture of an inanimate object. Common still life subjects include vessels, food, flowers, books and clothing, but you don't have to limit youself to these subjects; the variety of possible subjects is endless.

Mix Contour With Hatching

A simple household item can present some complex drawing challenges. Carefully observe the object before sketching it out. The ellipse of the larger wheel is a crucial perspective consideration.

MIXER
Oil on Masonite panel
18" × 14" (46cm × 36cm)

Draw Objects You Have at Home

I combined contour line drawing and crosshatching for the ice cream scoop. A degree of perspective is necessary to capture the bowl accurately.

SCOOPER
Fine-line technical pen on hot-pressed board
9" × 12" (23cm × 30cm)

SUBJECTS for STILL LIFES

Try sketching small objects such as pencils, brushes or coffee cups separately or as a group composition. Use objects you can find outdoors such as shovels, wheel barrows, or carousel horses offer other, more complex qualities. Larger objects such as trucks, automobiles, tractors or trailers interesting subjects because of their size and variety of textures and shapes.

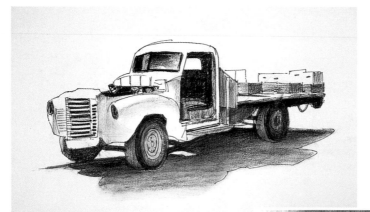

Combine Pen and Charcoal for Contour and Form
For this old truck I did a line drawing with a pen for proportion, perspective and shape. Then I used charcoal to create form and texture.

OUT OF COMMISSION
Ink and charcoal on ledger paper
9" × 12" (23cm × 30cm)

Draw Natural Objects
Here I combined soft tones and lights with crisp line to create the flowing organic shapes of the rose petals.

WHITE ROSES
Pastel and CarbOthello pencil on vellum
16" × 12" (41cm × 30cm)

Drawing a Steam Iron

Small household objects such as an old steam iron make great drawing subjects because you can control the angle and the lighting and clearly observe the details. Plus, you may start a drawing, then come back and finish it another time. There are a wide variety of drawing subjects right in your home.

Materials

SURFACE
11" × 14" (28cm × 36cm) bristol board

MEDIUMS
Pencil

Fine-line tecnical pen

5

1 Sketch Objects and Draw Contours
With a pencil, lightly sketch your subject. Go over your sketch with a fine-line pen. Be careful as you build up your sketch in pen. Pay particular attention to perspective and your use of ellipses.

2 Add Local Tones
Begin hatching in local tones with the pen. Remember that you will layer more tones on top of these to build up darker tones so don't make this first layer too heavy.

3 Build Tones
Use hatching to add the lighter midtones.

167

4 Continue Building up Tones

Develop the medium to dark tones by adding more layers of hatching. Decide where your lightest lights will be. Don't add tone to this area.

5 Complete the Drawing

Create your darkest tones by adding a final layer of hatching in the darkest areas. Add some hatching in lighter areas to emphasize the highlights which you must leave white.

THE OLD STEAM IRON
Fine-line technical pen on bristol board
11" × 14" (28cm × 36cm)

DRAWING ANIMALS

Animals offer a variety of subjects for drawings, but just sketching them often requires patience and practice. Rough in the pose of the animal first, then add details as the pose recurs while you continue to observe the animal. Focus on one animal at a time so you can become familar with its characteristics, proportions and motions. If you don't want to worry about the animal moving, take a photograph of your subject.

Use Pen for a Quick Sketch

Most animals are always on the move so you need a medium such as ink that will allow you to capture their essence quickly. In this sketch, I used ink to indicate the direction and texture of the fur.

SAMSON
Fine-line technical pen on bristol paper
10" × 12" (25cm × 30cm)

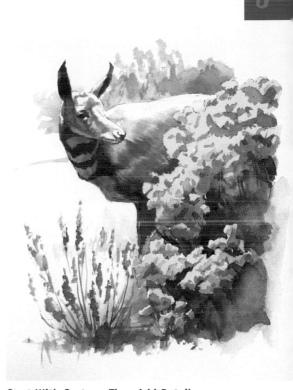

Start With Gesture, Then Add Details

I did a gesture drawing of the antelope with ink, then applied a few watercolor washes to add color and modeling. I left a lot of white for a sketchlike quality.

CALIFORNIA ANTELOPE
Ink and watercolor on hot-pressed watercolor paper
16" × 22" (41cm × 56cm)

169

DRAWING an ANIMAL'S CHARACTER

From a small mouse to an enormous elephant, size difference of animals is extreme. The shapes of animals vary just about as much as their sizes. The long neck of the ostrich or giraffe, the bulk of a hippo or a pig, the grace of a cheetah or deer, are unique qualities that artsits try to capture in their draw- ings. Attributes such as antlers, beaks, wings and horns contribute to the iden- tities of different animals and are also worth rendering. The texture of animals range from sleek to fur to feathers to wool. All of these characteristics makes drawing animals an enjoyable chal- lenge.

Establish Accurate Proportions First
Do a quick reading of an animal's proportions before you begin to draw. To get accurate pro- portions, try fitting the length of the animal's body and the height of its back into a rectangle.

Draw Basic Shapes, Then Add Details
After establishing the correct proportions, I sketched the basic shape of the cow, then filled in the details. I used a red- dish brown back- ground to accentuate the whites on the cow's face and chest, and added blacks in the body to create the look of solidity.

LONESOME COW
CarbOthello pencil and charcoal on drawing paper
12" × 16"
(30cm × 41cm)

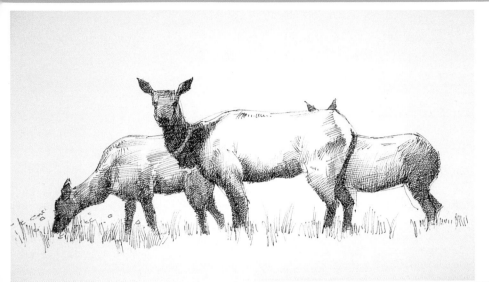

Capture an Animal's Identity

Here I captured the identity of the elk through their refined legs and through the bulk of the torso, which gives way to their graceful necks and heads. I used shadows to model their forms and darkened the fur in the neck and head for focus.

THREE ELK
Fine-line pen on bristol paper
9" × 12" (23cm × 30cm)

Use Texture to Add to the Animal's Identity

A Persian cat with two-toned fur has a nice texture and tone to deal with. While the overall shape is quite simple, the head contains sensitive proportions and delicate features. The front view requires a close study of the head and firm yet sensitive line work. The fur is captured with a loose application of tone and line, in this way, I've captured the feel of the fur, not its exact appearance.

SADIE
Charcoal and Nupastel on toned Canson paper
18" × 13" (46cm × 33cm)

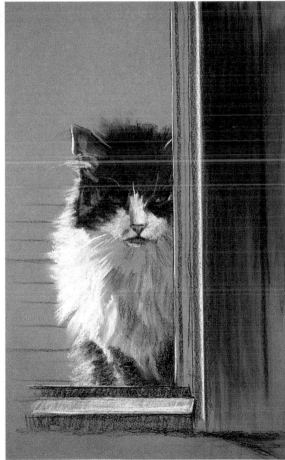

171

Drawing an Animal

You may draw animals from life or from photographs. If you draw from life, you run the risk of the animal moving in the middle of your work. For a more accurate portrayal, a reference photo is good to have on hand. Take your camera to the zoo and photograph various animals as references for your next sketch or drawing.

Materials

SURFACE
12" × 16" (30cm × 41cm) hot-press watercolor paper

MEDIUMS
Medium graphite pencil

Ivory Black watercolor

BRUSHES
¾-inch flat

No. 7 sable round

OTHER
Craft knife

1 Sketch the Shape and Features
With a medium graphite pencil, lightly sketch the lion's proportions on hot-press watercolor paper. Carefully sketch in the features and proportions of the face.

2 Apply Watercolor Wash
With a ¾-inch flat, dampen the entire shape of the animal. Using a no. 7 sable round, do a wash of ivory black watercolor. Cover everything that will not be left white.

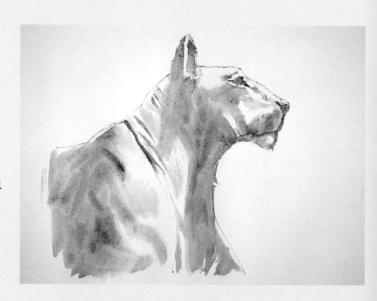

5

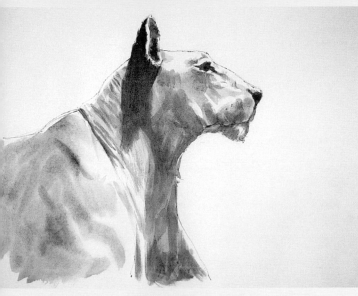

3 Apply a Second Wash

As the moisture begins to dry, apply a another layer of ivory black wash with the no. 7 round. The paint should not be too wet on your brush. Apply the wash to the ear and its shadow, the chin, jaw and their shadows, and the nose and eye.

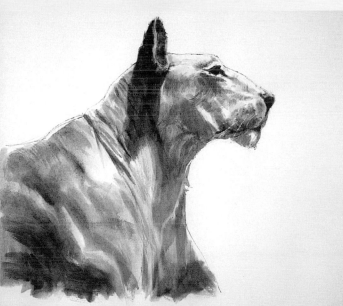

5 Finalize the Drawing

Finally, apply the darker and darkest darks. Use a no. 3 sable round for the neck and muzzle. Darken any areas that appear dark or deep in shadow. When the paint is dry, scratch out a few whiskers with a craft knife.

A NOBLE PROFILE
Watercolor on hot-pressed watercolor paper
12" × 16"
(30cm × 41cm)

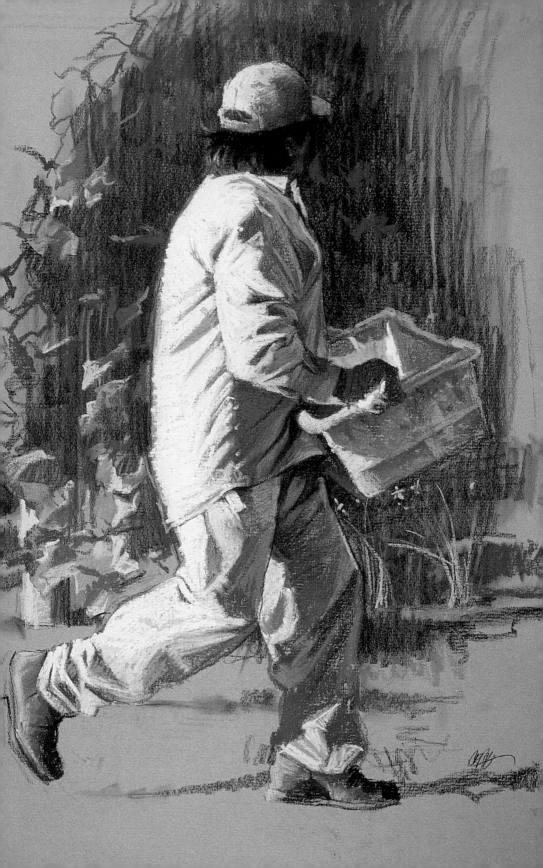

DRAWING
FIGURES
and FACES

Gesture and attitude constitute the "body language" of a figure. The angle of the head, the action of the arms, the use of the hands and the weight distribution of the body all play an important role in the attitude and pose of the figure. A great range of expression may be demonstrated through poses and gestures. Seated and standing figures as well as figures in motion can display gestural qualities. With moving figures, it is important to find the moment that best describes the action. In many cases this will be the moment that the action begins, or just prior to the actual movement.

When drawing any figure, it is vital to study and understand the attitude and gesture of that specific figure. Depicting individual attitudes will give life to the figure and help you avoid a static, paper-doll-like quality. Also use clothing to help you render the movement or gesture of a figure. Folds created by tension can be used to amplify the attitude or the action. Using all of the properties of pose and gesture will ensure a more pleasing and believable figure drawing.

THE VINEYARD WORKER
Charcoal and pastel on gray Canson paper
24" × 18" (61cm × 46cm)

PROPORTION in FIGURE DRAWING

Correct proportions are absolutely crucial in figure drawing. Because the figure is so mobile, the proportions seem to change constantly. This makes careful observation a must.

When I draw the figure, I first decide how tall I want to make it. The average adult is 7½ to 8 "heads" tall. (Use 8 or even 9 head lengths if you want to make the person look powerful, dignified and regal.) The groin is about halfway point of an ideally proportioned adult. Then I divide my paper up evenly about (eight head lengths) and use this as a guide for

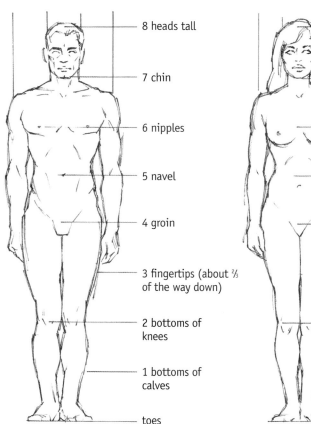

Body Proportions of a Man
The male figure's body proportions are wider and more square than that of a woman. Also notice that his navel is higher than that of a woman.

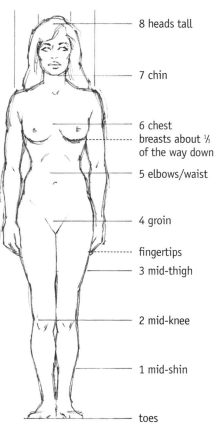

Body Proportions of a Woman
Notice that the body proportions of this female figure are drawn with feminine characteristics in mind: narrower shoulders and waist and rounder hips.

176

placing different parts of the body.

The ideal height of a woman is shorter than a man's by about half a head, but her total height is still eight head lengths. When drawing children, the head is usually larger in proportion to the body and the shoulders are narrower.

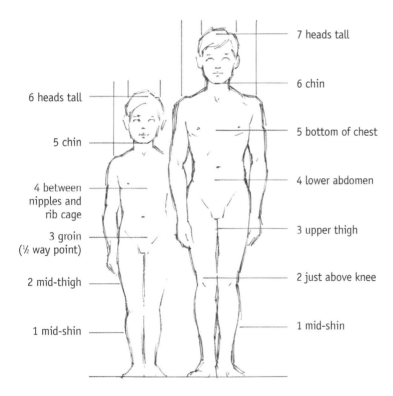

6 heads tall

5 chin

4 between nipples and rib cage

3 groin (½ way point)

2 mid-thigh

1 mid-shin

7 heads tall

6 chin

5 bottom of chest

4 lower abdomen

3 upper thigh

2 just above knee

1 mid-shin

Body Proportions of Children and Teenagers

When drawing children, the shoulders will be narrower, the head proportionally larger than the body and the facial features smaller in proportion to the head. To render a teenager, simply draw smaller adult proportions and less severe facial structure.

177

SKETCHING FIGURES

Once you've determined accurate proportions for a figure drawing, do quick gesture sketches to help you capture these proportions accurately before you start your final drawing. Doing quick gesture sketches will help you capture your figure's attitude. Once you have a sense of the proportions and attitude, you can begin to refine the details that bring out your subject's character.

Do Multiple Gesture Sketches

This drawing was created after sketching several poses of this model. By testing several poses with sketches as the waitress moved around, I was able to select the pose with the gestures and character I wanted.

THE WAITRESS
Charcoal and white chalk on Canson paper 17" × 22" (43cm × 56cm)

Try Sketching More Than One Figure

This sketch of three figures is composed of large dark masses accented with a little modeling and a touch of line. The pose and attitude of the figures contribute to the sense of an ongoing discussion.

THE DISCUSSION
Graphite on ledger paper
14" × 10" (36cm × 25cm)

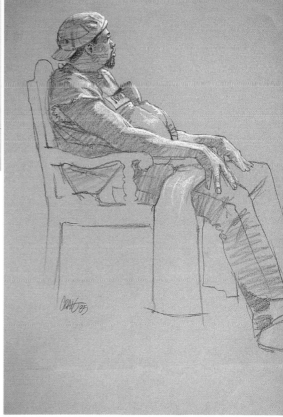

Include Tone in Your Sketches

I used charcoal line and tone for this sketch. The added white Conté helps to create form and interest, while the toned paper accentuates both the darks and the lights. I applied the darker gradated tones loosely to add to the informal character of the drawing.

THE TRAINER
Charcoal and Conté on toned Canson paper
25" × 19" (63cm × 48cm)

POSE

Figure drawing involves pose, the stance or position of a figure. A pose may capture a figure at rest or in motion, but even stationary poses can exude a sense of energy. Depicting an "active" stance will help you overcome the stiffness figure drawings often have. For example, try putting the weight of your subject on one leg, allowing the other to relax. This will cause the torso to lean slightly to one side for balance. This posing technique is referred to as *contrapposto*. You can enhance this position by placing the hands on the hips or by putting one hand behind the head.

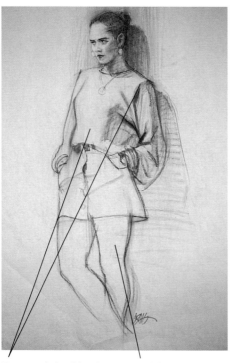

Torso and shoulders lean to the side for balance

Weight on one leg

Contrapposto
The weight of the body is supported on one leg and the wall upon which the figure is leaning.

SUPPORTING WALL
Conté and CarbOthello pencil on bond paper
22" × 17" (56cm × 43cm)

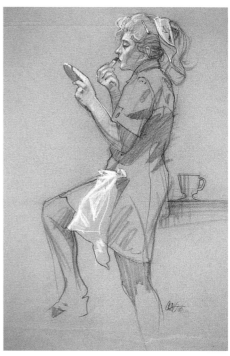

Find Interest in Commonplace Poses
Here I used the pose to suggest the casual attitude of the subject. I accented the sketchlike quality of this drawing with a few casual but thoughtful touches of white to place the focus on the activity of applying lipstick.

FRESH LIPSTICK
Charcoal and white chalk on gray Canson paper
25" × 19" (63cm × 48cm)

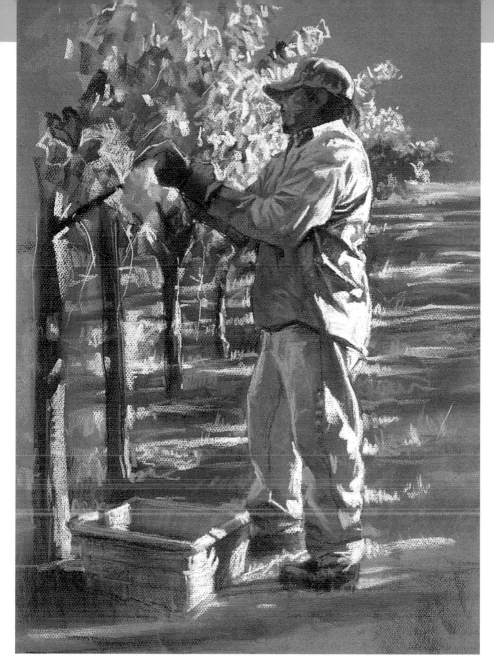

Pay Attention to the Background When Posing Models

In this figure drawing, the weight distributed between the legs is coun-
tered by the action of the arms. Figures do not exist in a vacuum, so it's
often helpful to show a figure interacting with the environment. The
background vines here are indicated in a casual and loose manner. I
added pastel over a charcoal sketch for some color and to create the
effect of sunlight.

EARLY HARVEST
Pastel and charcoal on
gray Canson paper
25" × 19" (63cm × 48cm)

POSING MODELS

Your subjects for figure drawing may be models, friends willing to pose for a short time or, for quick sketches, folks on park benches or in coffee shops. When posing models, it is important to keep gesture and balance in mind to ensure a nonstatic pose. Consider weight distribution, hand and arm positions, the direction of the upper body, the direction of the lower body and the head. The position should appear comfortable and natural, not obviously posed.

Take time to notice how people sit and stand. Such observation will help you pose models or draw figures from another resource. Candid poses are less likely to appear stiff and unnatural.

Relate the Figure to the Environment
Take note of "landmarks" on the figure and clothing to make sure that they relate properly to corresponding landmarks in the environment.

PICKING
Pen and ink on bristol paper
15" × 9" (38cm × 23cm)

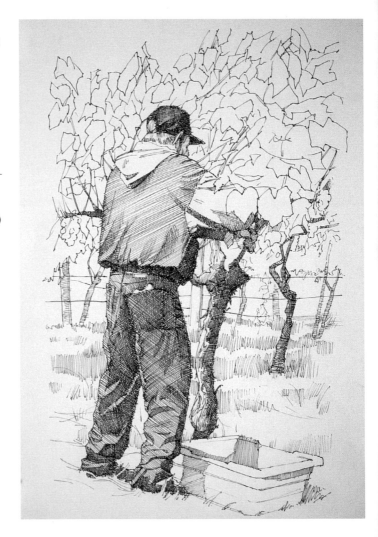

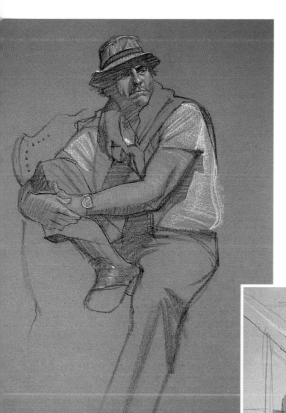

Counterbalance Your Figure

The position of the head in this casual pose counters the direction of the body and leg.

CASUALLY SEATED
Charcoal and pastel on toned Canson paper
24" × 18" (61cm × 46cm)

Use Models on Location

Try taking a model on location to sketch the figure in an outdoor environment. Look for areas where the model can feel natural, and where your work will not interrupt others.

THE SAILOR
Charcoal and white chalk on Canson paper
24" × 18" (61cm × 46cm)

BALANCE

A body always strives for balance, so any action of one part must be countered by a correspoding action in another part. For instance, if a figure leans forward, its foot must also move forward to keep the figure from falling.

Likewise, a seated figure may lean to one side, but it will need an arm for support. If a torso leans or twists to one side, the legs, hips, arms and feet will react accordingly to maintain balance.

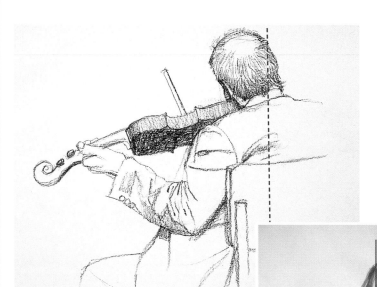

Achieving Balance
Movement requires adjustments to achieve balance. The slant of the shoulders and head is balanced by the action of the arms.

PRACTICE
Charcoal on bristol board
14" × 18" (36cm × 46cm)

DANCE ATTITUDE
Colored inks on ledger paper
24" × 18" (61cm × 46cm)

SEATED AND RECLINING FIGURES

Reclining figures also require balance. A figure rarely lies perfectly rigid. The body will always seek a relaxed position, angling the torso and hips in different directions. Arms also counter-balance the action of the hips and torso. They generally act independently of each other often taking opposing positions.

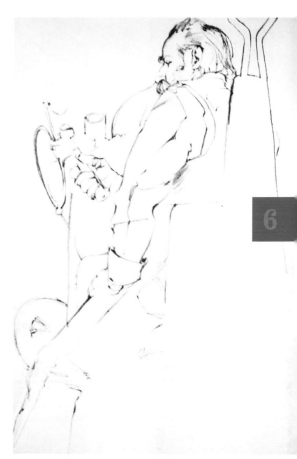

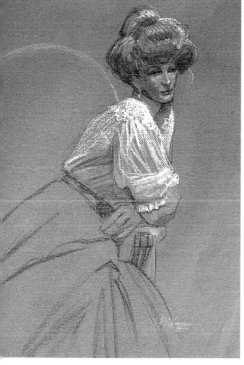

Even Static Poses Can Imply Movement
A seemingly static pose can shows a bit of movement: the shoulder is up, the head leans away and the elbow is raised.

ON THE CHOPPER
Charcoal on bond paper
22" × 17" (56cm × 43cm)

Balance in a Seated Figure
This gesture sketch demonstrates how a seated figure in an arm chair can appear more attractive. The body leans heavily to one side while the arms absorb the body's weight, creating balance.

PURELY VICTORIAN
Charcoal and pastel on toned Canson paper
24" × 18" (61cm × 46cm)

ANGLES

It is possible to break down complex movements into a more simplified statement. Just as proportions may be reduced to a set of measurements, gestures may be seen as simple angles and rhythms (page 188). Pure horizontal and vertical lines have no angle and are static, depicting no movement. Angles, however, lend a sense of motion. As a figure stands, sits, reclines or moves,

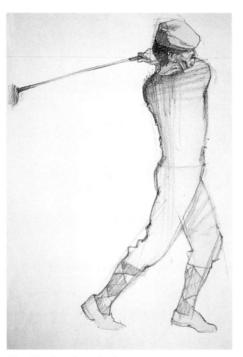 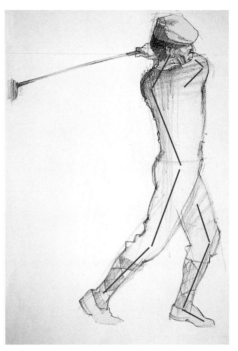

The Finale of an Action
This sketch is made up of angles which thoroughly describe the motion of the figure and the completion of a specific movement.

THE SWING
Graphite on bond paper
17" × 11" (43cm × 28cm)

angles play a major role in depicting that specific pose or action.

When sketching a gesture, it may be helpful to start with simple angles to depict the gist of the pose; then build your figure on that basic linear structure. This is easier than attempting to create accurate anatomy, clothing and gesture all at once.

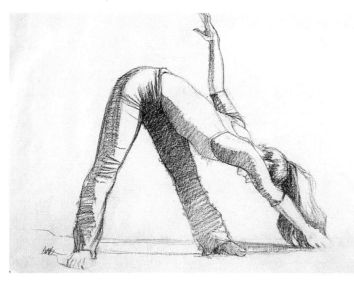

Angle Sketch
Notice that I used simple angles even for the arms and hands.

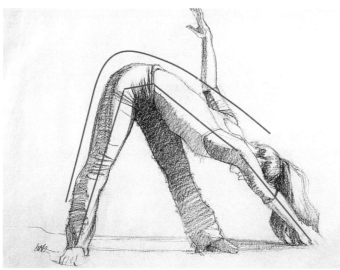

Build on the Basic Structure of Angles
This particular gesture is composed with a mixture of different angles. They oppose each other, but eventually achieve a wonderful balance and solidity.

STRETCH
Charcoal on gray drawing paper
17" × 22"
(43cm × 56cm)

RHYTHM

Visual *rhythm*, like its muscial counter-part, is created by the patterns formed through repetition. Rhythm contributes a sense of movement to a composition, so the use of rhythmic patterns is particularly helpful when drawing a figure in motion. The line of an arm may be repeated in the line of the leg, creating a diagonal that moves the eye across the drawing. Stationary figures may be given a sense of animation through the use of rhythmic patterns, such as in the repeated lines in the folds of clothing.

Rhythm Adds a Sense of Movement
Any figure may be reduced to a simple pattern of lines. The interplay of lines and angles can create a rhyth that provides a sense of movement.

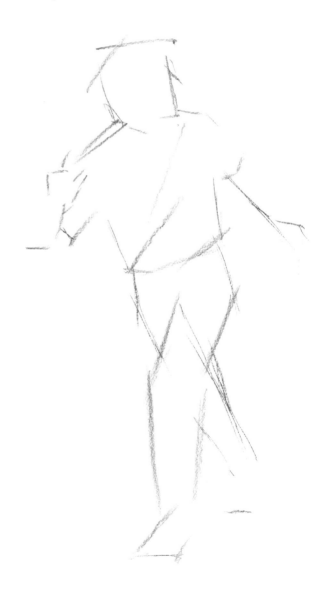

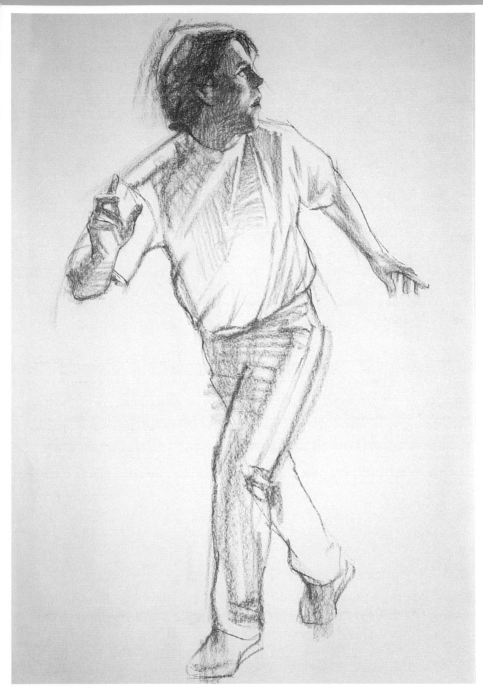

Rhythm Brings Gestures to Life
The rhythm of repeated angles results in a more animated gesture. Note the tension folds in the shirt that are created as the torso twists.

ESCAPE
Pastel pencil on bond paper
17" × 11" (43cm × 28cm)

189

POSE AND ATTITUDE

Stage actors use attitude and body language to develop their characters and enhance the story line of the play. Artists can achieve corresponding effects through the poses and attitudes they choose for their figures. Attitude can be subtle, as in a slight lift of the head, a raised eyebrow or subtle smirk, but often it is quite obvious. Attitude can involve the entire head or body, making the attitude much more noticeable.

STRIKE A POSE

Try striking the pose you are attempting to depict so you can feel the weight distribution and achieve the proper balance.

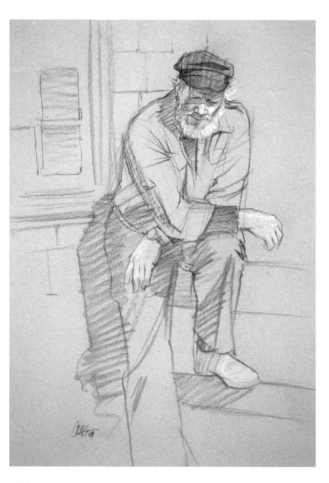

Use Pose to Indicate Attitude
The casual, relaxed attitude of this figure is reflected in the pose. Notice how the weight of the figure is distributed to achieve a sense of balance without stiffness.

ON THE DOCK
Charcoal and pastel on gray Canson paper
24" × 18" (61cm × 46cm)

RENDERING ATTITUDE

The viewer will understand the attitude of a figure if you render the pose accurately. Start by observing as many people as you can and do quick gesture sketches to capture the attitude implied by the pose.

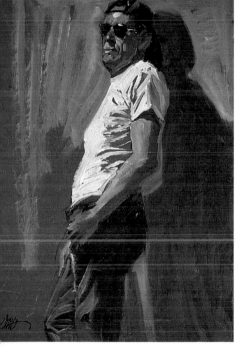

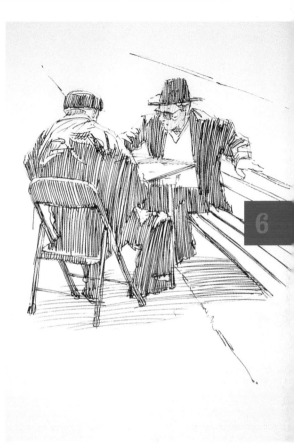

Use Lines and Angles to Render Attitude Successfully

I began this oil sketch by carefully observing the lines and angles of the figure. Once I had included the details I wanted, I added a cast shadow to add dimension to the figure leaning against the wall.

LEANING BACK
Oil on rusty toned panel
10" × 14" (40cm × 30cm)

The Way Subjects Relate to the Environment Indicates Attitude

Here I placed the figures in the center of the composition to suggest the figures' interest and competition in their game.

SKETCH FOR THE GAME
Fine-line pen on vellum
10" × 8" (25cm × 20cm)

191

CLOTHING YOUR FIGURES

When you draw clothing on your figures, do not draw every fold and detail. Focus only on those that are useful to your drawing. Use the lines of the clothing to help you show form and texture, intensify action or attitude, bring out the character of your subject and enhance the design of your drawing.

Add tone to reinforce these qualities.

Clothing offers visual landmarks, such as a sleeve length, belt line or major fold, that may be used as measuring points on which to base proportional relationships. When you draw clothing, be sure that it conforms to the figure underneath.

Use Line and Tone to Create Folds

Here the pose is accentuated by the forms and folds of the jacket. I used tonal variation to create the folds. Notice how the detail of the folds on the left sleeve enhances the design of the drawing.

A MAN IN THE PARK
Graphite pencil on ledger paper
12" × 9" (30cm × 23cm)

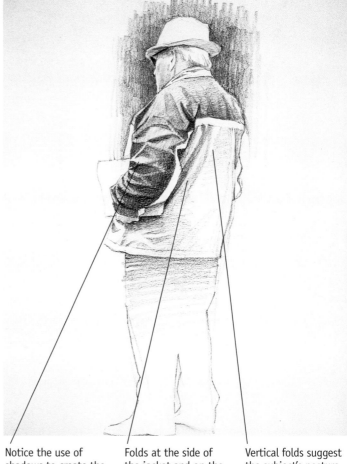

Notice the use of shadows to create the appearance of folds

Folds at the side of the jacket and on the sleeve indicate the weight of the item

Vertical folds suggest the subject's posture

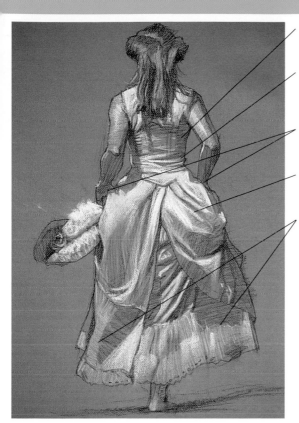

Tighter, horizontal folds wrap around the chest

Draping folds indicate the waist

Each hand is the source and destination for these folds

Folds created by the position of the hands on the clothing

Billowing folds show the figure's movement

Use Folds to Indicate Fit
Here I drew horizontal folds close together at the back to suggest the tighter fit of the top, while using wider folds to indicate the looser fit of the bottom portion of the dress.

STROLLING IN WHITE
Charcoal and white Nupastel on Canson paper
25" × 19" (63cm × 48cm)

Carefully Observe the Relation of Clothing to the Body
Notice how the shoulder seams do not exactly match up with the shoulder joint. This suggests the clothing's loose fit and the thickness of the fabric. The big, billowing folds in the sleeves add to the effect.

THE CHEF
Charcoal and white chalk on Canson paper
24" × 18" (61cm × 46cm)

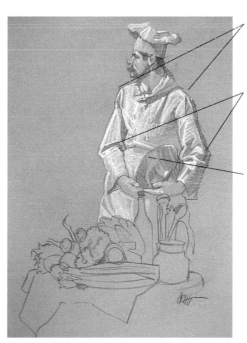

The fabric lies directly over the shoulders; folds indicate their position

Folds at the elbows to show how they are bent

A line and billowing fold indicate the waist

Drawing a Man in a Shirt and Vest

Before you begin to draw, plan for what you want to make the focal point. Here, the drawing should reflect the subject's character and the head should be the focal point. To emphasize the head, add more details and tonal variations to it than to the rest of the figure.

Materials

SURFACE
24" × 18" (61cm × 46cm) light gray drawing paper

MEDIUMS
4B charcoal pencil

White Nupastel

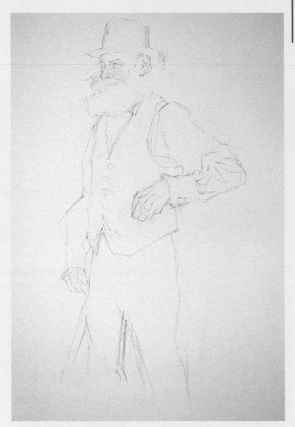

1 Sketch the Figure

Using a 4B charcoal pencil lay in a pale proportional sketch. At this point you should map out where the folds in the clothing will be. Use angles to help you render the attitude of the figure accurately.

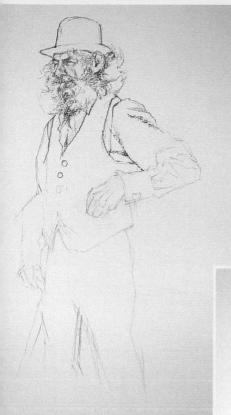

2 Add Details to Face and Clothing

On top of the sketch begin drawing for more accuracy with the 4B charcoal pencil. With the side of the charcoal pencil lead carefully add texture and movement to the clothing. Make sure your clothing conforms to the figure underneath.

Vary the type of lines you create. Keep your linework free and casual, but hold your pencil delicately so you can vary the darkness or lightness of your marks as necessary.

6

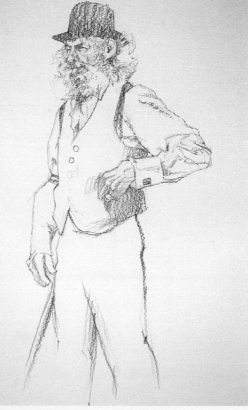

3 Add the Subtle Characteristics

With your 4B charcoal pencil, continue drawing, paying attention to the more subtle characteristics, particularly where the folds in the clothing change direction rapidly (as in the armpit or elbow). These types of folds will make your drawing look realistic.

Add in a bit of tone for accent using a light amount of shading. Don't over do it.

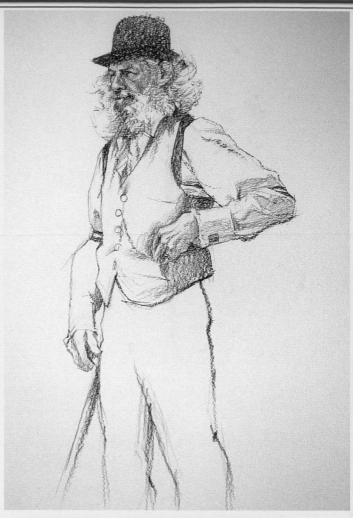

4 **Finish the Charcoal Portion of the Drawing**
Add the remaining soft darks and strong darks with the 6B charcoal pencil. Add more detail and tone to the face to make it the focal point.

5 **Add Light and Dark Accents**
Using white Nupastel and casual strokes, add the lightest lights to the face, beard and hat. Add a little bit to the shirt as an accent. Add in any dark accents that need reinforced with the 6B charcoal pencil. The contrast will give your drawing focus.

6

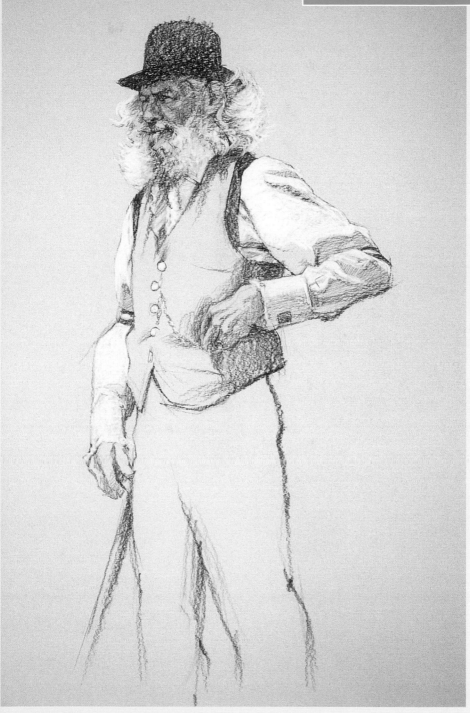

ALL DRESSED UP
Charcoal and Nupastel on gray drawing paper
24" × 18" (61cm × 46cm)

DRAWING the NUDE FIGURE

Drawing the human figure can be a challenge because we have such a strong sense of what constitutes a "correct" representation. Some knowledge of the underlying anatomy (bones and muscles) and the accurate rendering of proportions and balance can make your figures appear quite believeable.

Sketching from a nude model in a class or workshop offers the opportunity to study the human body in various poses.

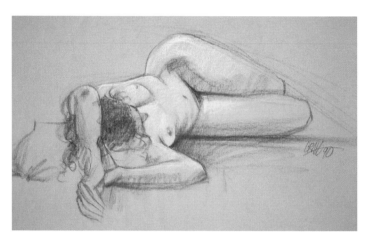

Try Conté on Toned Paper

The nude has been a popular drawing subject for centuries. Toned surfaces with sanguine Conté and white chalk are great mediums for drawing nudes.

ON HER SIDE
Conté pencil and Nupastel on toned Canson paper
16" × 24" (41cm × 61cm)

Proportion and Balance Are Important for an Accurate Nude Drawing
This oil sketch of a reclining figure required close study and keen attention to proportions. Get the basic lines right before adding anatomical characteristics.

RESTFUL POSE
Oil on panel
16" × 20" (41cm × 51cm)

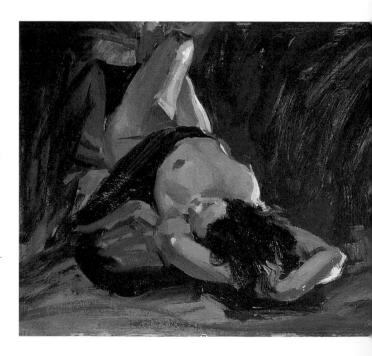

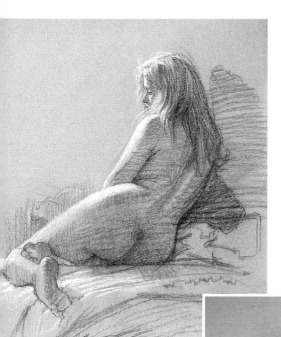

Try Sketching Different Poses

This unique pose, with the foot coming toward us, offered interesting changes in balance and direction.

NUDE POSE
Charcoal and white chalk on Canson paper
22" × 17" (56cm × 43cm)

An Understanding of Anatomy is Important for an Accurate Nude Drawing

A study of the underlying skeleton and musculature of the body will help you render nude figures more convincingly. Pay attention to how the anatomy influences the gesture.

SEATED NUDE
Conté pencil and white charcoal on toned charcoal paper
24" × 18" (61cm × 46cm)

Draw a Nude Figure

When drawing from a nude model, it is crucial to pay special attention to proportional accuracy. Study the pose for angles and reference points (page 124), taking note of shape and contour as they relate to anatomy and structure.

Materials

SURFACE
25" × 19" (63cm × 48cm) piece of sand-colored Canson paper

MEDIUMS
4B and 6B charcoal pencil

White Nupastel

OTHER
Facial tissue

Kneaded eraser

Workable spray fixative

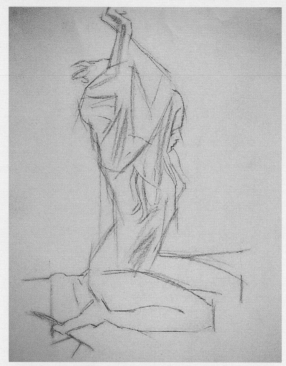

1 Draw a Proportional Sketch
Using a 4B charcoal pencil, lay in a proportional sketch on the smoother side of the paper. Check the angles and reference points (such as the distance from the shoulder to the elbow) to ensure accurate proportions.

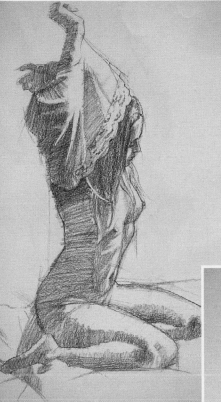

2 Add the Shadows
Lay in shadow tones on the figure with the 4B charcoal pencil. Use the side of the lead so the tones will be somewhat soft. Begin to map out the scalloped edge of her skirt, which you will build upon later.

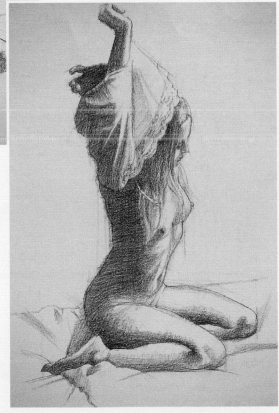

3 Darken the Shadows
Once you are satisfied that the tones are in the appropriate areas, use a 6B charcoal pencil to darken the initial tone that you laid down. Go over all the dark areas (including those in the skirt) with the 6B charcoal pencil.

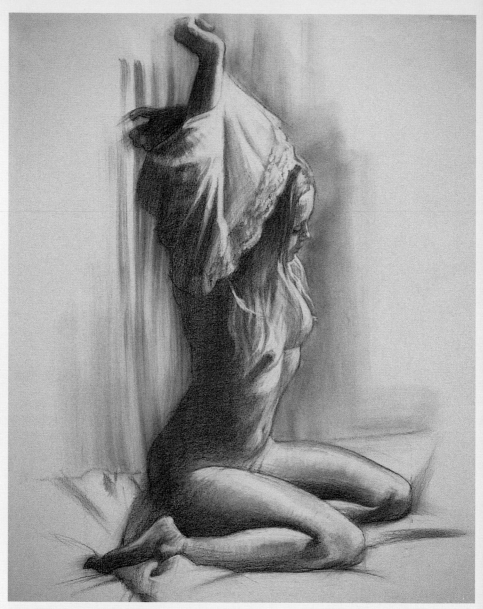

4 Soften the Edges

Lightly smear and soften the charcoal with a piece of facial tissue. Be delicate with the smaller, more intricate areas, such as the fingers, but don't be afraid of smearing into the highlights.

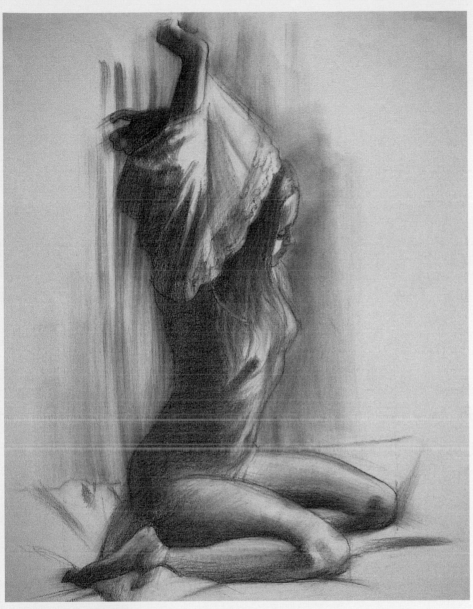

5 Lift Out the Lights

Mold your kneaded eraser into a point. Use it to delicately pick out the lights, clean up and clarify the edges around the lights, and to carefully soften the edges where necessary.

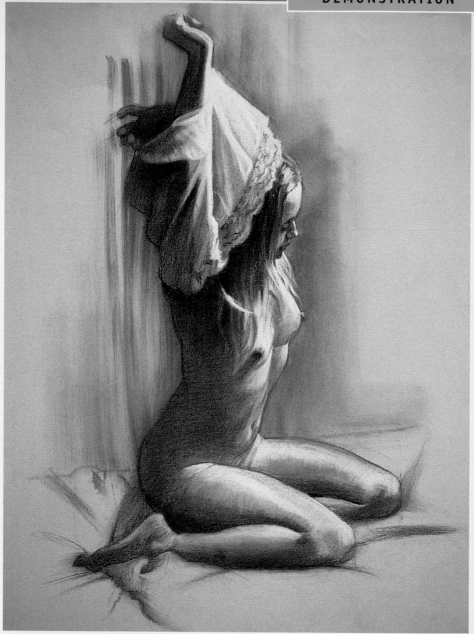

6 Add the Lightest Lights and Finish
Spray the drawing with a light coat of workable fixative and let it dry. Use white Nupastel to further brighten the lights on the figure. Layer another coat of white for the brightest lights.

SEATED GESTURE
Charcoal and Nupastel on toned Canson paper
25" × 19" (63cm × 48cm)

DRAWING HEADS and FACES

The head is usually the focus of a figure drawing, so it demands a lot of attention from the artist. Drawing heads and faces is a great challenge. It requires careful observation of proportions and values, as well as sensitivity to your materials. Heads have a variety of subtle tone changes. A delicate touch will allow the features to emerge gradually from these subtle changes in value and texture.

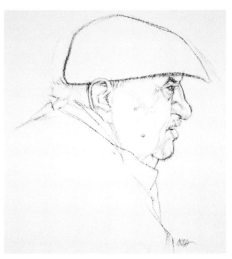

Practice Drawing Profiles First

Drawing the profile of the face is easier than drawing the front view. Once you have the outline of the profile, you can use it as a template for the face.

Drawing the Head Accurately Requires Attention to Detail

This young girl's head is modeled to demonstrate the forms of the head. The darker reddish hair frames the lighter flesh tones. There are two light sources, one toward the front and from the right and a brighter one far to the left.

LINDSAY
Oil on toned canvas
16" × 12" (41cm × 30cm)

205

PROPORTIONS in DRAWING FACES

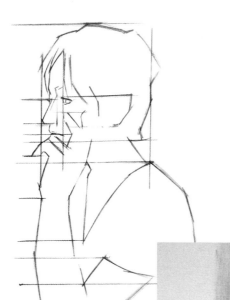

Achieving accurate facial proportions in drawing requires planning, either with careful thought or tick marks. Pay careful attention to the characteristics of your subject, looking for visual landmarks from which to measure proportions.

Plan Ahead for Accurate Facial Proportions
Here you can see the relationships of features, anatomy and clothing. I drew this diagram over the initial sketch to plan and measure facial proportions.

Accurate Proportions Lead to Realistic Drawings
Here, I used tones to build upon my carefully laid out proportional sketch.

ANNA
CarbOthello pencil on ledger paper
16" × 20" (41cm × 51cm)

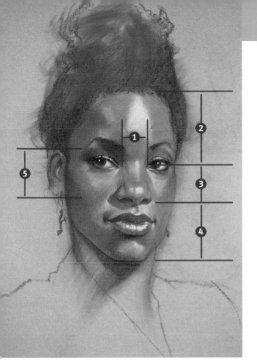

Basic Face Proportions

Once you understand these basic proportions, drawing the face becomes much easier. Mastering the head truly helps round out an artist's drawing skills.

① One eye length between each eye

② From the crown of the head to the eyes is half the length of the head

③ The nose is about halfway between the eyes and the chin

④ The mouth is about halfway between the nose and the chin

⑤ The ear extends from the brow to the nose

IT'S IN THE EYES
CarbOthello pencils on toned Canson paper
24" × 18" (61cm × 46cm)

6

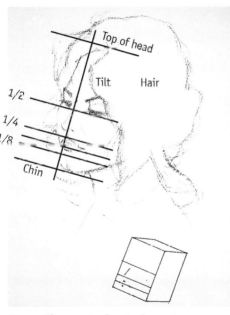

Use a Diagram to Create Accurate Proportion

This diagram demonstrates proportions for the drawing as angles on the slightly tilted head. Notice how I started out with cube, then shaped it into a face.

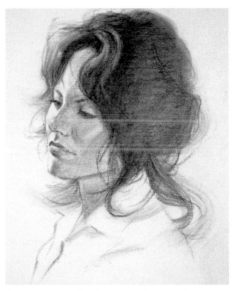

Consider the Angle and Point of View

The tilt of the head and the view's vantage point (at, below or above the subject's eye level) will affect the placement and proportions of features.

LOOSE HAIR
Charcoal on ledger paper
11" × 14" (28cm × 36cm)

DRAWING EYES AND EYEBROWS

To successfully draw the eyes, you need to know their basic structure. Use a pale sketch to lightly indicate the placement, shape and structure of the eyes. If your initial sketch looks correct, develop the darker tones and marks. Follow these steps when drawing eyebrows.

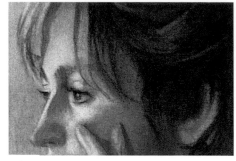

Basic Eye Structure
The eyeball fits into the eye socket and the eyelids wrap over the eyeballs. To individualize the eyes, vary the shape and proportions of the eye sockets and eyelids.

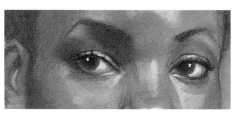

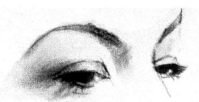

Make the Eyes and Eyebrows Work Together
Variations in the shape of the eyelids and the placement of the iris can make the eyes communicate different things. The eyebrows also reflect emotions; make sure they reflect the same feelings as the eyes.

Mouths can be a challenge to draw. They require the rendering of subtle details to look accurate. Understanding the basic structure of the mouth will help you render a realistic mouth. As you draw, remember that the lips protrude slightly from the face creating soft tonal variations in the skin and surrounding structures. Because of this, it's just as important for you to pay as much attention to the area around the mouth as to the mouth itself.

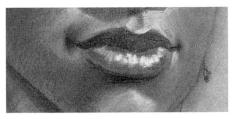

The Basic Features of a Mouth

The mouth is made up of many different planes. The junctions between planes can be either sharp or rounded.

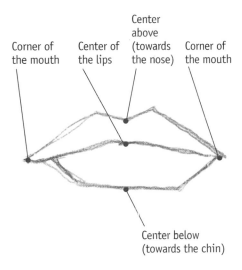

Corner of the mouth Center of the lips Center above (towards the nose) Corner of the mouth

Center below (towards the chin)

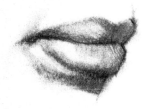

Three Quarters View of a Mouth

Notice how the upper lip slightly protrudes and the bottom lip slightly recedes. Applying principles of perspective and modeling to the key landmarks of the mouth will make it look more convincing.

Key Landmarks for Drawing the Front View of the Mouth

Use these landmarks to draw the front view of the mouth. To change the character of the mouth, simply change the spacing of these landmarks. If you're drawing the mouth from another point of view, adjust the landmarks accordingly to render perspective and proportion accurately.

209

DRAWING NOSES

Unlike the mouth, the nose is a very solid structural feature. It has a definite front, top, sides and bottom. Draw the nose with either subtle or firm strokes to give each nose individuality. Always develop the nose slowly. Indicate the nostrils once the overall form is rendered.

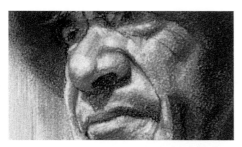

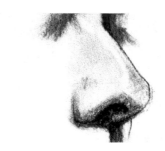

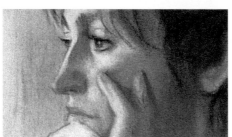

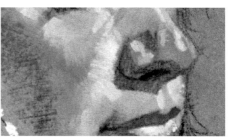

Profile of Noses
Noses come in a variety of shapes and sizes. Start with the basic shape, then add the details.

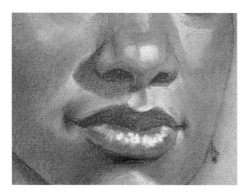

Make the Mouth and the Nose Work Together
The facial structures that surround the mouth are connected to the nose, too. Make sure your drawing reflects this connection.

DRAWING EARS

With all its folds and wrinkles, the ear seems like a difficult part of the face to draw, but as long as you get the basic shapes right, it isn't that hard.

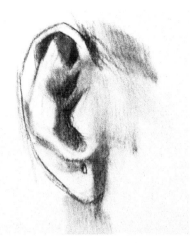

Basic Shape of the Ear

Ear on the Face

Three-Quarters View of the Ear

MALE FACES

The basic shape of the head is the same for men and women, but the details make them different. Male facial features tend to be more pronounced.

When drawing a male face, your value contrasts and structural definition will be more obvious.

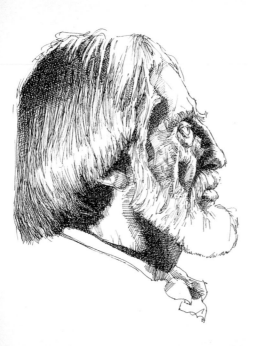

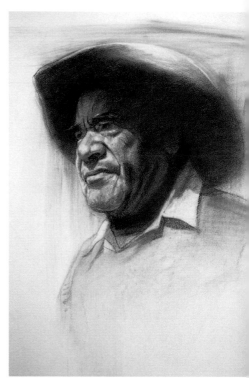

Make Male Features More Defined
I used crosshatching to build up the features for this profile.

BEARD PROFILE
Fine-line technical pen on cast-coated paper
16" × 12" (41cm × 30cm)

Use Variation to Add Character
The values on this head are built from light, reddish tones to deep browns in the rich darks. I used a tissue to smear the tones together and a kneaded eraser to recapture lighter details. I also added some crisp line work for contrast.

A HAT FOR SHADE
CarbOthello pencil on toned Canson paper
20" × 16" (51cm × 41cm)

Drawing a Male Face

The features on male faces tend to be more pronounced than those of females. In this demonstration, the way the model's head is posed shows off the nose structure, eye sockets and firm jawline. I also adjusted the lighting to amplify the form and create a lot of shadows and midtones on the face. Two lights illuminate the head, a dominant light from the front and another light in the back.

Materials

SURFACE
24" × 18" (61cm × 46cm) white drawing paper

MEDIUMS
4B and 6B charcoal pencils

OTHER
Facial tissue
Kneaded eraser
Workable spray fixative

1 Sketch the Subject

With a 4B charcoal pencil, lightly sketch the contours of the face. Be sure to note the widths and lengths of the features and the relationships among them.

GET THE POSE YOU WANT

Position models first, then observe them from different angles and directions. This will help you find a pose that suits you.

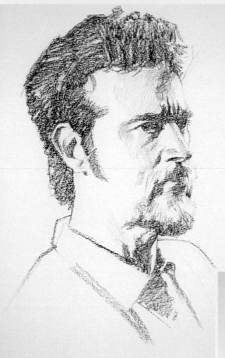

2 Add Details With Tonal Variations

Lay in the tonal variations on the head with a 4B and a 6B charcoal pencil. Use the 4B for lighter tones such as the shadow on the face and neck, and the 6B for the darker shadows and hair. Don't worry about the rough texture of the tones.

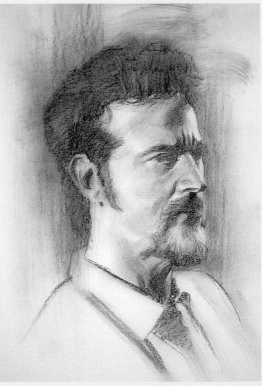

3 Blend the Tones

Use a tissue and your index finger to smudge the tones into the lights and the background. The darker background tones will provide a contrast with the lighter face. If necessary, darken the hair and other areas again and smudge with your index finger.

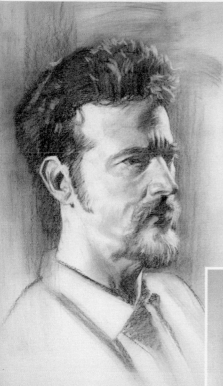

4 Lift Out the Lights
Use a kneaded eraser to lift out the lights and model the highlights on the form. Clean up any areas that are lit and defined with your kneaded eraser.

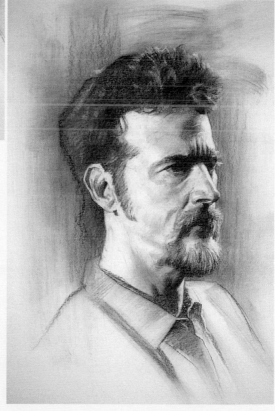

5 Add the Finishing Details
Spray the entire drawing with a light layer of workable fixative and allow it to dry. Use a sharp 6B pencil to refine areas that need more definition. Add darker tones where you see them, such as around distinct feature changes in shadow. Smudge if necessary.

THE NEAR PROFILE
Charcoal on white drawing paper
24" × 18" (61cm × 46cm)

FEMALE FACES

Drawing female heads generally requires more refined modeling than drawing males. Women's features are usually softer and more delicate than those of men. This requires a more sensitive touch with your medium. It is best to understate the value changes, especially in the beginning stages of the drawing. Dark accents should be minimal and applied only at the end.

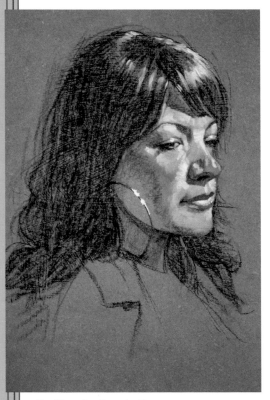

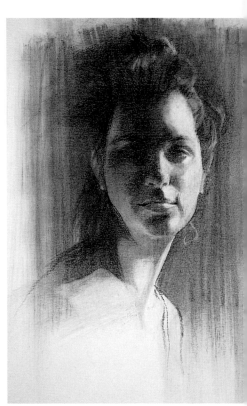

Profile of a Female Face
Notice that the nose in this profile drawing is more rounded and the lips are fuller than those of most male faces.

Front View of a Female Face
This side-lit head is more in shadow than in light. Within the shadows, there are subtle details of features and reflected light on the jaw line.

LAUREN
Charcoal on drawing paper
16" × 12" (41cm × 30cm)

Drawing a Female Head

A drawing of the female head has softer and more subtle forms than that of a male head.

Materials

SURFACE
24" × 18" (61cm × 46cm) drawing paper

MEDIUMS
Selection of CarbOthello pencils in light, medium and dark earth-tones

OTHER
Facial tissue

Kneaded eraser

Workable spray fixative

6

1 Sketch the Subject
Using a light earth-tone CarbOthello pencil, lightly sketch the contours. Pay careful attention to the proportions of the facial features.

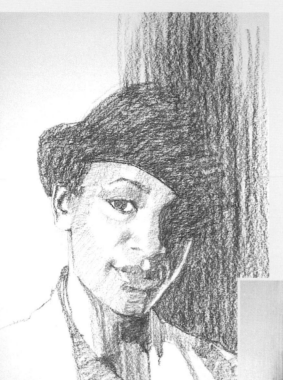

2 Add Shadows

With a medium-value earth-toned CarbOthello pencil, lay in a basic shadow tone on the head and into the background. Apply this color to the dark local tone of the hat.

3 Blend the Tones

Use a piece of facial tissue to lightly smudge and smear the tones. Use your index finger to smudge the smaller areas.

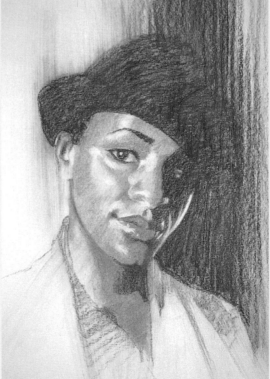

6

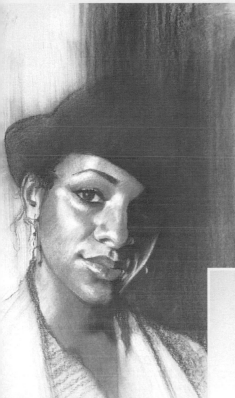

4 Apply Darker Tones and Lift Out the Highlights

Add darker tones with a darker CarbOthello pencil. Blend these colors together. Lighten, clarify and refine where necessary with a kneaded eraser.

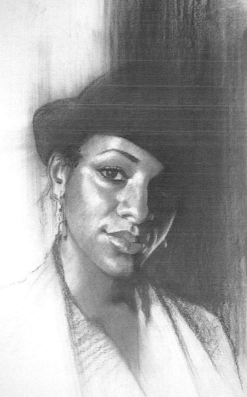

5 Complete the Drawing

Apply a light layer of workable fixative to the drawing and allow it to dry. With the darkest CarbOthello pencil, lay in the darker toned areas and blend them with a tissue. Apply linear accents for refinement.

THE DERBY
CarbOthello pencil on drawing paper
24" × 18" (61cm × 46cm)

CARICATURES

Caricature drawing is an exaggerated, usually humorous type of portraiture. It concentrates on the distinctive features and shape of the head. This takes careful observation of an individual's unique visual characteristics. Exactness in proportion is not a priority. Instead, the proportions, shapes and sizes of the features are exaggerated to add a degree of humor to the drawing. If the eyes slant down, if the nose is broad, if the cheekbones are pronounced, if a lip

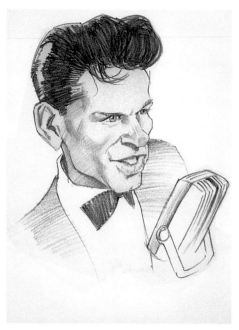

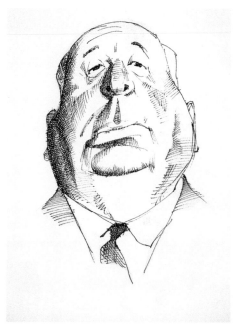

Focus on the Head
Here I exaggerated the youthful bone structure and pushed the expression of the eyebrows, nose and mouth to create this caricature of a youthful Sinatra.

Emphasize the Subject's Unique Features
The rounded, bony cranium is offset by the chubby cheeks. A unique mouth configuration is quite noticeable as depicted through exaggeration.

YOUNG SINATRA
Eagle draughting pencil on vellum
10" × 8" (25cm × 20cm)

MR. HITCHCOCK
Fine-line technical pen on vellum
10" × 8" (25cm × 20cm)

is large, or if the face is narrow, you can overstate these features, creating an amusing likeness.

Caricatures are fun to do. Get friends and relatives to pose for you. Although caricature drawing may seem challeng-ing and difficult at first, you can achieve successful results with repetition and practice.

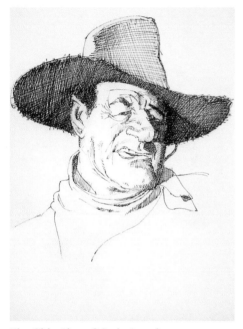

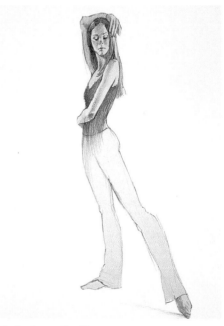

The Objective of Caricature is Exaggeration, Not Accuracy
The mouth position and overall facial expressioin are overstated in this case. The outfit adds to the character.

THE DUKE
Fine-line technical pen on vellum
10" × 8" (25cm × 20cm)

Caricature of a Figure
Dance poses can be enhanced through elongation of the torso and legs. This exaggerates the graceful gesture of the pose. In some ways, this type of caricature borders on cartooning.

DANCE POSE
Graphite pencil on ledger paper
14" × 11" (36cm × 28cm)

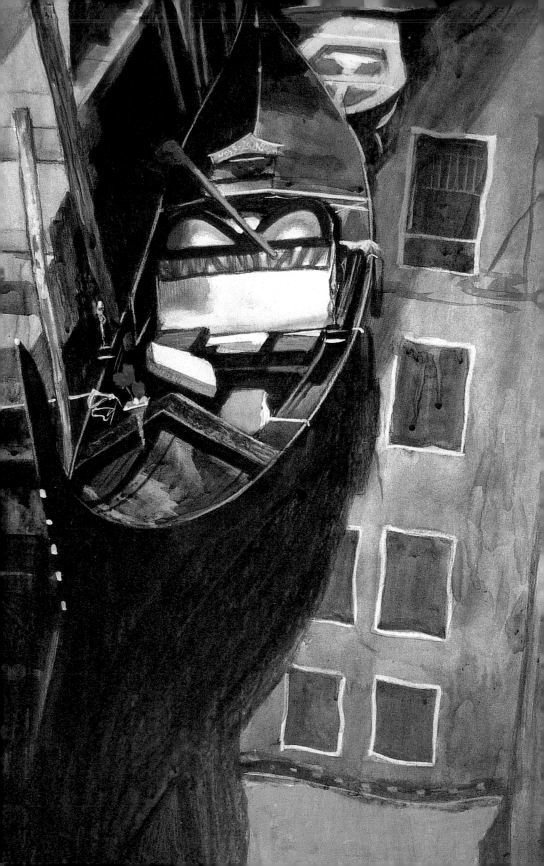

Mixing
MEDIUMS

When you begin an artwork, it isn't necessary to have an exact plan. Drawing is an adventure that involves reacting to whatever happens along the way. Sometimes a simple pen sketch seems to cry out for the added tone and texture of an ink wash. Mixing mediums allows the artist to explore such possibilities and provides greater variety to help him or her achieve the desired effect.

You may find that you have an affinity for a particular medium, but when you employ other mediums, you may find they give your drawing more substance and vitality. Experimentation is good for any artist. It will open your mind to possibilities that had not occurred to you before—and it's a lot of fun!

LONE GONDOLA
Graphite, acrylic, colored pencil and gesso on illustration board
20" × 16" (51cm × 41cm)

MIXED-MEDIA DRAWINGS

Mixed-media drawings are those in which more than one medium has been used. A mixed-media drawing may include only two simple mediums, or it may invlove several mediums working together as a complex unit to create a

uniquely varied work of art.

There are no specific rules for mixing mediums. Mediums such as pen, ink and watercolor, or charcoal, oils and pastels are traditionally mixed, but you don't have to limit yourself to these.

Add Other Mediums to a Pen Sketch
I first captured this pose with a marking pen, then I added the shapes and modeling with various other mediums.

GYPSY
Fine-line marker, acrylic, pastel and oil pastel on toned board
30" × 16"
(76cm × 41cm)

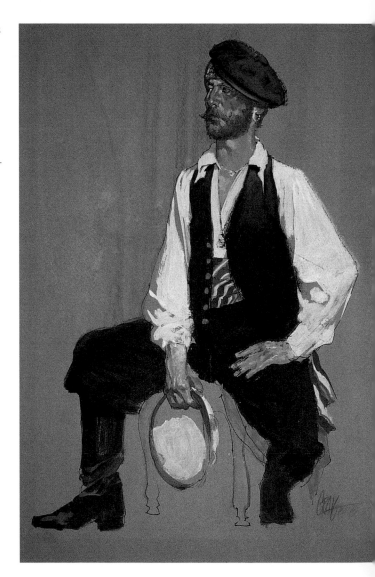

The varied qualities of the different mediums used in a piece may be very obvious, or they may be barely noticeable. The variety of possible combinations is almost endless. Be aware, however, that a water-based medium should not be used on top of an oil-based medium because it will not adhere. Other than this, anything goes. Sensitivity to the characteristics of various mediums and their inherent possibilities is truly the only requirement.

Watercolor Over Ink
Here I applied loose watercolor tones over an ink line drawing. I used the watercolors to convey the interior of this train station.

TO TRAINS
Ink and watercolor on hot-pressed paper
10" × 14" (25cm × 36cm)

MIXED-MEDIA POSSIBILITIES

As mentioned previously, the possibilities for mixing mediums are just about endless. You can combine wet mediums with dry, apply mediums to nontraditional surfaces, or use mediums in uncommon ways.

Keep your mind open as you decide what should remain "as is" and what should be changed or built upon with another medium. Perhaps one medium should be used only as an accent rather than as a dominant characteristic. Be careful, but do not be afraid of new effects. Have fun, use your basic drawing skills and always think of what is possible.

Keep Your Mind Open to New Possibilities
The basis for this drawing is a charcoal line-and-tone drawing. Then I spattered it with ink, acrylics and pastels to add color and lighten the accents.

AT THE TABLE
Charcoal, ink, acrylic and pastel on toned Canson paper
17" × 22" (43cm × 56cm)

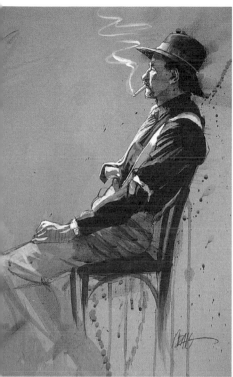

Mix Mediums for Exciting Effects

This drawing began as a loose charcoal sketch from a model. A quick layer of ink wash (pale to dark) was added, as was a little spatter. Whites were applied with white charcoal and acrylic to complete the effect.

WHITE SUSPENDERS
Charcoal, ink wash and acrylic on toned matboard
20" × 15" (51cm × 38cm)

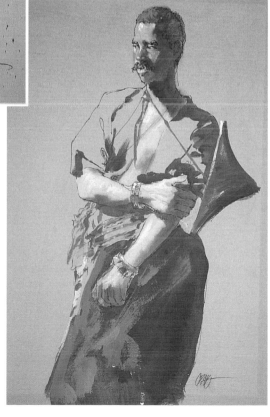

An Example of Ink Line and Wash

The model showed up in a unique costume that inspired me to create a quick drawing with ink line, transparent washes and a little opaque gouache.

STRANGE OUTFIT
Fine-line technical pen, ink wash and
gouache on toned mat board
18" × 12" (46cm × 30cm)

LAYERING

Layering, or applying one medium on top of another, is an integral part of creating mixed-media drawings. Certain layering combinations work better than others; for example, pastel works better on watercolor than pencil on oil.

Layering different mediums can create effects that cannot be achieved in any other way. Layers may be applied as transparent washes, glazes, spatters or sprays that allow lower layers to show through, or they may be thick, opaque films that obscure the layers underneath. Experimentation will help you understand the characteristics of each medium, how it can be used most

Layering is an Important Technique for Mixed-Media Drawings
Here I applied an acylic wash over the entire pen drawing, which set the mood for the opaque acrylics. The colors all relate closely to the blue mood.

FORMAL MUSICIAN
Fine-line marker, acrylic and gouache on coldpressed illustration board
20" × 16"
(51cm × 41cm)

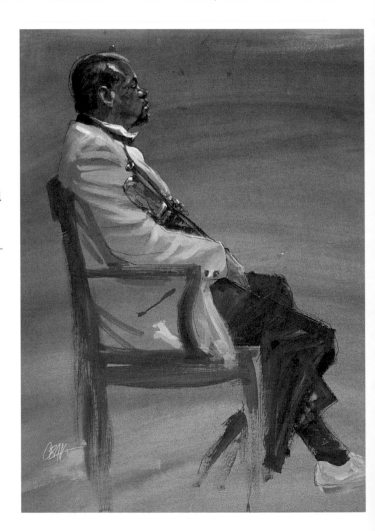

effectively, and how it interacts with other mediums. Experience will help build your confidence in choosing mediums that will complement each other. Don't forget that sometimes happy accidents occur, so keep your mind open to new possibilities.

LAYERING DIFFERENT MEDIUMS

A porous surface such as ledger, bristol or watercolor paper works best for this medium.

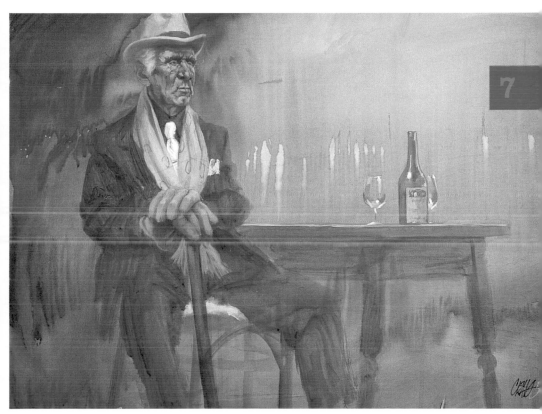

Let Color Dominate
This full-color drawing mixes washes with minimal opaque acrylics allowing color to play a prominent role in the overall effect.

THE MAN
Graphite and acrylics cold-pressed illustration board
20" × 30" (51cm × 76cm)

LINE-AND-WASH DRAWINGS

Line-and-wash drawings are a common mixed-media combination. Many mediums may be used for the line and many may be used for the wash, opening an enormous array of possibilities for the final drawing. Part of the fun of this approach is the potential for exploration and discovery. Finding new combinations to achieve different effects is stimulating and inspirational.

Remember that the color and value of the line are as important as the color and value of the washes in the overall palette. The ratio of line to wash is at the discretion of each artist. The application of a wash may complement an understated line drawing, but it could just as easily overwhelm it. The trick is deciding when enough is enough.

LAYER WASHES

To avoid using too much wash, start with as little as possible. You can add more gradually if you feel it is necessary.

Line With Light Wash
In this case, the brown pen drawing already worked well, so just a bit of wash was needed.

STREET CLARINETIST
Marker and ink wash on bristol paper
14" × 11" (36cm × 28cm)

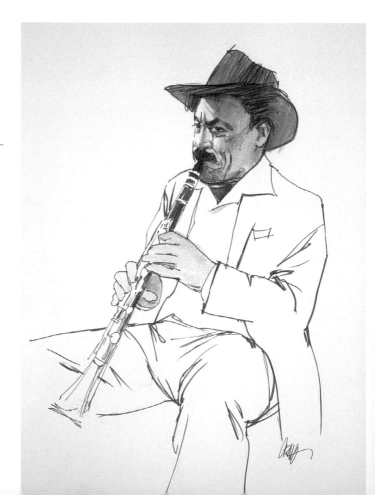

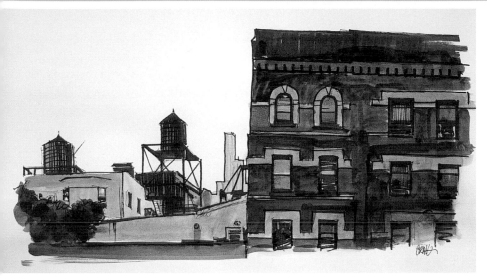

Line With Layers of Wash

This black marker drawing looked rather hollow and incomplete until several layers of washes were added, unifying the images.

A NEW YORK VIEW
Marker and ink on ledger paper
9" × 5" (23cm × 13cm)

Line Accented by Wash

A casual, loose charcoal sketch forms the basic image. A slight amount of oil (thinned with odorless turpentine) was washed onto it. Small touches of pastel were added for highlights.

HOLDING THE MASK
Charcoal pencil, oil and pastel on gray Canson paper
18" × 22" (46cm × 56cm)

BLACK-AND-WHITE WASH DRAWINGS

In black-and-white line-and-wash drawings, the black line becomes the skeleton on which gray to black washes are applied, fleshing out the image with a variety of values. Strong dark tones finish off the drawing, giving it form and solidity.

Any pen with black permanent ink can be used as a drawing medium. For the best results use a fine line pen, which will allow the tonal washes to dominate. Washes may be black watercolor, black acrylic or black ink. Thin these with water for the lighter grays,

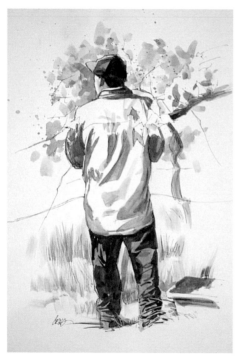

Strong Darks With Light Wash
The types of wash application vary from a dry brush effect in the weeds to splashing on the tone in the vines, but all are relatively light. The contrast between strong darks and lights brings out the figure.

VINEYARD FIELD WORKER
Fine-line technical pen and ink wash on bristol board
4" × 11" (10cm × 28cm)

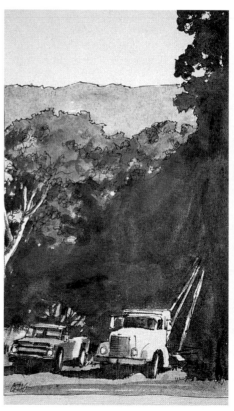

Watercolor Wash
The asymmetrical composition gives strength and emphasis to the two trucks occupying the bottom of the picture.

TWO TRUCKS
Fine-line technical pen and watercolor
on canvas paper
12" × 8" (30cm × 20cm)

and work the washes in layers from light to dark for optimum control. Be sure to plan where to leave the white of the paper for the highlights.

The way you handle the brushwork can add a lot of character. Everything from soft strokes to splash stains can be used to great effect, but is the initial pen sketch that establishes the proportions, perspective and dynamics of the composition.

Ink Wash
Dark, watery masses surround the white house which is defined by firm dark shapes. Loose strokes of light gray indicate the foreground weeds.

CHARLESTON BEACH HOUSE
Fine-line technical pen and ink wash on bristol board
11" × 14" (28cm × 36cm)

Using Line and Wash Together

Line and wash looks best when one serves as the accent to the other. In this demonstration the line supports the washes you will make. The washes will cover a range of gray values to black and will carry the bulk of the piece.

Materials

SURFACE
18" × 12" (46cm × 30cm) piece of cold-pressed water-color paper

MEDIUMS
No. 2 graphite pencil

Fine-point pen with permanent black ink

Ivory Black watercolor

White gouache

BRUSHES
Nos. 2, 4 and 6 sable rounds

1 Sketch in the Scene
With your graphite pencil, sketch the scene to establish the basic composition and perspective. Go over the pencil drawing with a fine-point pen with permanent black ink. Correct any obvious problems at this point.

2 Add a Few Washes, Saving the Light Areas

The perspective line drawing will act as your guide. Study the values in your subject and, using Ivory Black watercolor with a soft no. 4 or no. 6 sable round, apply the washes. Be sure to work from the focal point out, saving the whites and lighter tones. Remember you can always darken later, so try not to go too dark at this point.

3 Apply the Larger Dark Masses

Lay in some of the larger dark masses as they move away from the area of focus. Remember to leave the whites and lighter areas alone.

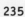

235

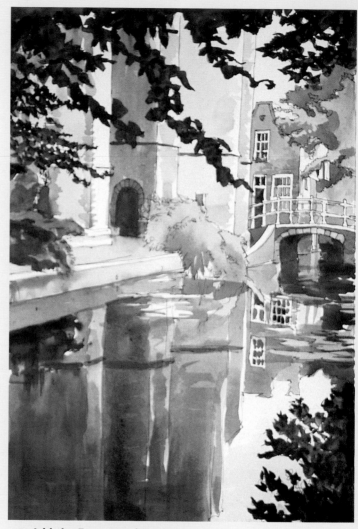

4 Add the Foreground Masses

Next put in the foreground masses using a dry brush effect with your no. 2 sable round. These masses are darker in value. Let the edges of the foreground shapes be fairly rough. It is these active, erratic edges that really makes this piece work.

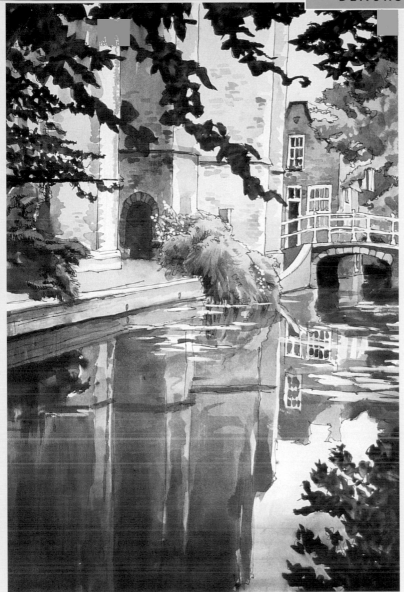

5 Finish

Finally, with a no. 2 sable round and white gouache, enhance the smaller white areas, such as the reflections and details on the water surface. Check to see if any dark details are needed.

A DELFT CANAL
Ink and watercolor on cold-pressed watercolor paper
18" × 12" (46cm × 30cm)

Mixing and Layering Mediums

Usually working with mixed mediums involves layering. Using a gessoed surface to work on offers additional technical possibilites because gessoed surfaces are not easily penetrated by layers and washes. As you layer, keep in mind that you are building your piece through several stages and that each medium will bring new possibilities to your work.

Materials

SURFACE
20" × 16" (51cm × 41cm) piece of cold press illustration board

MEDIUMS
4B or 6B charcoal pencil

CarbOthello pencils in warm earth-tones

Prismacolor Pencils Cream, pale yellow and white

ACRYLIC PAINTS
Burnt Sienna

Sap Green

Terra Rosa

Yellow Ochre

White Gesso

BRUSHES
No. 3 sable round

1-inch (25mm) flat

OTHER MATERIALS
Acrylic matte medium

Paper towels

Workable spray fixative

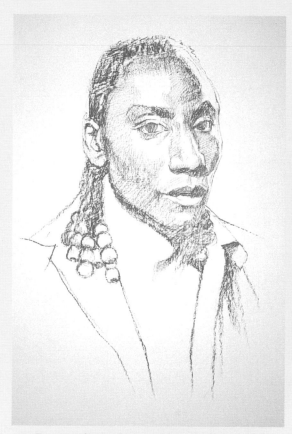

1 Prepare the Surface and Sketch the Subject
Prepare a piece of cold-pressed illustration board with a coat of gesso. With a very light, warm earth-tone CarbOthello pencil, sketch your subject using a tonal effect. Pay close attention to proportions of the face.

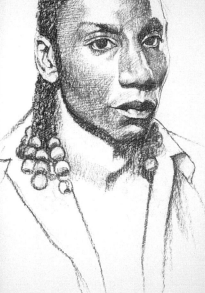

2 Add Darker Tones and Acrylic Matte Medium

Layer a dark sanguine CarbOthello pencil followed by a very dark brown to create a couple of layers of darker tones. Spray with workable fixative, and add a layer of acrylic matte medium. Let this dry for about twenty minutes.

7

3 Add Color and Texture to the Surface

Mix up an earth-tone acrylic wash using Yellow Ochre, Sap Green and Terra Rosa or Burnt Sienna. Use a 1-inch (25mm) flat to wash the acrylic mixture over the entire surface. Blot the surface a little with a paper towel. Use your finger to spatter the surface with a little water to create some texture. Repeat this if necessary and let it dry for about thirty minutes (use a hair dryer if you want to speed up the drying process).

4 Refine the Dark Areas and Add the Highlights

Reinforce the lines and tones with the earth-tone CarbOthello pencils. Use a 4B or 6B charcoal pencil to deepen the dark tones. Spray with a light coat of fixative and let it dry for about five minutes. Begin to work up the highlights with the cream, pale yellow and white Prismacolor pencils. Use a very sharp pencil and a very delicate touch. Press harder for more intense tones, building layers gracefully.

5 Brighten the Highlights

Using a no. 3 sable round with thinned gesso, highlight the brighter whites. Don't try to get the brightest white with your first application. Use three to four careful layers, letting the gesso dry ten minutes between layers. Add any necessary darks with a charcoal pencil.

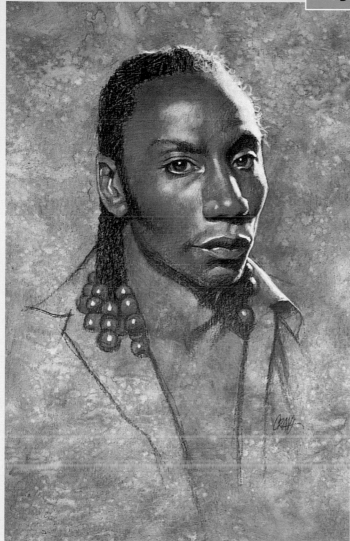

6 Add the Finishing Details

Use the earth-tone acrylic mixture of Yellow Ochre, Sap Green and Terra Rosa or Burnt Sienna to layer a pale wash over the light tones facing you. Make the subject stand out against the background with a subtle wash of white gesso added to the right of the head and into the chest. Add white opaque accents to the shirt collar and hair.

HEAD BEADS
Acrylic, charcoal, CarbOthello pencil and gesso on illustration board
20" × 16" (51cm × 41cm)

COLOR in MIXED-MEDIA DRAWINGS

Color in mixed-media drawings is based on the hues avilable in your chosen medium. Paints, inks, pastels and colored pencils all come in a wide range of colors. The palette for your drawing using color may involve a wide spectrum or it may be limited, with only a few color accents.

Before beginning a drawing, decide whether you want the color to dominate or merely enhance the composition.

This will influence to how much of

Variation in Color and Medium
Although there is a lot of color variation in this piece, the strong lights (both opaque acrylic and pastel) keep it unified.

SOUTHERN COLONEL
Fine-line pen, acrylic and pastel on cold-pressed board
14" × 18"
(36cm × 46cm)

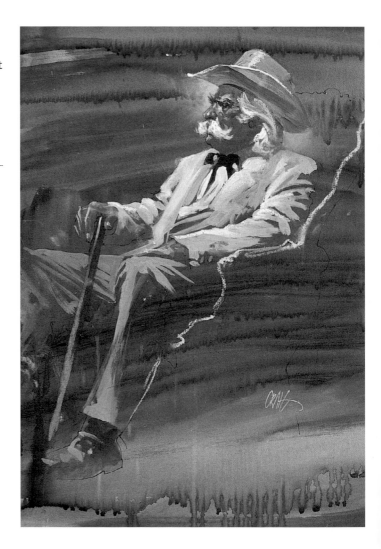

the drawing surface is to be covered or left exposed. In many cases, the tone of the surface becomes an integral part of the art serving as one of the values in the composition. You must also keep in mind that each color has a value. In a drawing (as opposed to some paintings), the value contrasts should dominate rather than the color. As important as color may seem to any piece, value takes precedence; color simply adds spice.

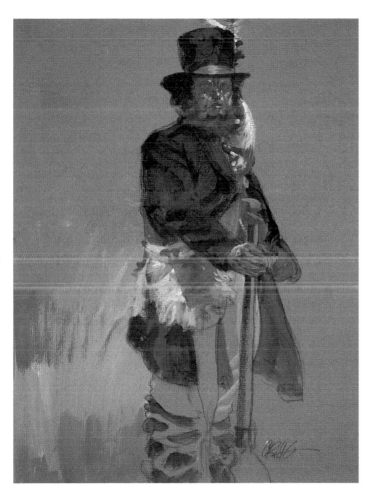

Color Detail as Accent
This quick figure sketch done with pen and acrylic, shows most detail in the face.

LIVIN' IN THE MOUNTAINS
Ink and acrylic on toned mat board
20" × 16"
(51cm × 41cm)

Drawing a Boat in Full Color

To prevent your surface from warping as the gesso dries, use a large brush such as a 3-inch (75mm) house painting brush and some water to wet the back of the surface. Then, turn the surface to the front and apply a layer of diluted gesso. The sides will dry at the same time and will prevent any warping. It will take the surface about thirty mintues to dry, so prepare your surface in advance.

Materials

SURFACE
20" × 16" (51cm × 41cm) cold-pressed illustration board

MEDIUMS
Gesso

HB or no. 2 graphite pencil

Acrylic matte medium

Selection of Prismacolor pencils in black, cream, dark brown, pale yellow, pale lavender, grayish green and white

ACRYLIC PAINTS
Alizarin Crimson

Burnt Umber

Cadmium Red Light or Medium

Sap Green

Ultramarine Blue

Yellow Ochre

Titanium White

BRUSHES
Nos. 2 or 3 and 7 or 8 sable round

3-inch (75mm) house painting brush

OTHER MATERIALS
Workable spray fixative

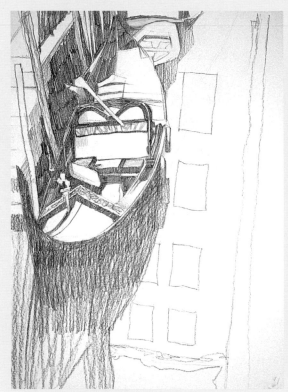

1 Prepare the Surface and Sketch the Subject
Prepare a piece of cold-pressed illustration board with a light coat of gesso and the 3-inch (75mm) house painting brush. Use an HB or no. 2 graphite pencil to sketch your subject, paying attention to perspective and proportion. Add the tones loosely. Spray with a light layer of fixative and let this dry.

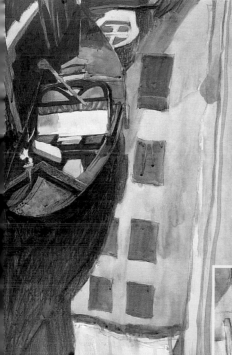

2 Lay In the Base Colors

Lay out a palette of acrylic Yellow Ochre, Cadmium Red Light or Medium, Alizarin Crimson, Ultramarine Blue, Sap Green and Burnt Umber. Use a no. 7 or no. 8 sable round to lay in the basic tones over your drawing. This may take a couple of layers to get dark enough. If the washes do not go on neatly, add a little matte medium, which help your washes adhere to the surface.

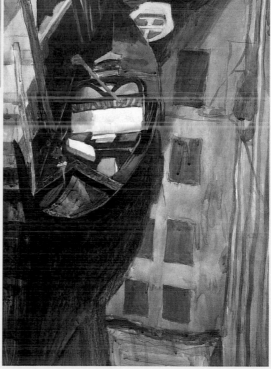

3 Darken the Colors by Layering

Add another layer of paint to deepen the dark tones and strengthen the colors and values. At this stage, it may seem a bit too dark, but you want deep color because the paint will dry lighter. Use as many layers as necessary to achieve dark colors.

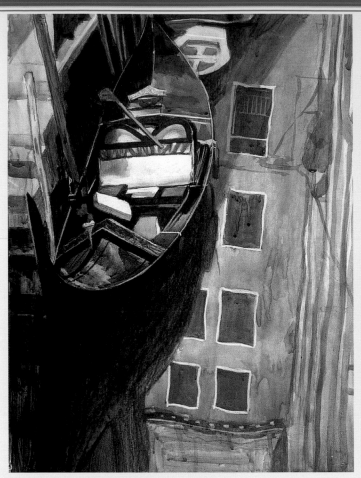

4 Add Line Detail and Tonal Gradations
Sharpen the Prismacolor pencils. Use the lighter colors to add some linear detail and tonal gradations where necessary. Coat the surface with a thin layer of matte medium and let it dry.

5 Complete the Drawing
Study the subject to determine whether any washes may be needed, such as for the building reflections on the right. Mix together Titanium White, Yellow Ochre and Burnt Umber. Add some gesso for opacity. Use a no. 2 or 3 sable round to add details to the window reflections. If any dark, crisp line accents are necessary, use the brown or black Prismacolor pencils.

LONE GONDOLA
Graphite, acrylic, colored pencil and gesso on illustration board
20" × 16" (41cm × 51cm)

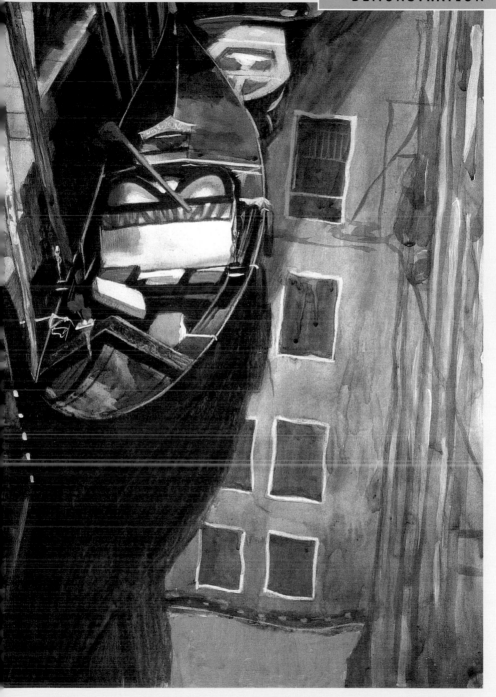

WORKING with LIMITED COLOR

Sometimes too much color can get in the way of a good composition, overwhelming other elements as the hues compete for attention. One way to avoid this problem without sticking strictly to black, white and shades of gray is to work within a limited color palette. Such a palette may include only one color in addition to black and white, or it may consist of a few related hues from the same area of the color wheel. A palette could also be limited

A Little Color Can Go a Long Way
Here I let the costume dictate the color palette of this drawing. The pink rose is subtle but relatively bright.

BLACK, WHITE AND PINK
Fine-line technical pen, ink and acrylic on toned illustration board
20" × 16" (51cm × 41cm)

to two or three contrasting colors, such as red and green.

Another way to limit the color in your drawing is to use only subtle, low-intensity hues such as browns and blue-grays. You can also use brighter, more intense colors in limited ways, accenting only a few small but strategic areas. By limiting the color of your drawing, you can emphasize lines, values or other elements and achieve some very satisfying effects.

Use a Subtle Palette
This simple charcoal line drawing is subtly accented with some dark and light oil paints and pastels in very limited colors.

LEANING
Charcoal, oil and oil pastel on toned Canson paper
22" × 17" (56cm × 43cm)

A Limited Palette of Earth Tones
Here I used a white Prismacolor pencil as an accent to the palette of earth tones I employed for this drawing.

WORK OUT CLOTHES
Mixed medium on gessoed illustration board
22" × 17" (56cm × 43cm)

Drawing With Limited Color

Another interesting suface for drawing is a cast-coated surface (also known as chrome coated). Use this slick, non-porous surface with oil-based mediums like oil pastels. Oil pastels are great for loose, spontaneous drawings.

Materials

SURFACE
18" × 24"(46cm × 61cm) cast-coated paper

OIL PASTELS
Black

Burnt Sienna

Burnt Umber

BRUSHES
Nos. 4 and 6 hog-bristle filbert

No. 8 or 10 sable flat

OTHER
Turpentine

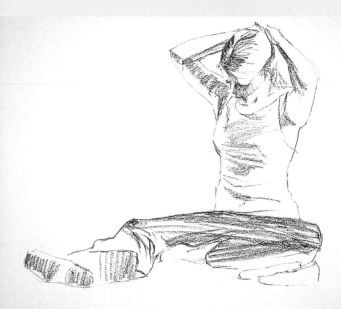

1 **Sketch the Subject**
Use a black oil pastel to lightly sketch in your subject, paying careful attention to proportion and gesture. Apply light pressure for a pale sketch.

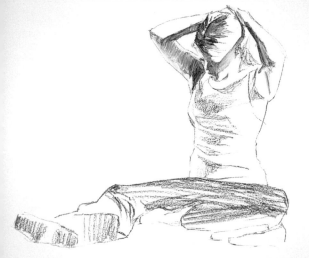

2 Smooth Out Some of the Rough Tones

With a no. 6 and a no. 4 hog-bristle filbert and a slight amount of turpentine, carefully smear some of the shadow tones. Do this delicately. The slick surface will not absorb the tone, so you can push it around with very little turpentine.

7

3 Keep Building and Smearing Tones

Continue smearing tones, but do not overdo it. If the sketch seems too pale and more tone is needed, let it dry a bit before adding more oil pastel. Then continue with the brush.

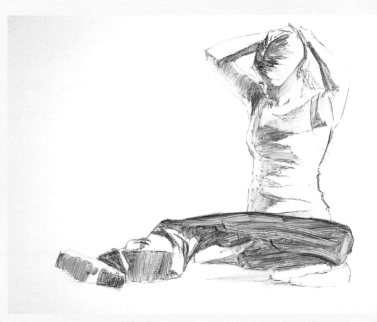

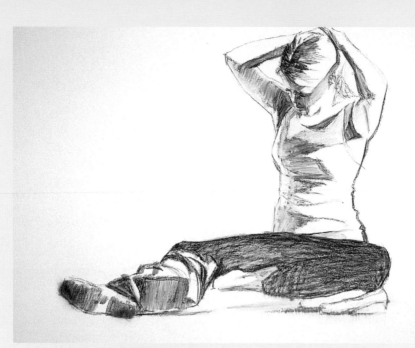

4 Add Refining Accents

Let the turpentine dry for 5-10 minutes, then add more dark accents and strengthen the linework where necessary. Again, smear the oil pastel with turpentine where desired.

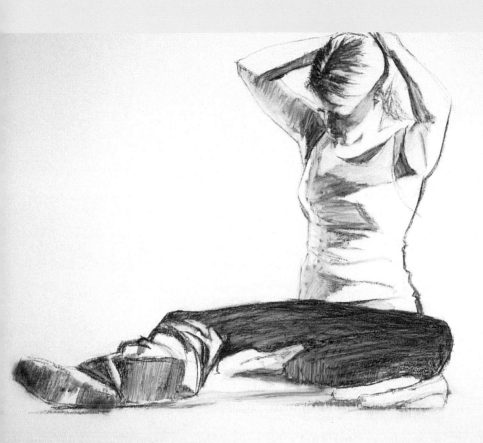

5 Add Color and Finishing Details

Once the surface is dry, you can decide where to add color. Apply some subtle warm hues with the Burnt Umber and Burnt Sienna oil pastels. Apply these toward the head with a light touch. Use a no. 10 or a no. 8 sable flat with a slight amount of turpentine and a very delicate touch to slightly smear these tones. Finish any necessary line work and dark touches. The sketch should appear loose and spontaneous.

FIXING HER HAIR
Oil pastel and turpentine on cast-coated paper
18" × 24" (46cm × 61cm)

Drawings as PRELIMINARY STUDIES and as FINISHED ART

Artists draw for many reasons. Many do it purely as a form of recreation or relaxation. Some draw for practice, so that they may continually improve. Artists who work in other mediums such as painting and sculpture draw studies to help them plan compositions and work out problems before beginning a larger piece. Others find satisfaction in producing a drawing as a finished work of art.

FLOWING RIBBONS
Charcoal and oil on toned mat board
17" × 12" (43cm × 30cm)

PRELIMINARY STUDIES and SKETCHES

Many drawings are created as preliminary studies for a painting. Others may be sketched directly on the canvas as a foundation for the painting to be completed on top.

Preliminary drawings usually focus on a particular principle or problem. They may concentrate on value patterns or lighting issues. They may be concerned with proportions, perspective or the placement of elements within the frame. They allow the artist to experiment with different formats before committing to a specific surface. Preliminary studies are often smaller than the final work so that they may be done more quickly.

Value Sketch for *Morning Reisling*
This is a quick charcoal sketch I did to develop the value pattern and compositional content for the painting on page 257.

REISLING SKETCH
Charcoal on vellum
4½" × 9" (11cm × 23cm)

Final Painting

Since I had already addressed issues of design and value in the sketch, I was free to explore the warm indoor palette I used for my finished painting.

MORNING REISLING
Oil on panel
15" × 30" (38cm × 76cm)

8

SKETCH to SOLVE PROBLEMS

Preliminary sketches do not have to be detailed, and they don't even have to be entirely accurate. It may be enough for your sketch to roughly establish the shape and placement of major forms if you plan to work out the exact proportions and measurements on the final surface itself.

Composition Sketch
Darks, midtones and lights create this composition of tonal shapes representing trees, water and brush.

LANDSCAPE REFLECTIONS SKETCH
Graphite on ledger paper
5" × 7" (13cm × 18cm)

Value Sketch
A pattern of lights, darks and a few midtones establishes the values for this sketch done with simple tones and shapes.

TETON ELK SKETCH
Graphite on vellum
5" × 7" (13cm × 18cm)

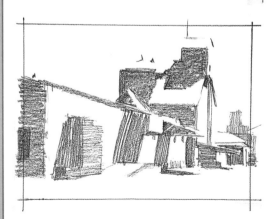

Sketch of Perspective
Perspective is the basis for this architectural sketch. Shadows define the structure of the value pattern.

STRUCTURE OF LIGHT AND SHADOW SKETCH
Graphite on ledger paper
5" × 7" (13cm × 18cm)

SKETCH to ENSURE SUCCESS

Preliminary drawings—whether rough or detailed, small or large, on scratch paper or on the final surface—are crucial to successful painting. Use them to plan your design, to solve specific problems, to answer the question: *Will this work?* Preliminary drawings can also boost your confidence so you can paint with greater ease and conviction.

MEDIUMS FOR SKETCHES

You may sketch with a brush, graphite or charcoal depending on what particular painting medium you plan to use.

Initial Sketch

Final Painting
The final oil painting was begun with a matching grid as depicted by the outside tick marks, then drawn and painted over.

CHARDONNAY HARVEST TIME
Oil on canvas
36" × 48" (91cm × 122cm)

Drawing on the Finished Surface

When drawing on the finished surface prior to painting, accuracy in proportion and placement are paramount.

Materials

SURFACE
20" × 16" (51cm × 41cmm) cold-pressed illustration board

MEDIUMS
2H and HB graphite pencils

ACRYLIC PAINTS
Alizarin Crimson

Burnt Umber

Cadmium Red Light

Hooker's Green

Terra Rosa

Titanium White

Ultramarine Blue

Yellow Ochre

BRUSHES
1-inch (25mm) flat

No. 8 bristle filbert

Nos. 3 and 6 synthetic or sable round

OTHER MATERIALS
Gesso

Workable spray fixative

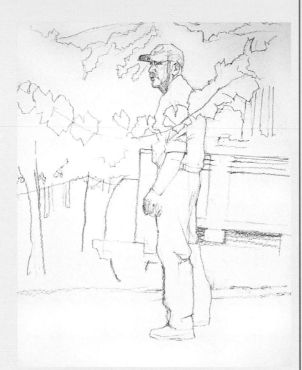

1 Prepare the Surface and Sketch the Composition

Coat the illustration board with gesso and allow it to dry completely. Using a 2H graphite pencil, lightly sketch the composition. Check the proportion and shapes of the sketch then go over it with the HB graphite pencil to strengthen your initial drawing. Use the HB graphite to add more definition to the face. Give the sketch a light coat of workable spray fixative and let it dry.

2 Add Undertones and Background Colors

With a thin mixture of Yellow Ochre and Burnt Umber and a 1-inch (25mm) flat, apply light (watery) coat of tone to the entire surface. Once this is dry, lay in Burnt Umber and Ultramarine Blue to the background with a no. 8 bristle filbert. This will create subtle variations between the warm and cool tones. The values may not be dark enough, but another layer or two later will take care of that.

8

3 Add Local Tones

Add a little bit of water to the local tones to give them a transparent quality. Use the no. 8 bristle to lay in local tones. Think of these tones as a scrubby-wash, which you apply by rubbing the colors in with your bristle brush. Wash in warms and cools in the head. Add a little Titanium White with a touch of Ultramarine Blue to lay in the shirt shape. Another layer of darks may be necessary in some areas.

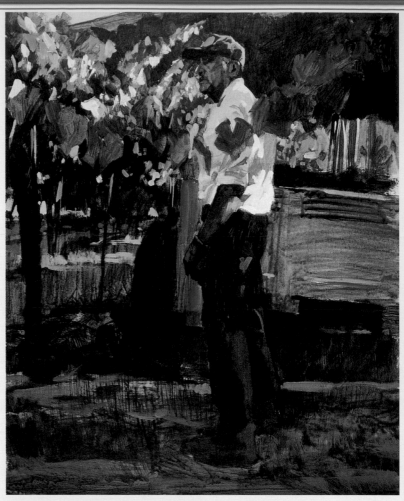

4 Add the Lights

Switch to the no. 6 and no. 3 rounds and begin adding lighter opaques mixed with Titanium White. Refine the face and add filtered light on the shirt, and some on the pants. Add lights and color variations on the foliage and ground.

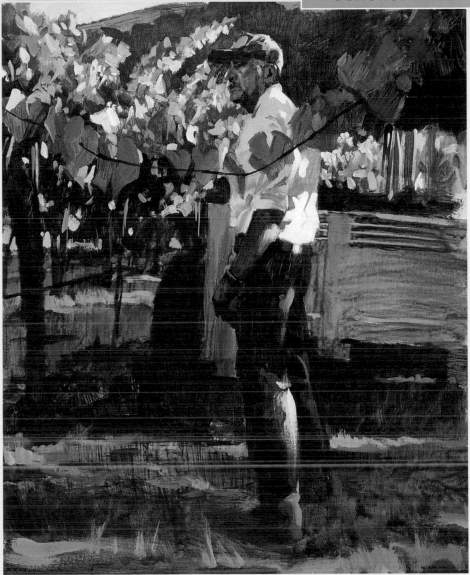

5 Add the Finishing Details

Finally, use the no. 6 and no. 3 rounds to strengthen the lights on the shirt, hat, legs and ground. A cool bright on the cart helps, as does color variations on the ground. Finish with bright lights on the foliage, the foreground leaves and stem. A pale cool white sky should be opaqued in at the end.

THE FOREMAN
Graphite, acrylic and gesso
on illustration board
20" × 16" (51cm × 41cm)

APPROACH and STYLE

Some painters begin a project with a few very rough sketches, while others prefer to work from a more refined preliminary drawing. Your approach to preliminary work and the style of the resulting drawings will depend on your personality and modes of thinking. If you like to work freely without too many constraints, your preliminary sketches are likely to be rough, emphasizing broad contours and value contrasts. If you feel more comfortable

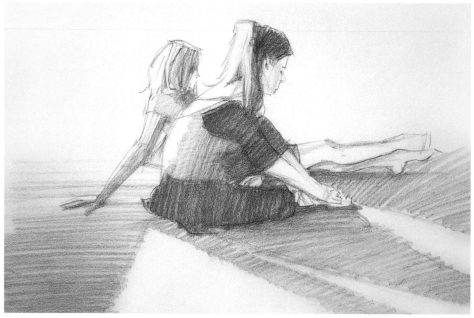

Sketch for *Changing Shoes*
In this sketch I worked out the positioning of the two figures, their relationship within the composition and the shadows.

DANCE GIRLS SKETCH
Graphite on ledger paper
9" × 12" (23cm × 30cm)

working withing established bound-
aries, you will probably prefer creating
more detailed drawings that focus on
precise positioning and proportions. A
graphtic artist who thinks more in
terms of lines and shapes will create
different prliminary sketches from a
painter who is more interested in cap-
turing impressions with light and shad-
ow. Either approach can lead to a
successful painting; strive for the style
that feels natural to you.

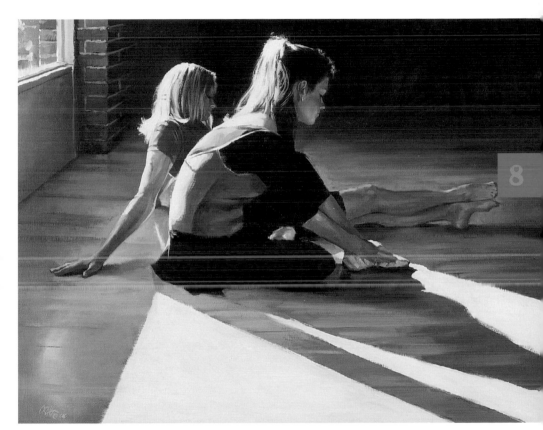

A Preliminary Drawing Forms a Foundation

Because I had already determined where to place the figures and the
shadow forms in my initial sketch, I was free to concentrate on the back-
ground values and color scheme when I began to apply the paint. Whether
you choose a rough sketch or a more refined drawing for your foundation,
this preliminary step will lead to a more successful painting.

CHANGING SHOES
Oil on canvas
24" × 36" (61cm × 91cm)

COLOR STUDIES

In many instances it may be helpful to do a small color study before beginning a painting. A color study can help you decide whether to use the full spectrum or a more limited palette, and choose the most effective hues for creating a certain mood. You can use color studies to explore value relationships and try out compositional ideas before committing paint to your final surface.

Color studies do not have to be done in the same medium as your final painting. Pastel, acrylic and watercolor can be used for quick sketches prior to working in oils.

Color Study for *Alone in the Woods*
For this quick pastel sketch, I chose a yellow, green and earth-tone palette, accented by the dark moose.

ENVIRONMENTAL MOOSE STUDY
Pastel on Canson paper
11" × 14" (28cm × 36cm)

Finished Painting Based On the Color Study
Once the palette has been established by a color study, the artist can concentrate on value relationships and technical aspects such as brushwork in the final painting.

ALONE IN THE WOODS
Oil and pastel on Masonite panel
22" × 24"
(56cm × 61cm)

Working With Matte Medium

When applying oils to paper, prepare the surface with a coating of matte medium. Oils will cause your paper to deteriorate, but matte medium will prevent this from happening.

1 Prepare the Surface and Sketch the Subject
Coat the surface of the mat board with acrylic matte medium using a no. 10 flat bristle. Rough in a loose, quick sketch of the figure with a 6B charcoal pencil.

Materials

SURFACE
17" × 12" (43cm × 30cm) toned mat board

MEDIUMS
Acrylic matte medium
6B charcoal pencil
Wash tone

ACRYLICS
Alizarin Crimson
Burnt Umber
Naples Yellow
Terra Rosa
Titanium White
Ultramarine Blue
Yellow Ochre

BRUSHES
No. 8 filbert bristle
No. 10 flat bristle

OTHER MATERIALS
Turpentine

8

MATTE MEDIUM

Matte medium provides a protective seal to your surfaces. Matte medium dries with a matte finish, but it prevents the oils from deteriorating the surface, giving your surface an archival quality.

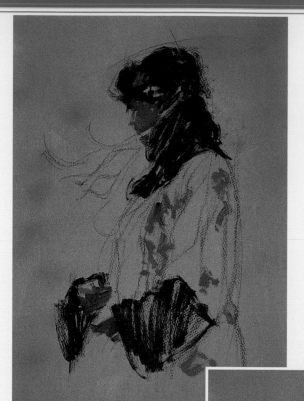

2 Add the Darker Tones

Use a no. 8 filbert bristle to freely indicate the darker tones where you see them. Add some turpentine to your paint to loosen it up. Don't be too concerned if you don't get complete coverage. For now, just lay the tones in and leave them as is. Focus on how the darker tones relate to each other. The darkest part will be the hair, so all other darks should be lighter in comparison.

3 Add Details

Using the same brush, quickly apply a few lines to suggest flowing ribbons. Use wamer tones like yellows, reds and browns. Use the same colors to add a loose wash tone for the scarf shape. For the coat, lay in a base color of Yellow Ochre mixed with Titanium White and apply it in a pattern detail.

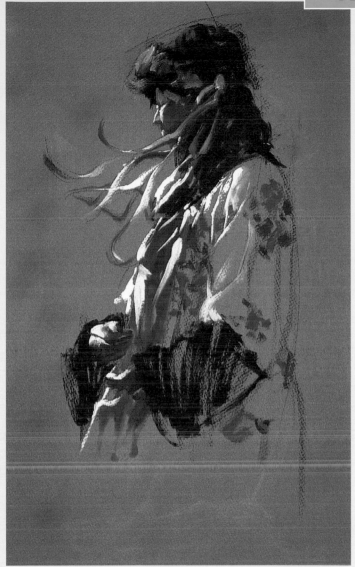

4 Add Highlights

Mix Titanium White, Yellow Ochre and Cadmium Red and apply this mixture to the light areas with the no. 8 filbert. Use rapid yet careful strokes that employ the entire arm.

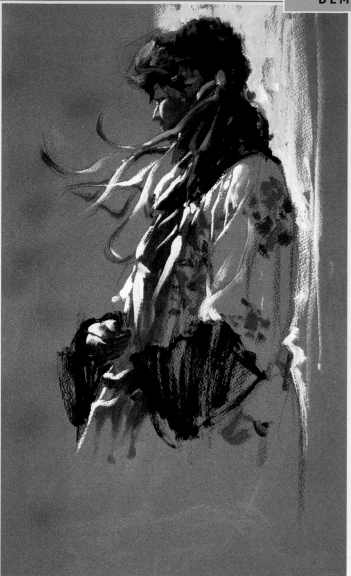

5 Add the Background
Since the tone of the board is incorporated in the figure, mix up a lighter color of Titanium White with a little Ultramarine Blue and apply it in strokes that use your entire arm with the no. 8 filbert to part of the background. By adding this to the background, you will bring out the figure more.

FLOWING RIBBONS
Charcoal and oil on toned mat board
17" × 12" (43cm × 30cm)

ROUGH SKETCHES

The purpose behind a rough sketch is to try out a compositional idea before committing to a more finished piece of art. The scale of rough sketches may be quite small, just big enough to allow the artist to get an idea of how to bal-ance forms and values. Rough sketches also give the artist an opportunity to explore options without investing a great deal of time or wasting expensive materials.

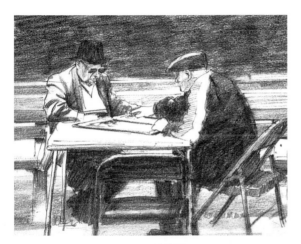

Rough Sketch for *It's Your Move*
I drew a quick line sketch with ink to try out the placement of different elements. I used loose charcoal tones to indicate the values. While I sketched, I simplified the background so it would contrast with the fore-ground activity.

PLAYERS
Fine-line pen and charcoal on vellum
8" × 10" (20cm × 25cm)

8

Sketches Save Time and Energy During Painting
When I began to paint, I followed the value patterns and simplified background I had worked out in the sketch, making only subtle adjust-ments. The colors, edges and brushwork became my primary concerns.

IT'S YOUR MOVE
Oil on canvas
24" × 30" (61cm × 76cm)

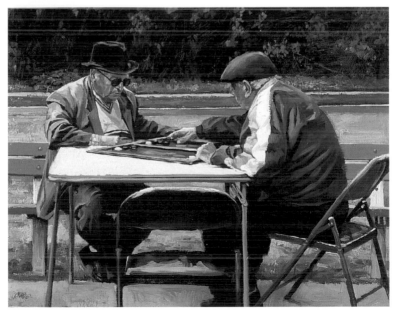

Create a Painting From a Drawing

When I do a full color interior painting, I prefer to use a warm color pallet. I use blues and greens to tone down some of the warms. When working with a pallet like this, unify the tones by adding a subtle, warm color to your surface first.

Materials

SURFACE
20" × 16" (51cm × 41cm) toned stretched linen

OILS
Burnt Umber

Terra Rosa

Titanium White

Ultramarine Blue

Yellow Ochre

BRUSHES
Small liner brush

Nos. 8 and 10 hog-bristle flats

Nos. 4 and 6 bristle flats or filberts

Nos. 3 or 4 sable round

Nos. 2 or 4 egbert

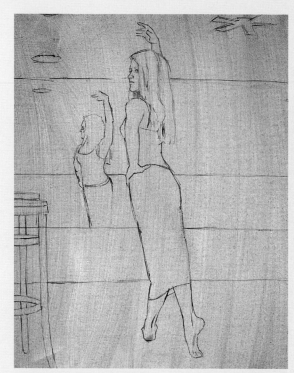

1 Sketch the Subject
On your toned stretched linen, use a small liner brush to sketch the subject. Work slowly to achieve accurate proportions and perspective. Correct any errors before you begin painting.

8

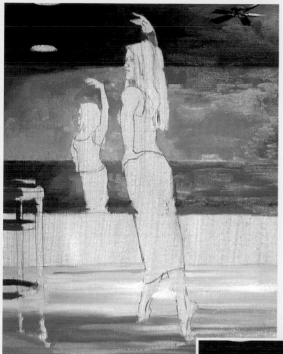

2 Add the Initial Tones

Use a no. 8 or a no. 10 hog-bristle flat to establish the background tones and environmental color scheme. Keep in mind where you are heading with your focal point.

3 Begin Refining the Figure

After the environment is roughly laid in, begin to lay in darker tones with Burnt Umber, Ultramarine Blue and a touch of Yellow Ochre in the main subject. Use a no. 8 bristle for this.

Continue refining the subject with a no. 6 and no. 4 bristle flat or filbert. Focus on light and middle values of Titanium White, Yellow Ochre and a touch of Terra Rosa. Observe carefully, painting slowly and sensitively with a delicate touch.

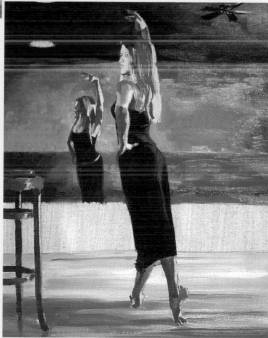

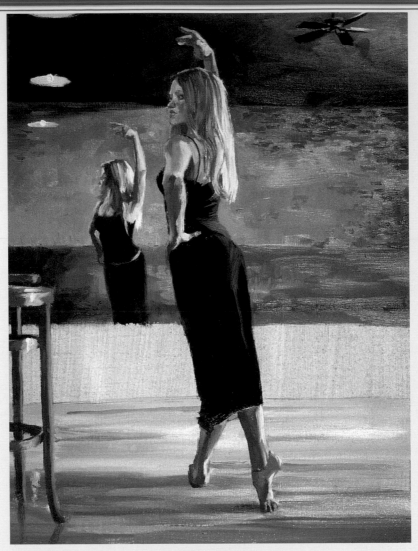

4 Refine the Figure, Face and Other Details

Switch to a no. 3 or no. 4 sable round to add the delicate details in the face, hair and hands with the Titanium White, Naples Yellow and Terra Rosa. Use a no. 2 or no. 4 egbert to emphasize brighter highlights on the hair and detail on the background wall.

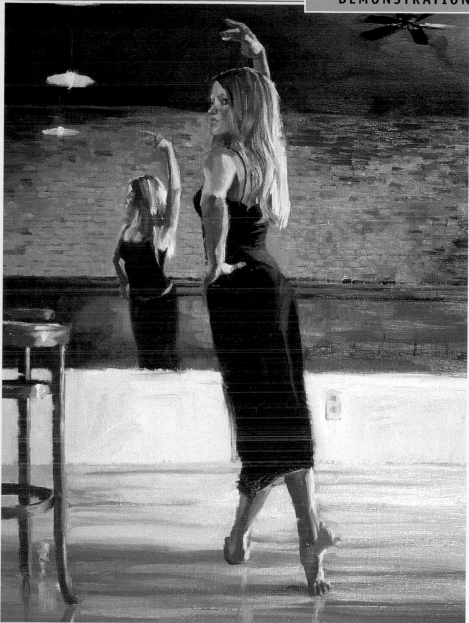

5 Add Final Details

Finish adding the background details to complete the painting.

JAZZ REHEARSAL
Oil on linen
20" × 16" (51cm × 41cm)

REFERENCE SKETCHES

Reference sketches provide an artist with resources to consult during the production of a painting. They are often drawn from life or from a model to help the artist render a more realistic gesture or pose. For example, reference sketches capturing the motions of a trotting horse can help the artist accurately portray that movement in the finished work. A reference sketch done on location can serve as a guide for work to be completed in the studio.

Reference Sketches Resolve Many Questions

Perspective usually is a major concern when drawing architecture, so it's a good idea to do a rough sketch first. In this sketch I used pastels to help me decide on a color palette for the painting as well as to work out the perspective.

VENETIAN SCENE SKETCH
Pastel on Canson paper
11" × 14" (28cm × 36cm)

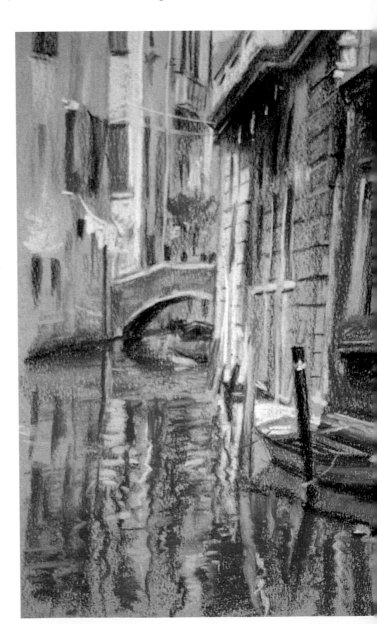

Problems of proportions and perspective may be resolved in carefully calculated reference sketches so that the artist doesn't have to stop and figure them out during the painting process. Reference sketches also allow the artist to focus on only one small area of a subject that may be particularly demanding so that her or she can get the details right before trying to depict them with paint.

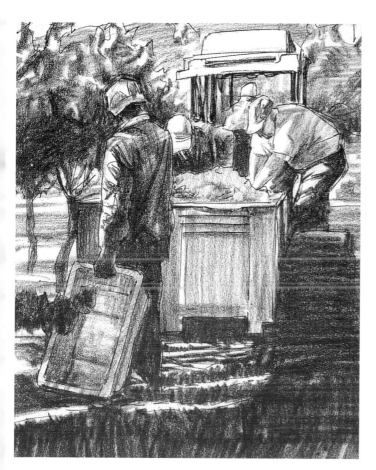

Establish a Painting's Composition in a Reference Sketch
Complex, active compositions can be more easily worked out in a small sketch prior to completing a larger painting.

WORKING IN THE VINEYARD
Ink and charcoal on vellum
9" × 12" (23cm × 30cm)

Using a Reference Sketch for a Paintin

In this demonstration, you will use the reference sketch on page 277 as a guide to composition and value pattern.

page 277

Materials

SURFACE
30" × 24" (76cm × 61cm) Masonite panel

MEDIUMS
Gesso
Graphite pencil

OILS
Alizarin Crimson
Burnt Umber
Cadmium Red
Gold Green
Raw Sienna
Terra Rosa
Titanium White
Sap Green
Ultramarine Blue
Yellow Ochre

BRUSHES
Nos. 8 and 10 bristle flats
No. 6 bristle flat or filbert
No. 2 bristle egbert
No. 6 sable flat

OTHER MATERIALS
Palette knife

1 Prepare the Surface and Sketch the Subject
Coat the Masonite panel with gesso and allow it to dry. Sketch your composition with a graphite pencil, paying attention to perspective and proportion. Lay down a pale wash of Raw Sienna over the drawing. Do not rub too hard or you will smear your drawing. After the wash dries, begin painting from background to foreground.

2 Add Colors to the Background, Foreground and Shadows

Establish the environment with the appropriate tones. Remember to add the background colors first, then the middle ground and finally the foreground.

Use a no. 10 and a no. 8 bristle flat to put in the environmental tones. Do not attempt to paint precisely each line. Instead, slightly overlap the lines in the sketch with your paint.

8

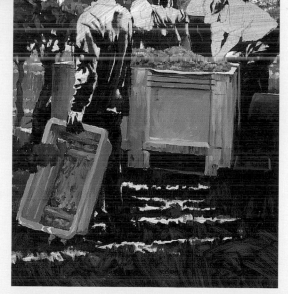

3 Add Color Variations

Begin to emphasize the focal point by adding shadows and color variations to the figures using a no. 8 bristle flat. Indicate the details and color variations of the background.

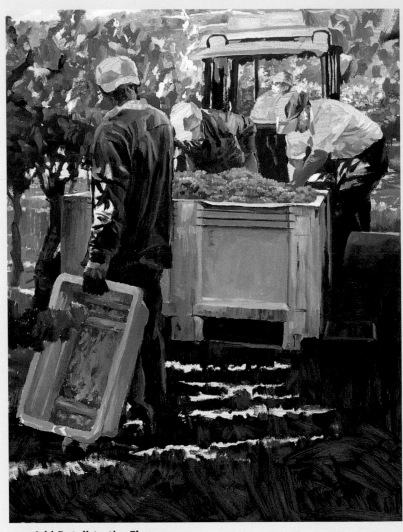

4 Add Detail to the Figures

Using a no. 6 bristle flat or filbert, paint in the lighter areas of the primary subjects indicating subtle tone variations and form.

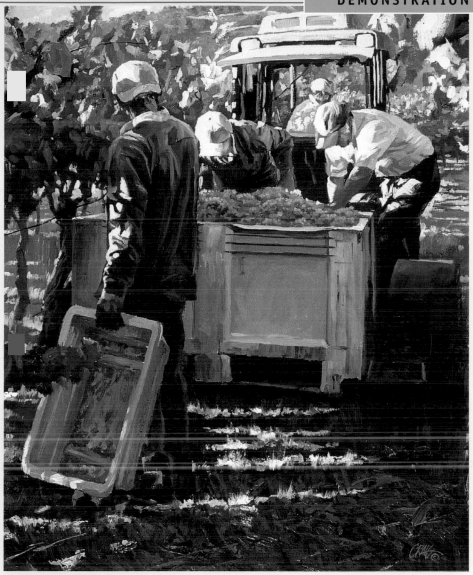

5 Complete the Painting

Add brighter lights to the figures using a no. 2 bristle egbert and a no. 6 sable flat. Add light to the pattern on the ground plane and some shadow detail. Use a palette knife to apply some strong lights to the foliage. Then scrape on some the shadow tones to the ground for texture.

FULL OF CHARDONNAY
Oil on Masonite panel
30" × 24" (76cm × 61cm)

DRAWINGS as FINISHED ART

When is a piece of art finished? This question can be answered only by the artist, because only the artist knows exactly what he or she is striving to achieve. To arrive at an answer for any particular piece, the artist might ask:

- Does it meet my quality standards?
- Does it accomplish what I set out to do?
- Is there any way I can improve it?
- Am I satisfied with it?

Deciding when a piece is finished is a judgement call that depends on the style and sensibilities of the artist. What one artist calls complete may seem lacking—or perhaps over-worked—to another, no matter what the meduim. You must be the judge of your own work.

Sometimes it may be helpful to leave a piece alone for awhile. Allow yourself some time and distance from the work before deciding whether it is truly done so that your evaluation can be more objective.

Even drawings that are very simple and abbreviated can be considered "fin-ished" if you are satisfied with them. A mat or frame may be all that's needed to provide that "finishing touch."

You Must Be the Judge of Your Own Work

I decided this piece was finished because I was satisfied with its quality.

A LITTLE SHY
Graphite pencil on bond paper
14" × 10"
(36cm × 25cm)

◀ **The Artist Determines When the Work is "Finished"**

This charcoal drawing is obviously a finished piece. The varied values, covering the full range from rich darks to soft, light grays, produce a work with enough detail to feel complete.

BELOW THE RIALTO
Charcoal on artist's vellum
13" × 18" (33cm × 46cm)

283

Draw a Landscape in Earth Tones

This drawing is composed to emphasize the difference between the dark areas and the light areas. To discover the areas with greatest contrast, close one eye and squint. The blurred image will allow you to focus on design and composition, not the shapes.

Materials

SURFACE
18" × 24" (46cm × 61cm) artist's white vellum

MEDIUMS
Soft vine charcoal

CARBOTHELLO PENCILS
Choose a slection of CarbOthello pencils in light, medium and dark earth-tones

PASTELS
A range of earth-tones

Black

Cream

White

OTHER MATERIALS
Facial tissue or paper towel

Kneaded eraser

Workable spray fixative

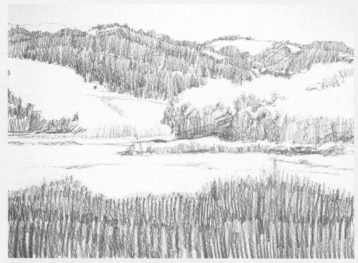

1 Sketch the Composition and Add Dark Tones

Using a pale earth-tone CarbOthello pencil, sketch the composition and add the basic dark tones.

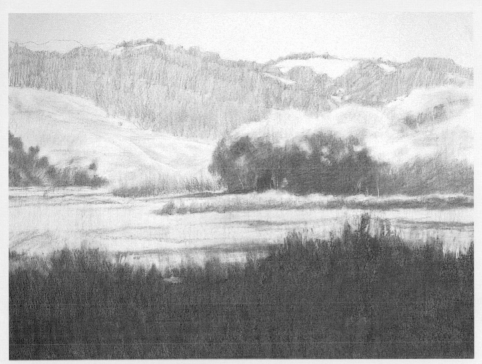

8

2 Soften the Edges and Add Highlights

Use a facial tissue or paper towel to smudge the tones. With a darker earth-tone pastel, roughly mass in the darks that appear darker. After smudging these, use a kneaded eraser to lift out a few lights in the middle ground trees, which will become the focal point. Lightly spray with workable fixative and let it dry.

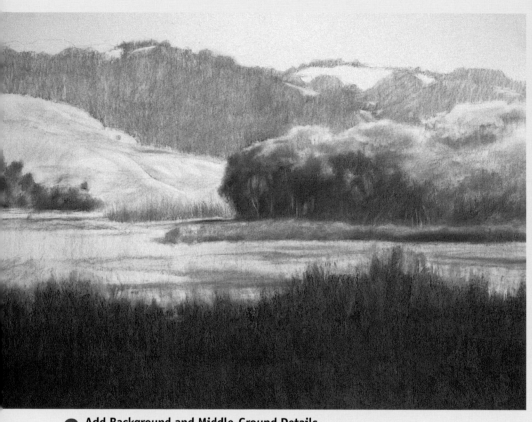

3 Add Background and Middle-Ground Details

Use a soft vine charcoal to lay over background hills and various darker earth-tones (some reddish, some brown) in the middle-ground trees. After adding a darker brown tone, lift out the lights in the trees with a kneaded eraser. Lightly spray the suface with fixative. Let it dry.

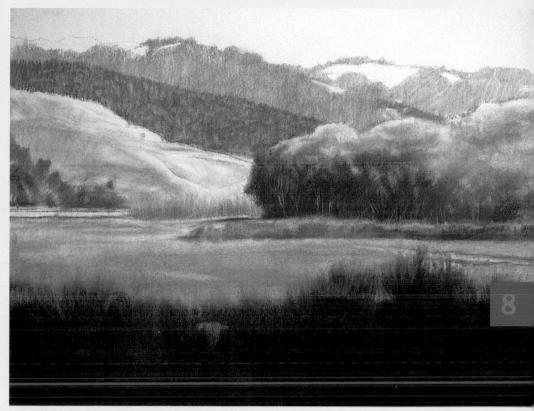

4 Add More Varied Tones

Add a slightly darker tone in the near background mountains. Add an ochre earth-tone in the middle ground field. Use a very dark brown CarbOthello pencil to add more darks in the middle-ground trees. Use some black charcoal or pastel in the foreground shadow. Smudge the tones carefully, clean up the edges with a kneaded eraser and lightly spray with fixative.

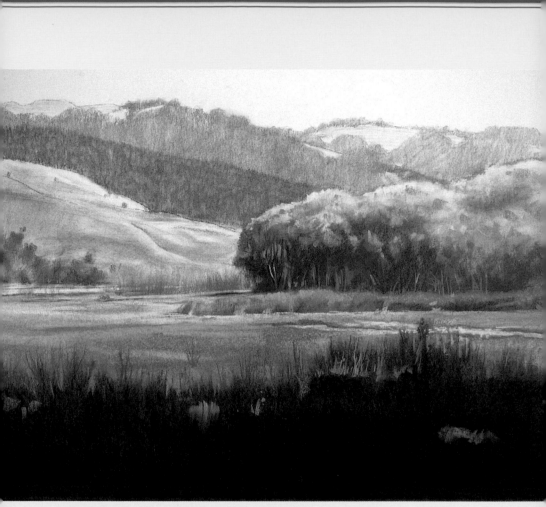

5 Add Details to Finish
Focus more attention on the trees with a few more subtle colors and tones. Add some pastel off-whites and whites in middle-ground trees along with some linework. Add a few accents with line work in the foreground weeds. Add some surface activity to the field in the middle ground to create the texture of the brush and weeds. Enhance the middle ground to your satisfaction with line and tone.

LAYERS OF LANDSCAPE
CarbOthello pencil, charcoal and pastel on artist's vellum
18" × 24" (46cm × 61cm)

REFINING A DRAWING

Final, refining touches are those additions or corrections that turn an adequate drawing into a truly satisfying one. They can take various forms, depending on the style of the drawing and the artist's intent. For example, a light tonal wash may be just the right final touch for a simple line drawing. A pastel sketch may benefit from some more colorful accents or deeper contrasting shadows. Perhaps more highlights need to be lifted from a charcoal drawing, or the facial features in a pencil sketch could be more carefully defined. Practice and experience will refine your ability to recognize the needs of your drawing and make those final aesthetic decisions.

Detail of Lone Rider

The crisp edges and strong tones of the rider contrasts with the softer, smeared weeds in the field through which he is riding. I added greater definition to draw the eye toward the figure, which is the focal point.

Notice the casual way in which the tree branches have been rendered. Masses of leaves have been indicated with a piece of soft vine charcoal. (See the full drawing on page 290.)

A Refined Drawing

I wanted to evoke a feeling of loneliness in this drawing, so I placed the figure within the composition accordingly. I also employed a full range of values and varied edges to create a feeling of spaciousness.

LONE RIDER
Charcoal on artist's vellum
18" × 11" (46cm × 28cm)

Crosshatched Charcoal Drawing

For this charcoal demonstration, we'll use crosshatching to build up the tones rather than smearing and blending them as we've done in previous charcoal exercises. Crosshatching can be an equally effective way to achieve varied values.

Materials

SURFACE
17" × 14" (43cm × 36cm) artist's white vellum

MEDIUMS
2B, 4B and 6B charcoal pencils

OTHER MATERIALS
Kneaded eraser

1 Sketch the Subject

Sketch the subject lightly with a 4B or 2B charcoal pencil, concentrating on proportions, shapes and shadows.

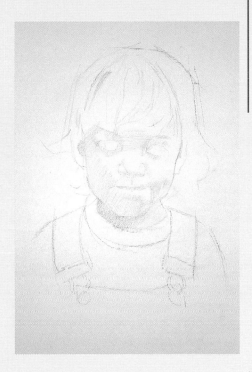

8

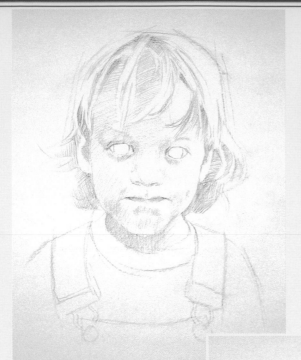

2 Develop the Light Tones and Underlying Structures

Using the 4B and 2B charcoal pencils, develop the lighter tones with hatching. These begin to develop the structure of the features.

3 Add Darker Tones and Facial Features

Continue with the 4B charcoal pencil, using crosshatching to further develop the features with darker, more definitive tones Define the eyes with darker tones as well.

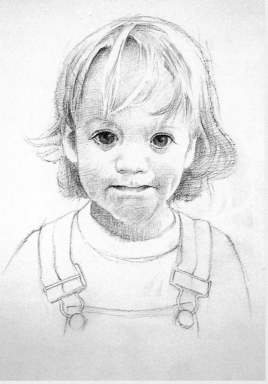

8

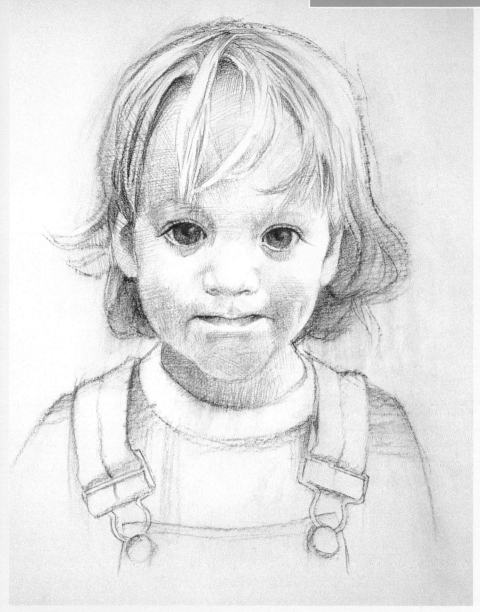

4 Finish the Drawing

Use the 4B and 6B pencils to complete the darker structure tones and accents in the face and hair, and around the eyes. Finally, add a bit of tone in the clothing. If you have slightly smeared any of the charcoal—accidentally or intentionally—use a kneaded eraser to clean up the lights.

IAN'S EYES
Charcoal on artists' vellum
17" × 14" (43cm × 36cm)

MATTING

The placement of a mat around a drawing makes it appear more complete. A mat helps to focus the viewers' eyes on the art and away from what is around it, emphasizing its significance. A mat is generally about 2½ (64mm) to 4 inches (102mm) in width and ½-inch (13cm) longer on the bottom.

The color of the mat should not detract from your art. When in doubt, keep it relatively neutral. Black or white may be too harsh, but on certain

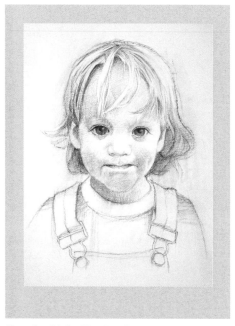 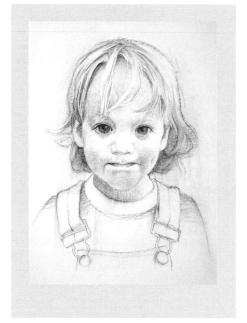

Use the Right Mat For Your Art
If you were going to frame the drawing *Ian's Eye's*, which mat would you choose?

CHOOSING A MAT FOR A COLOR DRAWING

If the drawing is in color choose a compatible color for the mat so that it doesn't overwhelm the picture. The fillet can pick up a contrasting tone from the artwork.

pieces either might be very effective. Fabric such as linen may be stretched over the mat for a more elegant presentation. A fillet, a narrow (¼-inch to ⅜-inch [6mm to 10mm]) mat in a contrasting color, can provide an accent between the mat and the art. You can cut mats yourself or have them done by a professional framer, although the latter will cost quite a bit more. For longevity, choose acid-free matting materials.

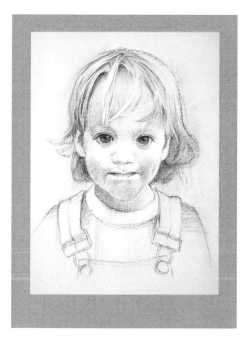
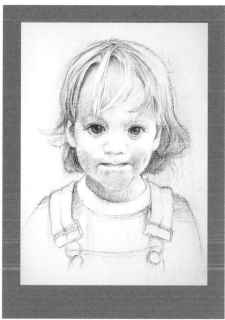

8

TAKE THE WORRY OUT OF CHOOSING A MAT

Take the time to look at the mats used on other people's drawings. This will give you an idea of what kind of mat would work for your artwork.

FRAMING

The final stage in presenting your art for exhibition or display is framing. Frames come in various colors, finishes, textures and styles to suit any type of artwork. Selecting a frame is a matter of personal taste, but I think it's best to not overdo the framing. I prefer frames that are narrower than the mat so the artwork remains the focus.

The glass used in framing is also important. It protects the artwork and adds a nice surface finish. The mat keeps the glass from touching or rubbing against the surface of the artwork so you don't have to worry about smearing or other damage. Glass options include traditional plate glass and Plexiglas; both come in non-glare versions. If you're going to exhibit your work, Plexiglas is the rule for most shows.

Unframed, Matted Art
An off-white mat helps complete this mixed-media portrait, complementing the white shirt in the art.

SINATRA
Acrylic and mixed-media on cold-pressed illustration board
22" × 16" (56cm × 41cm)

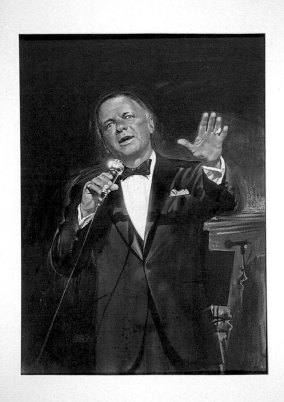

8

Framed Art
The mat color and frame style should not detract from or overpower the art. The glass finishes and protects the image.

SINATRA
30" × 24" (76cm × 61cm) with frame

CONCLUSION

With its variety of mediums, surfaces and approaches, and with endless possibilities for subjects, drawing offers a lifetime of stimulating challenges. Whether in classes and workshops or through personal study, nearly every artist has explored the richness of this art form, developing personal techniques and styles along the way. Remember that drawing should be enjoyable, not painful. If it ever begins to feel monotonous, simply switch to a different medium or try a new technique. Drawing can be a form of recreation as well as a means of practicing skills and studying visual concepts. Whether you draw for relaxation or professional exhibition, or even if you draw primarily to prepare for painting, don't forget that drawing can be a very satisfying end in itself.

LINDSAY
Oil on toned canvas
16" × 12" (41cm × 30cm)

INDEX

THE BEST IN FINE ART INSTRUCTION IS FROM NORTH LIGHT BOOKS!

The Watercolor Bible
This handy guide offers indispensable advice for nearly every aspect of watercolor painting. With a comprehensive section to materials and supplies and over 20 step-by-step demonstrations, this provides and in-depth look at drawing and painting techniques every artist should know.
ISBN 13: 978-1-58180-648-9
ISBN 10: 1-58180-648-5
Concealed spiral binding, 304 pages, #33237

Secrets to Realistic Drawing
Get great results fast by learning basic, tried-and-true principles of drawing in a clear and concise manner. This book is ideal for any beginning pencil artist as only a few supplies are needed-pencil, eraser and paper.
ISBN 13: 978-1-58180-649-6
ISBN 10: 1-58180-649-3
Paperback, 128 pages, #33238

60 Minutes to Better Painting
Author of *The Drawing Bible*, Craig Nelson, examines 9 distinctive areas where quick studies will improve one's painting, including lighting effects, capturing new subjects and more.
ISBN 13: 978-1-58180-196-5
ISBN 10: 1-58180-196-3
Hardcover, 144 pages, #31969

These books and other fine North Light titles are available at your local fine art retailer or bookstore or from online suppliers.